KU-827-288

THE SKETCHES OF TURNER, R.A.

endpaper: *The Shipwreck*, mezzotint by
Charles Turner after J. M. W. Turner, 1805

The sketches of Turner, R.A.

1802–20: *genius of the Romantic*

Gerald Wilkinson

BARRIE & JENKINS, LONDON

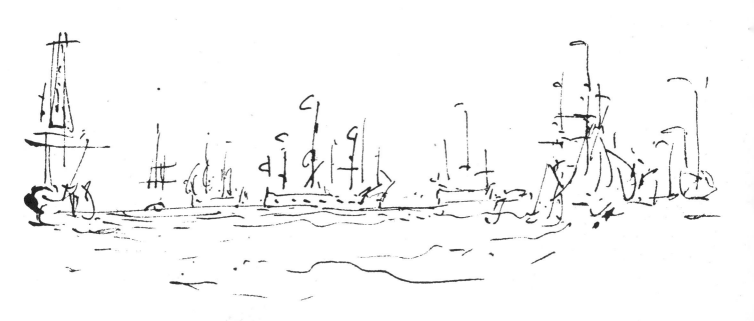

cm I 2 3 4 5 6 7 8 9 10 11 12 13 14 15 16 17 18 19

inches I 2 3 4 5 6 7

In series:
Turner's early sketchbooks, 1789–1802

HERTFORDSHIRE
COUNTY LIBRARY

741.942

6713863

Text copyright © by Gerald Wilkinson
First published in 1974 by Barrie & Jenkins
24 Highbury Crescent, London N5 1RX
Colour reproduction by
Colour Workshop Ltd, Hertford
Printed and bound in Great Britain by
Jarrold & Sons Ltd, Norwich
ISBN 0 214 66904 1

Preface

All the drawings in this book are in the Department of Prints and Drawings at the British Museum, unless otherwise labelled. The Finberg Inventory number of each sketchbook appears at the head of each page or preceding page. Pages of the sketchbooks are referred to in the text as folios; these folios appear in italic figures under most of the reproductions, along with Turner's labels, if any, *in italics*. Finberg gave some sort of descriptive title to each drawing, and this has been retained in every case where it contributes information. Finberg's captions appear in ordinary type with a capital: captions which I have added are set without capitals.

I have been asked to mention watermarks. These will be found in the running headline within angular brackets. Not every paper carried a watermark, and the dates are rarely very helpful. The mark 1794 appears with a frequency out of all proportion, because a new Excise duty in that year made it advantageous to use a date in the watermark. Any date would do, and papermakers did not bother to alter the first one for some years. (I cannot understand why Turner persisted with the stiff and unsympathetic Whatman 'laid' paper for so long when other, softer and whiter papers were available. Perhaps his lead pencils were harder than he really liked, and a hard surface was necessary to take them. Or perhaps, since he was not striving for effect but simply storing information, he didn't care.)

To avoid overcrowding the running head I have included the sizes of the sketchbook pages in inches only. I hope this will not be too inconvenient to readers who are used to metric sizes. In fact most of the reproductions are about half the size of the original. This means that Turner's favourite size of page, about $4\frac{1}{2}$ by $7\frac{1}{4}$ (the size, in fact, of a modern paperback) can be fitted into our page six or even eight 'up'. Trusting to the patience and perspicacity of the reader I have not hesitated to crowd in as many as possible. The 'half-size rule' is modified here and there, especially where the drawings are very finely detailed.

Any editor will agree that it is harder to select one than to include three. But, though a good collection could be made by selecting say, one in three of the pictures in this book, I feel that the element of personal choice would certainly distort the representation of Turner's extraordinary fecundity, which is an important aspect of his artistic character. No amount of empathy for the 'artist's intention' would help, because Turner had no intention at all to exhibit his sketches. He did not let any of these books out of his care until he

died, and he wanted History, that is presumably, you and me, to judge his work as a whole. He hated bits, and 'gems', and trifles. Nevertheless this is very much a selection – from 6,585 pages. I can only claim that it comes nearer to reviewing Turner's whole output in a given period of years than does any previous publication.

In two years of pencil copies, notes, trial layouts, photography, checking proofs, I have found my favourites among these drawings. But what has impressed me is the classical quality of all, even the most casual sketches: one is never tired of them. And for variety, you need only turn the page: Turner left us a wonderfully entertaining document. Anyway, I hope you agree that the drawings printed here are entertaining; for art, and books, must be that at least.

Contents

Books constantly referred to

A. J. Finberg *Inventory of the Drawings of the
 Turner Bequest* HMSO 1909
 The Life of Turner, 2nd edn OUP 1961
 The History of Turner's Liber Studiorum
 Benn 1924
Graham Reynolds *Turner* Thames &
 Hudson 1969
James Grieg (ed) *The Farington Diary*
 Hutchinson 1922
Charles Holme (ed) *The Genius of Turner*
 The Studio 1903
Camille Mauclair *Turner* Hypérion 1939
Jack Lindsay *J. M. W. Turner: his life and
 work* Cory Adams & Mackay 1966
 The Sunset Ship (the poems of J. M. W.
 Turner) Scorpion Press 1966
John Gage *Colour in Turner* Studio Vista
 1969
Martin Butler *Turner Watercolours* Barrie &
 Rockliff 1967
Mary Chamot *The Early Works of Turner*
 Tate Gallery booklet 1965

Acknowledgments

Special acknowledgment to Sheila Wilson,
of the British Museum, for her accurate
colour photography. Kodak Ektachrome
film was used. The pencil pages were
photographed on 35mm Ilford FP4 film,
with a few exceptions. I used my own
judgment in raising the contrast of the
prints so that, I hope, the grey pencil lines
show up in reproduction – another
necessary distortion? Or perhaps just an
improvement in the signal-to-noise ratio.
 My thanks to Evelyn Joll for helpful
information about Turner paintings and to
Clovis Whitfield for essential help in
obtaining one illustration; to the Directors
of various public galleries for providing
photographs and waiving reproduction
fees. Special thanks to Richard Wadleigh
for long sustained enthusiasm in production.
 Perhaps unconventionally, I would like to
acknowledge the handful of reviewers who
realised where *Turner's early sketchbooks* was
leading to. From one of them, Pierre
Rouve, writing in *Arts Review*, 17 June
1972, I feel I learnt a great deal – though
I may not have applied what I learnt. Two
years older, perhaps wiser, certainly no
richer, I still find Turner enigmatic: not
because some bad Victorian journalists
surrounded him with a somewhat sinister
aura, but because, being such a great man
he was so naif. In this last respect I am his
equal and fit to explore his biography
through his sketchbooks.
 Very special thanks to Leopold Ullstein,
the publisher, who before retiring made
certain that my research could continue.
 Once again, thanks to the staff at the
Print Room of the British Museum for their
labours and kindness.
 The drawings of the Turner Bequest are
available on microfilm from EP Microform,
Bradford Road, East Ardsley, Wakefield,
Yorkshire.

INTRODUCTION

In the early nineteenth century a sketch was still an unfinished, therefore worthless, piece of work. A firm distinction between 'finished' and 'unfinished' continued to be made until the early years of this century, and the value of a sketch or study depended on the light it cast on some important work or perhaps on the life of the painter. Many of Turner's sketches, of course, still have this dual value, and I have tried to exploit it where it helps to clarify the artist's purpose or in any way deepens our understanding or enjoyment of his paintings. But I think that all the drawings in this book, and I include written notes and other trivia, are fine things in themselves. I have considered each one lovingly and passed over hundreds of others regretfully.

Turner, as he matured, could hardly put pencil to paper without at once claiming the attention of the appreciative eye. This is a mystery, and I shall not attempt to explain it except to remind you of what art teachers always *used* to demand of their students: constant practice and unremitting observation of nature. Turner's fantastically brilliant and attractive draughtsmanship is the result of these, almost to excess. There were times, especially on his journeys, when he should have done less. Who needs 1800 pencil drawings of Rome and northern Italy, all done in six months? Apparently Turner did, and there are sixteen sketchbooks in the Turner Bequest to prove it. It would be crazy to pretend that every drawing is a masterpiece – in fact, looking through them can get very tiresome. Turner didn't mind spending his skill and effort on hundreds of pages that he could never hope to make use of. He would have the satisfaction of knowing he had recorded everything he saw. But I think the real reason for his obsessive industry was that for him drawing *was* seeing. It was a habit and it was his way of observing nature. He is supposed to have explained to a fellow artist in Rome that he could do fifteen pencils in the time it would take to do one coloured sketch – of which he did only a few in Italy. But perhaps he didn't want to attempt to record the colour and atmosphere of Italy: it was all being absorbed and transmogrified in his mind, in general, not particular, schemes.

After 1820 his pencil draughtsmanship becomes a good deal less careful and literal, more a sort of shorthand – which he had already developed, as we see in many quite early pages. This book contains some of Turner's pencilwork at the height of his power and virtuosity with that medium.

Sketches

The title of this book is intended to suggest that its subject is not merely the sketchbooks but other sketches and drawings as well. Some explanation seems necessary of the scope of the selection.

A sketch is nowadays defined as a slight or rough drawing – and most people would agree that slightness and roughness are not necessarily faults – can even be virtues in that they imply freedom and spontaneity.

Such a drawing can be a sketch from nature, or a sketch of an idea, or be one stage in the execution of a more elaborate work. The term *study* was applied by Turner to the last two of these categories: *Studies for pictures* – so he labelled his notebooks that contained such sketches.

'Study' was also used later in the nineteenth century to mean careful drawings of, say, drapery or foliage, or for life drawings. I am thinking of the almost devotional studies of detail, often severely overdone and gloomy in atmosphere, that became routine in Late Victorian art schools. These were not sketches. Where studies of details were done by Turner I have regarded them as suitable material for this book. He didn't do very many and they are all obviously purposeful. He wasn't in the habit of drawing for drawing's sake, prolific though he was. In fact he expressed in his lectures a particular aversion to 'pictures of bits', by which he meant that the parts should be subject to the whole, and good pictures couldn't be made by merely assembling collections of studies.

The studies for pictures

There is a wide range of techniques in Turner's sketches during the period covered by this book; from the slightest, quickest note and the roughest of ideas to quite carefully worked pencil compositions and to watercolours and oil sketches which were not 'finished' in Turner's sense but which we can judge as works of art. Some of the more meticulous pencil compositions are in fact the skeletons of watercolour, or even oil, pictures, as I shall explain. In addition, there are scores of composition studies, 'roughs' in fact, for oil paintings (not usually for watercolours). Some of these, in the large *Calais Pier* sketchbook, he has labelled: *Last study to the Dutch boats*; or *Macon. Ld. Yarborough's Picture*. Evidently Turner kept them as records of his work, but they are sketches and within the scope of this book.

Sometimes a note in one of his sketchbooks becomes at once the basis for a completed picture. The flash of recognition is one of the pleasures of looking through the sketchbooks. Examples are two fine sketches in which appears the odd-looking classical watertower at Tabley (p. 95). The whole picture is there, in a few square inches of paper and scribble. While the paintings (two of them, one 'calm', one 'windy') leave nothing to be desired (they are favourites of *mine* anyway) the sketches recording the moment of inspiration take on a special value, not exactly of hindsight. I think they help one to identify with the painter – to sympathise with his motives. The pencil note is human, while the painting is a *thing*, however delectable. This is a legitimate extension of one's observation, not a mere biographical irrelevance.

Another example of a great picture emerging from the pages of a tiny sketchbook is provided by the famous *Battle of Trafalgar*. The sketch records an exciting moment not so much of inspiration as of practical imagination. Instead of leaving the design of his picture

to be worked out in the studio (the contemporary method with such works was rather like arranging a stage tableau), Turner has gone aloft, and with the help of eyewitnesses, has visualised the whole tremendous scene from the best possible viewpoint – as he is careful to record in the full title of the oil painting: '. . . *from the mizen starboard shrouds of the Victory*'.

Not all Turner's paintings had their main lines laid down in a simple sketch, of course: and such a sketch was itself often at the end of a long sequence. The many violent variations on the 'Shipwreck' theme (p. 66) show that there could have been a dozen different paintings, each as exciting as the one which finally saw the light – and fame, through Charles Turner's impressive engraving (see front endpaper). The pages of the large *Calais Pier* sketchbook show that Turner worked on a new version of the *Lee Shore* of 1802 (p. 27), and one less burdened with circumstantial clutter. *Lee Shore unpainted 1805*, says his label on a similar sketch to *Mr Dobree's Lee Shore* (see p. 57). The gentleman did buy one picture: the *Boats carrying out anchors and cables . . .* of 1804. And Turner did paint a new *Lee Shore*, though it was never exhibited in his lifetime.

There are many studies for pictures based on classical mythology and history in the sketchbooks of this period. I have attempted to assess their value as drawings irrespective of subject. I don't much like Turner's classical mood but I have to admit that it was very important to him, and engaged his most heroic endeavours right to the end of his life. It was in the gold light of imagined Carthage that he saw his own rise and decline, and since he was anything but a hero to look at we must forgive this pose. Often enough the real subject of such studies is a captivating effect of light and shade, somewhere along the Thames, and not *Driope*, whoever she was, or the *Birth of Adonis*.

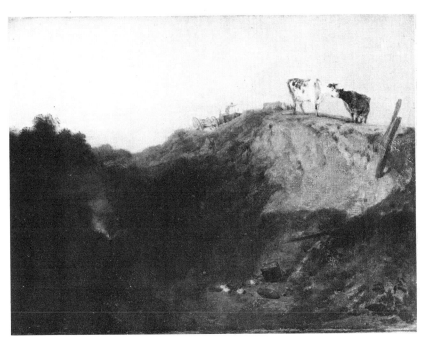

Sketch of a Bank with Gipsies, oil painting exhibited in Turner's Gallery in 1809. Tate Gallery

Sketches in oils

Not all the sketches are drawings – no term in practical art can be precisely defined. Turner began to make oil sketches in the open air, some on paper and some on panels of wood, in about 1806–7. Oil sketches are of course paintings in any sense. In the Turner Bequest there are also many (larger) unfinished paintings on canvas. The difference will be clear from the illustrations.

Wilenski, attempting to verbalise the distinction, introduces the term *pochade* for the oil sketches. He says 'the experienced *pochadeur* can produce such records and carry on a conversation or think about the gas bill at the same time' – a curious reaction to these visual poems from Turner's thinking hand.

The larger paintings are remarkable for their period in being painted into a white ground – even the oil sketches on panels made use of dark grounds.

Turner's oil sketches, like Constable's of the following decade, were done for private study and not for exhibition – though Turner may have exhibited the series in his own gallery, for a contemporary described it as 'like a green-stall': another talked of 'views on the Thames – crude blotches'. They are in fact some of Turner's most original works: their colours are fresh and naturalistic; and forms are flattened, detail subdued, in true Impressionist style, derived no doubt from his early watercolour sketches from nature. Unlike Constable's oil sketches, which are mostly concerned with recording transitory effects of nature in an almost scientific spirit, Turner's are compositions. He even used the term *sketch* in the titles of two paintings exhibited in his own gallery in 1809.

These would not have been accepted at the Academy and it is not thought that the Thames sketches were for sale. The series remains to us as 'oil sketches' and of unique value as the first attempts in history to interpret scenes directly into oil-based pigments, that is, in a medium which activates the whole picture surface and therefore cannot be called a drawing medium.

Wash drawings

Drawing is by definition the use of line – something is dragged, drawn, or pushed across a surface. You can draw with anything that makes a mark. Though by modern definition 'making marks' is not necessarily drawing, in the early-nineteenth-century context I think we can agree on the 'linear' definition. The idea of brush drawing in the Chinese calligraphic sense had not been expressed by the Georgian painters, though Turner certainly practised the technique. They would have called it 'blotting' – blots were a late-eighteenth-century pastime, supposed to have been invented by the elder Cozens, who wrote a treatise on blots as a 'method of invention in the composition of landscape'.

Much of the brushwork in the sketchbooks is in the form of monochrome wash. The history of the use of monochrome in Europe has yet to be studied. The psychology is curious. Do we tend to see – as we are supposed to dream – in black and white? But infants, essentially primitive artists, do not choose to draw in monochrome, if they can lay their hands on coloured pencils.

The whole academic tradition of drawing since the

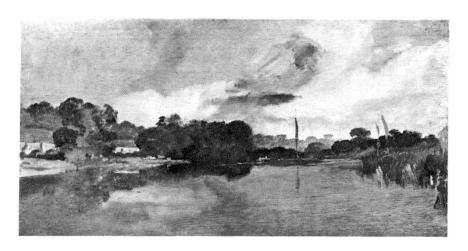

oil sketch on wood panel: *Walton Reach* 1807? 14 × 29 inches

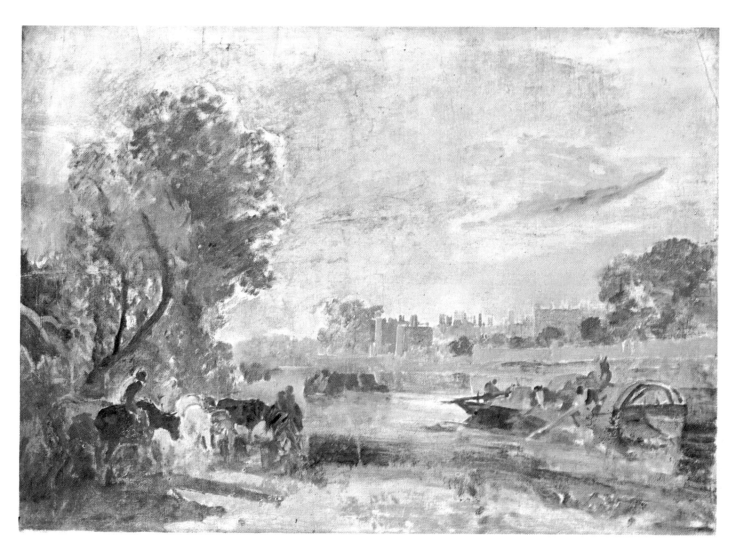

unfinished oil on canvas: *Hampton Court* 1807? 34 × 47 inches

Tate Gallery (both)

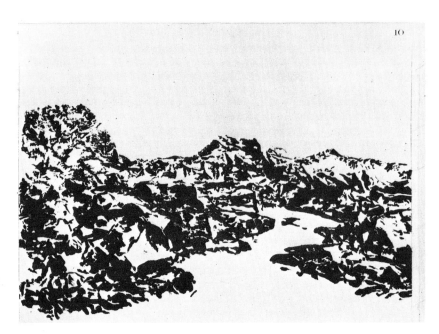

10

blot drawing by Alexander Cozens, engraved in his *New Method for Assisting the Invention*, 1785

Renaissance has depended not merely on representing natural appearances in monochrome, but on deliberately ignoring colour, which, if represented as tone, produces 'dirt' – and interferes with the pure expression of form. The ready availability of various forms of carbon – as charcoal, as printer's ink – and the unique value of white, so rare in nature, does not quite explain our fascination with black and white. It certainly doesn't explain our monochrome habit – grey is merely the colour of death and ashes. Line engraving doesn't quite explain the fashion for *grisaille*. The answer must lie at least partly with the academic use of ancient statues as models for drawing practice. These antiques had once been painted and gilded, but by the time of their rediscovery in the Renaissance were respectably bald and white. Drawing 'from the antique' was fundamental to academic teaching and it became natural for artists since the Renaissance to use ink and wash to represent form; while *chiaroscuro*, the art of composing with light and dark, became a compulsory study for three centuries afterwards.

Claude sketched his landscapes in brown as an alternative to black. Some eighteenth-century watercolourists favoured blue. Turner as a young man copied many monochrome wash drawings in grey and blue. When he wished to emulate Claude in the *Liber Studiorum* he used brown, or sepia (cuttle-fish ink).

By the end of Turner's life a new art of monochrome had emerged – photography. In black and white it still has a firm hold on us in spite of the universal appeal of colour. Perhaps the days of monochrome are almost over – yet, when colour printing and colour projection become universal, monochrome may still be fascinating, or at least, restful.

Turner, the great colourist, was quite at home in monochrome, whether pencil or wash, and it is perhaps because of this that he found it necessary to experiment in pure colour, as in the many vague watercolours catalogued as 'colour beginnings'. Thus the schism between form and colour worked to his, and our, advantage and he was able to break through the tyranny of the outline and away from the confinements of chiaroscuro – but only when his mastery of these methods was complete.

Watercolour

Watercolour is a peculiarly English (and American) art. On the Continent watercolours were really *gouache* (body colour) and not essentially transparent. Watercolour itself is merely transparent pigment bound with a solution of gum and as such has been used in every age and climate. The English watercolour in its 'pure' form depends on the use of transparent washes of colour. It evolved from the eighteenth-century habit of *staining*, or tinting, a pencil drawing. Obviously, transparent washes were necessary so as not to obscure the precise detail of the pencilwork which was the main support of the drawing – the colour washes were an optional extra. In the hands of such as the younger (John Robert) Cozens the technique acquired a new depth: it was married to the French tradition of monochrome painting. Turner began his early watercolours in this way, laying down a monochrome underpainting, with a pencil framework, and then

tinting with washes which could mingle to controlled degrees with the monochrome. Partly because of his habit of rapid sketching in the, usually cold, open air he was soon laying down directly, first the basic colours, then later the actual colours of his finished drawing. It was his use of direct watercolour which led, not only to the very fresh results in many of his early sketchbook pages but to his ability to see colours in nature, rather than light and shade to which colours could be added. This was a slow process of development which of course culminated in his later use of colour as a primary means of expression. As late as 1818 'form' and 'colour' were still quite distinct conceptions in Turner's mind.

He was no purist: when it suited him he would add Chinese white for highlights. His technique was much admired in his day, though we find his exhibited watercolours often too laboured. Instead of building up washes of colour around areas which were to be light he often removed the lights by blotting out and scratching out – much remarked on by contemporaries. Tradition has it that his thumbnail was sharpened for scratching out lights – just as the nails of the forefingers of certain eighteenth-century persons were supposed to be shaped as pens – a practical method.

The essential quality, then, of an English water-colour lies in the transparency of undisturbed washes of colour: its essential value its directness – the same, in fact, as that of a sketch. Both Turner and Girtin played a formative part in the final evolution of the English watercolour, but Turner, like Sandby before him, did not specialise in a pure technique. He often chose the alternative of using opaque water-colours on toned or coloured paper, at first when designing rough work for compositions and later, less experimentally, in the famous Petworth series of 1830 and others.

Since transparent washes can never completely cover the paper there is some justice in the habit of calling all watercolours, except the most finicking, 'water-colour drawings'. The Academy oil painters of Turner's time called them all merely drawings, and hung them badly. The watercolourists called themselves painters; and it was Turner's friend Wells who was instrumental in forming the Society of Painters in Watercolour, in 1805, as a very successful breakaway group.

Watercolours were popular, and in a period when pictures began to be in demand not only by the traditionally rich, they were cheap. This factor, added to the demands of engraving, explains Turner's enormous production of finished watercolours, apart from his less affected use of the medium in his sketches.

Many pages of his sketchbooks, and many miscellaneous pieces of paper, contain watercolours casually done, which, mounted and framed, could take their place in any gallery. Since Turner did them as sketches (and his public certainly would have regarded them as no more) I have included as many as I could: but I have ignored those watercolours which were 'worked up' for exhibition, or for the engravers.

There is still a lot of misunderstanding, in the minds of people who should know better, about the real value of watercolour. A mystique and, conversely, a snobbery, still puts watercolour in a class apart. Pigment bound with gum is more durable, properly cared for, than oil paint. It is every bit as valid a method as any other,

above and below: the watercolour style perfected by Girtin in the last year of his life, 1802, aged 27. Reproduced actual size from the originals in the British Museum

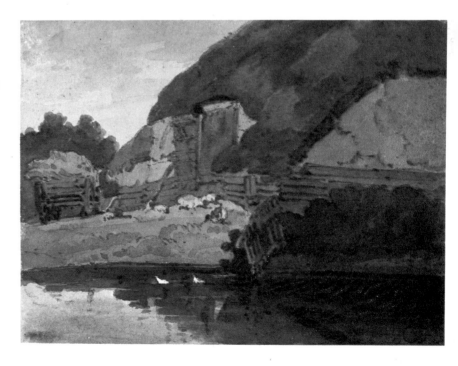

even though a piece of paper *is* somehow less formal than a canvas, panel, or wall.

Turner was accused in his time of transferring the techniques of watercolours into oil paint, as if it were some sort of pollution instead of what it was, a gain both in expressiveness and permanence. Because 'sketching in watercolours' was taken up as a hobby by polite young ladies the medium has still the stigma of amateurism. Because Cotman and de Wint acquired fantastic facility in the use of the 'pure' medium it became known as a collectors' fad. Watercolour is just a way of sticking colour to paper, and it doesn't matter whether you call it painting or drawing.

Working drawings

Most of Turner's sketches were potential working drawings, and many of his finished watercolours were originally done for the engraver (engravers preferred to work from colour, and anyway a coloured drawing could find an extra market). When Turner planned to originate a series of engravings himself, however, he worked in monochrome.

The sepia drawings which Turner made as 'cartoons' for the engravings he published under the title of *Liber studiorum* are nearly all 'finished' – nothing left to chance and every detail worked out in a form that the engraver could copy. These drawings were exhibited in Turner's Gallery – perhaps simply as a prospectus for the series to be published. They are sketches only in the sense that they were not the final stage of the work, but I feel justified in including a selection in this book – I wish I could include them all, but there are 96: they make a book in themselves* – partly because of their intrinsic quality and partly because they show something of Turner's attitude to his work.

During the central years of his life the subjects of his *Liber*, and their classification and publication, occupied Turner a good deal; perhaps wasted his time. The work played its part in clarifying his purposes. As he began to see his way more clearly he dropped the series while in sight of the end. He may have been influenced in this by the rise of steel engraving and its very sensitive practitioners.

He did most of his own etching, that is, the initial scratching on the waxed metal. The etched plate was handed to the engraver proper, along with the wash drawing for him to follow with his mezzotint (scraping away a heavy tint applied mechanically) and aquatint (etching by acid through porous varnish).

Proofs of Turner's original etched plates are all preserved. The method imposes a severe discipline. The line is naked, and incapable of modulation by pressure – in Turner's case it is clearly unsympathetic.

* The drawings, as well as the etched and final states of the engravings, are all reproduced in Finberg's *History of Turner's Liber Studiorum* (Benn, 1924).

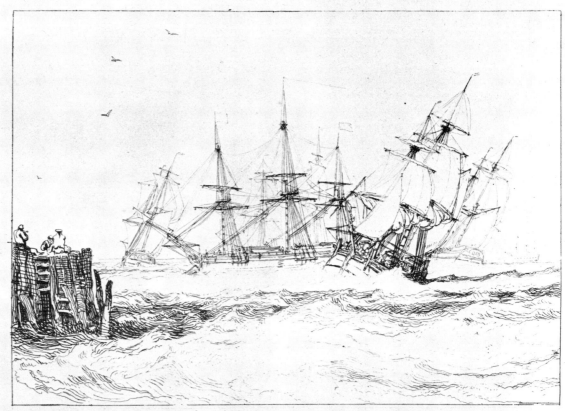

In the Possession of the Earl of Egremont

proof of the etched state of *Liber Studiorum* plate 10, *Ships in a Breeze*: Turner's line work before the mezzotinting

colour sketch, CXCVI–N, for *Wreck of an East Indiaman*, inscribed by Turner: *Beginning for Dear Fawkes of Farnley*. 12 × 18 inches

It is at its best where complexity provides a sort of clothing – in the rigging of ships, for instance.

But the effect of all this disciplined practice with the needle becomes very noticeable on his pencilwork. To a draughtsman of his perfect accuracy a gain in precision did not seem possible – yet it happens and we realise that quite large areas in his earlier drawings were relatively meaningless, graceful scribbling, compared with the poised effectiveness of the mature line. And this is an artist whose fame has been largely due to his *losing* the outline! Even he was heard to say (in 1833) 'indistinctness is my forte'.

Art is a hard mistress, and many have laboured for some skill that gained them little until, ironically, she taught them how to lose it. But perhaps the difference between the master and the amateur lies just in this: he who hasn't learnt the utmost skill cannot dare to ignore its rules – or as it is in reality, appear to ignore them. For accuracy and precision of drawing are essential to every work of visual art: drawing is conceptual, not a matter of sharpened points.

On this solemn note let us turn to some of Turner's most mysterious glances into the abyss.

The 'colour beginnings'

A few of this famous series so named by Finberg – a more modern name is Lindsay's 'colour structures' – he was able to date as 'before 1820'. Some others can be related intuitively to works of this middle period – where they can be related to anything at all. Finberg called these sketches 'colour beginnings' because he thought they had been meant to be hardened into more representational form. It's true that many of them lack the air of finality or inevitability: they are not epigrams, neither are they mere fleeting thoughts. At least it was better than cataloguing them as merely 'miscellaneous colour': the name gave some prominence to their quality. They *are* sketches and I have included some that seem to be relevant to our period. The rest of the 400 'colour beginnings' with some of Turner's greatest colour sketches and many miscellaneous but more recognisable colour sketches, must form the basis of further selections.

It doesn't seem necessary now to call a drawing a beginning or a structure. In our (and Turner's) beginnings are our ends, and *all* Turner's later work is colour structure. There's no need now to make excuses for some of Turner's works being almost abstract.

The pencilwork

In the sketches as a whole the tool nearest Turner's hand is always the lead pencil. Fortunately he nearly always had a little book in his pocket, so there were not too many masterworks folded up in old bills. A famous anecdote, gullibly repeated by every biographer, has the artist out on the Otley Moors with Hawksworth Fawkes of Farnley Hall, the son of Turner's good friend and patron; Turner is busy making notes, on the back of an old letter, of a thunderstorm over Wharfedale and he portentously (and most uncharacteristically) announces: 'Hawkey, in two years time you will see this again and call it "Hannibal crossing the Alps".' The drawing doesn't seem to be in the Turner Bequest.

Turner's handling of his pencils, soft or hard, is wonderfully versatile. The fact remains that, obviously, the more he had to see – on his travels abroad or in the West Country – the less could he give his attention to its composition on the page. In the most exciting surroundings he does some of his dullest drawings, while, conversely, gems of inspiration – perfect miniatures – turn up while he haunts his own reaches of the river or plods around some ruin looking for the best view.

Some of the (usually large) sketchbooks devoted to commissioned works on the houses and parks of his patrons contain very careful renderings. In the *Petworth* sketchbook for instance (p. 98) is a pencil drawing line-for-line exactly like the painting *Petworth: Dewy morning* of 1810. Such careful exactitude was not the result of the artist's passing mood. These drawings were what some of us would now call 'clients' roughs', meaning not rough at all but worked up to give the patron an accurate idea of the projected work. Turner's

care for detail is no artistic servility: it is to anticipate possible complaints. If, say, Lord Egremont complained later that you'd obscured half his house behind a clump of trees you could point out that he had seen the pencil outline before you started. Patrons, though not, I think Lord Egremont, were much given to demanding changes in commissioned works. Farington, the diarist R.A., tells of some cases even of cancellation because of disagreements, and this would be before any money had changed hands.

These specially finished drawings apart, the pencil sketches are rapid and intensely articulate. The ones I love best are very rapid indeed – those in Sussex for instance (pp. 71, 156). But note the equally economical, simply dignified house (p. 170), and the excellently characterised trees on p. 165. He could build up complex architectural detail, adding line to line with perfect accuracy and no hesitation at all, as in the townscapes on p. 128. His accuracy is also convincing in the ruins of Stonehenge (pp. 130–1). These drawings could well be useful to an archaeologist – far more use than contemporary prints, which are at best based on less accurate drawings than these. Turner never makes a mistake, or if he does, it is like Rubinstein playing a wrong note, a masterly slip. He never erases a pencil line.

His pencilwork is most endearing when, less than articulate in the face of such amorphous subjects as cloudy skies, he scribbles in words which become part of the sky. Or, bringing a large and impressive subject into a small compass, as at Scarborough (p. 139) or in the pencil rainbow on p. 176, he despairs of evocation and boldly states the scene as a working diagram. It still works.

a pencil sketch of 1819, from the *Ancona to Rome* sketchbook, 4 × 7 inches. Church of the Casa Santa, Loreto

The perspective diagrams

Turner was appointed Professor of Perspective at the Royal Academy in the year 1807 after the death of Edward Edwards, who had been his teacher. Turner fancied himself as a professor – he frequently signed himself R A, P P. He was keen, too, to get a platform for his theories, and as he was the only candidate for this least popular professorship, he was voted in easily by twenty-seven to one against. Only one R.A. had the guts to express what everyone must have known, that Turner would be a hopeless lecturer, on grounds of speech alone, even by Royal Academy standards – though of course no one could deny his superlative skill in the use of perspective.

Throughout the following decade he was always full of excuses for not delivering lectures. His desultoriness even gave rise to comments in the newspapers. Perhaps he was shy, but he was neither lazy nor uninterested – in fact he was so serious about his subject, which he interpreted in the widest possible sense to include composition and colour and indeed the whole art of picture-making, that he never had enough time to prepare his complex material. When he did deliver a lecture it was said to be inaudible, and probably unintelligible, and half delivered to his assistant whose job it was to hold up the large illustrations which Turner had prepared. Stothard was enthusiastic, however – he was deaf, and found '. . . much to *see* at Turner's lectures – much that I delight in seeing, though I cannot hear him'.

There remain to us Turner's manuscript notes, which will need a genius to decipher, and 181 diagrams, of which I have chosen some examples. The majority of the diagrams illustrate the methods of earlier authorities: obviously Turner used other pictures as well to illustrate his lectures.

See also Graham Reynolds, *Turner*, pp. 61, 62, 86 for other perspective diagrams, and John Gage, *Colour in Turner*, for quotations from the lectures.

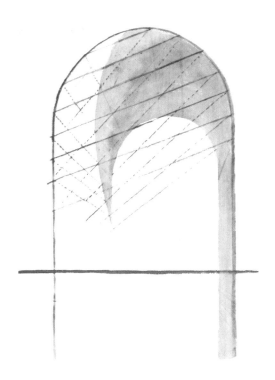

illustrations prepared by Turner for his lectures as Professor of Perspective. Much reduced

THE ARTIST'S DEVELOPMENT IN THE YEARS 1802–20

In July 1802 Joseph Mallord William Turner R.A., aged 27, staggered ashore at Calais after a rough landing. He was on his way to see France and Switzerland for the first time. During August and September he made about 400 drawings, not all of them strikingly original in subject, treatment, or style: but the journey changed him as one can easily see from his work. During the following fifteen years, for various reasons – the war and his own busy affairs – he didn't go abroad again. Working in England, not even travelling to Scotland or Wales, he developed his art in many different directions, none of them apparently relevant to the great imaginative works which have made him revered as the master of light and colour. Throughout this period there are less signs of his future luminosity than in the early sketches up to 1802. His drawing, as I have remarked, moved on from excellence to perfect mastery – virtuosity but without display. Drawing is his servant absolutely, before he begins, in the 1820s, to discard its conventions. If you (unfashionably) wish to draw there is something to be learnt from these pages. If it is the history of England that interests you, there is intimate detail here. If you would study the life of a great artist you will see him here struggling to rise above the pressures and preoccupations of his time by sheer hard application to what he, perhaps misguidedly, sees to be his problems. He carries the artistic weight of the previous century with him into the nineteenth – the century of revolution – and he must drive out the old ghosts before he can emerge as the prophet of the new. He has also his own fears of insecurity and must face much destructive criticism. But of the transcendental, the visionary Turner you will find comparatively little here. It is not a time of great discoveries – in that respect the years are unfruitful, and his products untypical of the Turner so well known by picture postcards and framed reproductions, and by sensitive literary studies of our own time. But it is an exciting and interesting segment of the artist's career, or so I have found.

I have listed and collected small reproductions of some relevant oil paintings and watercolours. Some of the titles are abbreviated. The oils are shown roughly to scale.

Fall of the Riechenbach
1804

1803	*Calais Pier*	Tate Gallery
	Holy Family	Tate Gallery
	Bonneville	Goodbody
	Châteaux de St Michael, Bonneville	Agnews
	Macon	Sheffield, Graves Art Gallery
1804	*Boats carrying out anchors . . . 1665*	Washington, Corcoran Art Gallery
	Passage of the Mount St. Gothard (watercolour)	Manchester, Whitworth Art Gallery
	Edinburgh from Caulton-hill (watercolour)	Tate Gallery
	Fall of the Riechenbach (watercolour)	Bedford, Cecil Higgins Museum
1805	*The Shipwreck*	Tate Gallery
	The Deluge	Tate Gallery

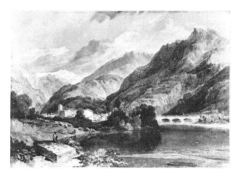

Bonneville
1803

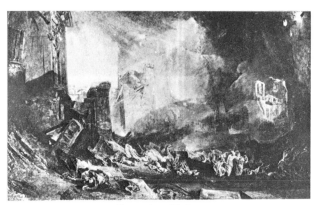

Destruction of Sodom
1805

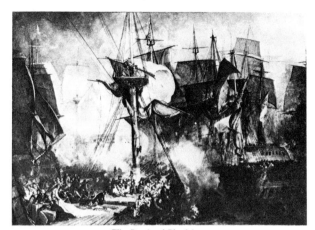

The Battle of Trafalgar
1806

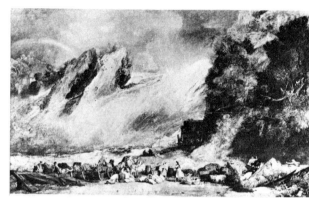

Falls of the Rhine at Schaffhausen
1806

about 1805 *Destruction of Sodom* Tate Gallery

1806 *The Battle of Trafalgar (The Death of Nelson)* Tate Gallery
 The Garden of the Hesperides Tate Gallery
 Falls of the Rhine at Schaffhausen Boston, Mass.
 Walton Bridges 1 C. L. Loyd Collection
 Walton Bridges 2 Melbourne, National Gallery
 Valley of Chamounix Manchester (Whitworth)
 The Victory beating up the Channel . . . Mr and Mrs Paul Mellon

1807 *On the Wey* Mr and Mrs Paul Mellon
 Mouth of the Thames Melbourne
 A Country blacksmith . . . Tate Gallery
 Sun Rising through vapour Tate Gallery
 (another version at the Barber Institute, Birmingham)

1808 *Dorchester Mead* (sometimes called *Abingdon*) Tate Gallery
 Eton College from the River Petworth
 Pope's Villa at Twickenham Sudeley Castle, Gloucestershire
 Richmond Hill and Bridge Tate Gallery
 Two of the Danish ships seized at Copenhagen entering
 Portsmouth Harbour (title changed, see *Spithead*
 1809)

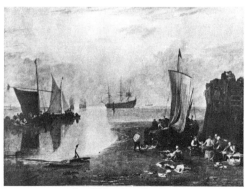

Sun Rising through vapour
1807

Windsor: Ploughing up turnips near Slough
1809

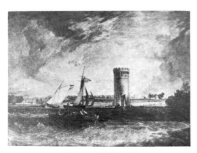

Tabley: Windy day
1809

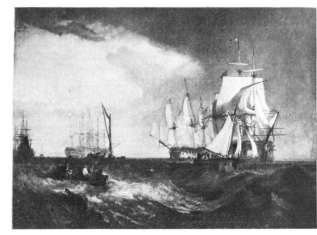

Spithead: Boat's crew recovering an anchor
1809

1809	*Sketch of a bank with Gipsies*	Tate Gallery
	Sketch of cows	Tate Gallery
	Shoeburyness Fisherman hailing a Whitstable Hoy	Ottawa
	Fishing on the Blythe-Sand	Tate Gallery
	Near Thames' Lock, Windsor	Petworth
	Windsor: Ploughing up turnips near Slough	Tate Gallery
	Guardship at the Nore	Major-Gen. Goulburn
	London (Where Burthen'd Thames, etc.)	Tate Gallery
	Spithead: Boat's crew recovering an anchor	Tate Gallery
	Tabley: Windy day	Tate Gallery
	Tabley: Calm Morning	Lt-Col. Leicester-Warren
	The Garreteer's Petition	Tate Gallery
1810	*Cottage destroyed by an Avalanche*	Tate Gallery
	Wreck of a Transport ship	Gulbenkian
	Cockermouth Castle	Petworth
	Lake of Geneva from above Vevey	Los Angeles County Museum
	Lowther Castle (two oils) *Evening*	Lord Lonsdale
	Midday	Lord Lonsdale
	Petworth: Dewy morning	Petworth

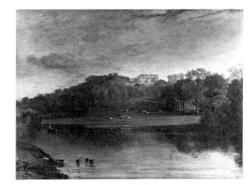

Somer-Hill
1811

1811	*Somer-Hill*	National Gallery of Scotland
	Whalley Bridge and Abbey	C. L. Loyd Collection
	Apollo and Python	Tate Gallery
?1812	*Hulks on the Tamar*	Petworth
1812	*Teignmouth*	Petworth
	Saltash with the Water Ferry	New York, Metropolitan Museum
	Ivy Bridge Mill, Devon	Mrs Jolly de Lotbiniere
	View of High Street Oxford	C. L. Loyd Collection
	Snowstorm: Hannibal and his army	Tate Gallery

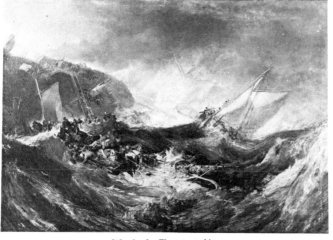

Wreck of a Transport ship
1810

Snowstorm: Hannibal and his army
1812

Frosty morning
1813

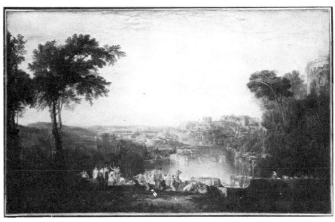

Dido and Aeneas
1814

1813 *Thames at Weybridge* Petworth
 Windsor Castle from the Thames Petworth
 Frosty morning Tate Gallery

1814 *Apullia in search of Apullus* Tate Gallery
 Dido and Aeneas Tate Gallery

1815 *Crossing the Brook* Tate Gallery
 Dido building Carthage Tate Gallery
 Eruption of the Souffrier Mountains . . . from a sketch University of Liverpool,
 by Hugh P. Keane, Esq. Department of Geology

1816 *Temple of Jupiter*, from a sketch by Duke of Northumberland
 H. Gally Knight, Esq. in 1810

engraving for Hakewills *Italy*
[drawn about 1818]

1817 *The Decline of the Carthaginian Empire* Tate Gallery

1818 *Raby Castle* Baltimore, Walters Gallery
 Dort Packet boat becalmed Mr and Mrs Paul Mellon
 Field of Waterloo Tate Gallery
 First Rate, taking in Stores (watercolour) Bedford, Cecil Higgins Museum

1819 (Leicester and Fawkes exhibitions)
 Entrance of the Meuse . . . Tate Gallery
 England: Richmond Hill, on the Prince Regent's
 Birthday Tate Gallery
 Richmond Hill (watercolour) Port Sunlight

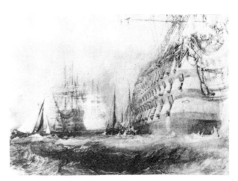

First Rate, taking in Stores
1818

1820 *Rome from the Vatican* Tate Gallery

Rome from the Vatican
1820

Not a bad showing for an arid period you will say. But Ruskin was right in regarding the first twenty years of the century as still part of Turner's learning time. He had still a lot to discover about himself, even though he threw off masterpieces as he went – and masterpieces in several different fields of painting. He was more than the equal of any of his contemporaries – and he could prove it. Only portraiture he wisely avoided. Why was it so important to him to prove his versatility and superiority?

'The man must be loved for his works, for his person is not striking nor his conversation brilliant.' So Dayes had written, and when Dayes died in 1805 Turner had the pleasure of reading these words about himself, and of knowing that everyone he knew had read them too. It established a pattern: but was he loved for his work even? There is plenty of evidence to the contrary.

We know that he was a man of small stature and of humble origin: who knows what snobbery he had to face from the gossipy Academic and dilettante circles in which he moved? He took far more than his share of abuse and uninformed, destructive criticism just because of his early originality and success. Many of his critics half believed he was mad – he might have sometimes feared it himself, since both his mother and a spiritual father, Cozens, had ended their lives in Bedlam.

The tradition of English art in which he worked was threadbare except for the fading patches of Gainsborough, Wilson, and Reynolds – I ignore the watercolourists, who didn't really qualify as far as the Academy was concerned. Wells, a watercolourist, was a real friend.* Lawrence alone among the oil painters gave him any firm support – though he had a following among younger men. Apart from these he was for many years friendless. He acknowledged only the dead and distant Wilson, and the even more remote Claude and Poussin, as his masters. (Thus Dayes was able to claim that he was self-trained, seemingly an odd comment on Turner, who had been a good student at the Schools, but typical of the time when apprenticeship counted for much more than schooling in the still controversial Royal Academy.) How else could he consolidate his position other than by beating his contemporaries at their own games?

These intimations of Turner's isolation are inferred rather than based on factual evidence. But there is one plausibly accurate record of Turner's manner of speech, perhaps in an unusually garrulous mood, quoted by John Gage. It is from an article by Reinagle about Turner's engraved *Views in Sussex*. I quote from Gage: '. . . a rare and entertaining pronouncement of the artist himself which was retailed as an anti-Cockney joke in Thomson of Duddingston's Edinburgh circle. When Thomson was admiring the drawing for Battle . . . Turner is said to have called out "Ah, I see you want to know why I have introduced that 'are. It is a bit of sentiment, sir! for that's the spot where 'Arold 'Arefoot fell, and you can see I have made an 'ound a-chasing an 'are".' Twenty years earlier his accent must have been even more noticeable. One reason, perhaps, why he was always gruff and uncommunicative with his colleagues but 'merry and lighthearted' with his friends.

* W. F. Wells, who died in 1836. 'The best friend I ever had in my life', said Turner.

The opposition

Here are some of the things that were said about Turner and his work in his first two years as an R.A. reported by Farington (his italics):

'So much was left to be imagined that it was like looking into a coal fire or upon an old wall [that is almost praise!] . . . but his *manners* so presumptive and arrogant'. This was Hoppner, once a kind adviser.

'. . . Finishes his distances and middle distances upon a scale that requires *universal precision* throughout his pictures, but his foregrounds are comparative *blots*' – Beaumont. Sir George Beaumont was a sort of dangerous buffoon. He was an amateur landscape painter much admired by the gentry and despised by younger artists. He seems to have tried to win favour with newcomers to the Academy – particularly Constable – but soon became hostile when they did anything original. He had praised Turner's *Plague* pictures of a year or two before. He was a leader of the reactionary, old-master-orientated British Institution, founded in 1805. When he died he left the Academy a Michaelangelo, so he can't have been all bad. But he was noisy: Calcott, an early follower of Turner's, was once so dismayed by Beaumont's constant barracking that he refused to exhibit. As late as 1815 Beaumont was complaining loudly that Turner's approach was senile and his picture (the unexceptional *Crossing the Brook*) 'all of pea-green insipidity'.

The work of 1803 which divided opinion for and against Turner was the *Calais Pier*. Even Lawrence was critical: 'too much of the square touch – and the water like veins in a marble slab'. (Lawrence was standing too close.) Martin Shee said, 'raw in colour'. Hoppner: 'wanting the delicate precision of Sir Joshua' (but note the lofty comparison). Fuseli, speaking of the rather weak *Holy Family* of the same year: 'like the embryo or blot of a great master of colouring'.

Farington was at some pains to gather opinions of the new star of the Academy. I think he had begun to fear him, and in the following spring, 1804, he was to quarrel with Turner badly enough to suppose (wrongly) that he would be too outfaced to exhibit. He told Turner, in the Council meeting, 'that his conduct as to behaviour had been a cause of complaint to the whole Academy'. Indeed, the new member might well have erred on the side of assertiveness, interested and involved immediately as he had been in the Academicians' interminable debates about their own constitution. His older colleagues, many of them founder-members, were not to understand that to Turner the Academy was Mother.* (His pictures were his children – his own words – and when, later on, they strayed from their owners, he often bought them back at prices greater than he had been paid.)

So Farington had dropped Turner and taken up with Constable, a safer ally among the juniors. 'Turner has become more and more extravagant and less attentive to Nature' reports Constable. 'His views in Switzerland fine subjects but treated as if some brittle material' –

* 'He stabbed his mother' was all Turner had to say about Benjamin Robert Haydon's suicide. But Haydon's attack on the Academy had also been directed against the cruelty of Sir George Beaumont, who had refused a picture. The cruelty was real, for Haydon, though pugnacious, was poor, and Turner's remark is callous as well as smug. This was in 1826.

whatever *that* means. Constable was still some way from reaching even A.R.A. standard, though only a year younger than Turner. This use of the word 'Nature' at this time in his life was probably idiomatic. Finberg attempts to define the eighteenth-century usage. 'By an ingenious casuistry "Nature" was regarded as the principle of sound reason in art; whatever the critic thought was right he called Natural.' In other words 'Nature' was convention. By the same topsy-turvy thinking, accurate modelling from life was 'scientific' – high praise then (as now, when a section of the public believes that all artists should be programming computers to get their effects). But Constable admitted that younger artists 'all consider Turner's pictures as being of a very superior order and do not allow them to be in any extreme'.

Finberg quotes a letter by an Irish lawyer who hadn't heard of all the fuss: '. . . a new artist has started up, one Turner: he beats Loutherbourg and every other artist all to nothing. A painter of my aquaintance, and a good judge, declares his pencil* is magic: that it is worth every landscape painter's while to make a pilgrimage to see and study his works.' This clearly places Turner's position with the intelligent public in 1802. But Turner would have thought such fame only just: he yet had to bear the brunt of professional jealousy. Thus Marchant, older, but not yet an R.A.: 'curious but *bad*, and his prices beyond comparison!' Opie, years his senior, was doing portraits for 20 guineas, while Turner was asking more than 250 for *Calais Pier*, so jealousy was not unnatural. Opie himself was not always critical, but in 1804, on Varnishing Day, he said that the water in Turner's *Boats carrying out anchors . . .* 'looked like a Turnpike road over the sea'. Northcote added another gem: he 'should have supposed Turner had never seen the sea'.

The newspapers joined in the derision with heavy wit. 'Seems to have been painted with a birch broom and whitening,' said the *Sun*. (White was the great horror: Turner and his followers were called 'the White Painters' by the old school. 'A good picture,' said Sir George Beaumont, 'like a good fiddle, should be brown.' This is the sort of remark to reassure the ignorant. He added, no doubt indicating one of his own works, 'there ought to be one brown tree in every landscape'.)

The *St James's Chronicle* cuttingly remarked that 'the sailors are all bald'. It seems to have been the sea-pieces that worried them all, for the *Morning Post* was much kinder about a classical work: 'the story' was 'gracefully told . . . and the landscape . . . exceedingly beautiful' (quoted in full by Finberg). Some balm, in 1804, for the smarting Turner.

Before we leave the critics, here are some more remarks about *Calais Pier*. A newspaper report: 'when the exhibition opened, *Calais Pier* was a centre of attention: it affords a striking specimen of the merits and defects of the artist, and is indeed a lamentable proof of genius losing itself in affectation and absurdity . . . the sea looks like soap and chalk . . . the sky is a heap of marble mountains.' Criticism of Turner's work was always in terms of odd comparisons.

* Sable brushes were used to finish the details of oil paintings and these long-haired, fine brushes were called 'pencils' – as they still are by signwriters.

One further conversation recorded by Farington (1 April 1804) adds a few kitchen elements. West, the P.R.A., said loyally that the Turner sea-piece in the Bridgewater Collection made the Duke's van de Velde 'look like glass bottles'. Beaumont retorted that van de Velde's sea made Turner's appear like pease soup. Hearne, the watercolourist, also present, is reported as remarking that the sea in *Calais Pier* 'appeared like butter'. Farington's guests continued their dinner. 'Sir George and Edridge (an A.R.A.) both said that Turner never painted a good sky.' You couldn't say more than that.

But they did. In 1806 Farington notes that he 'met J. Taylor (of the *Sun*) and Boaden (of the *Oracle*)' at the Academy Exhibition. 'The latter after looking round the room sd. He had never seen so many bad pictures. On looking at Turner's *Waterfall at Schaffhausen* He sd. "That is Madness. – He is a madman" in which Taylor joined.'

Now it is impossible to suppose that Turner was not affected by this general abuse of his works of 1803–6. A young artist of a century later might have thrived on it, at least emotionally. But Turner came, not at the end of a long line of revolutionary artists, but at the beginning: he was the first revolutionary in landscape.

While earlier exhibits of 1802 had not avoided adverse comment on the 'sea-like-chalk' level and the *Lee shore* had been described as sketchy, his success in the historical department had then been almost complete. Even in landscape the *Morning Post* had hailed Turner as being giant strides ahead of his fellows: he 'more deserved the name of genius than any of his rivals. He could be another Claude or van de Velde if he thought it expedient, but it is necessary for the dignity of the British School that he should be the father and founder of his own manner'.

If anyone took seriously these extraordinarily penetrating remarks, they had forgotten them a year later. In 1803 he had no historical picture, apart from the unimpressive *Holy Family*, to balance the shattering effect of *Calais Pier*. Other landscapes in the same exhibition do not appear to have caused excitement of any sort.

Calais Pier

The difference between *Lee Shore* and *Calais Pier* seems slight at this distance unless we compare their fundamental composition. The *Lee Shore* is wild and dramatic, but the action is all parallel to the picture plane and well held by the enormous phallic bulk of the boat at the right, with the sailor in white leaning against the wind. The sailor's pose and the white mast-head pennant lead us to the triangular gap in the clouds which forms the characteristic still point of the composition – in this case it is the apex of a strongly based pyramid.

Calais Pier has no such stabilising elements. It is twice as big and much more disturbing. It is, in fact, the first of Turner's 'vortices'. Using the same pictorial elements as the *Lee Shore* it yet sweeps us off our feet – there's nowhere to stand anyway. The reassuring bulk of the boat on the level shore is replaced by the crazy wave-swept jetty with its disorganised figures. No phallic symbol here, with which the male critic might identify.

As Turner wrote of the woman he'd left in London:

Love is like the raging ocean
Winds that sway its troubled motion
Woman's temper will supply.

The gap in the clouds of *Lee Shore* has exploded in *Calais Pier* into an orifice framing a piece of infinite blue. Slashing diagonals divide the composition. Only the far-distant ship remains as a 'still point'. A mast-head pennant, white, as in the *Lee Shore*, now beats a discord against the light sail of the next boat as this sweeps inwards towards the centre, its movement emphasised by the dark cutter passing close by in the opposite direction. (A dark ship passed by a lighter one became a symbolic theme of Turner's.) As we grasp, or try to grasp, the swirling movements of all these between the turbulent waves and sky the safe proscenium of the frame disappears: the strong receding and spiralling lines of the composition instead grasp the spectator's eye.

The same composition, without the detail and with the added disturbance of a tilted horizon, served, 39 years later, for one of Turner's greatest works, the *Snowstorm . . . going by the lead*. But critics of 1803 were not mollified by incidental detail, which they anyway thought unconvincing (with some justice). They must have reeled from the aggressive effect of a picture essentially 40 years ahead of its time. Lacking vocabulary or standards in any way adequate to the situation they fell back on vituperation in whatever terms were available.

This reaction came, not from the general public (that is to say, the small percentage of the population that read books or looked at pictures) but from the painter's peers, the very men who had voted him into the Academy which he loved so much. Reaction varied in degree, but clearly most of his contemporaries thought he had gone too far – and three years later it was being muttered by influential journalists that he was mad.

Turner, who had hardly had time to adjust to his new, eminent position, must have felt it to be a dangerously precarious one. 'Must have felt' is a phrase I try hard not to use about Turner, whose various biographers have credited him with a whole orchestra of supposed feelings. But he was not a rebellious young man, even if his new importance had somewhat gone to his head so that he offended older Academicians. The facts are there to show that he still felt he had a lot to learn, especially about painting the human figure. As an artist he was humble – his search for Romantic material in Switzerland had been diligent and pursued in spite of his admitted sufferings from heat, weariness and indigestion (from drinking the wine). His researches in the Louvre had been prolonged and his notes are free of arrogance. He had a vision. He knew his power and he wished to lead British painting on to the level where it could compete in Europe. In this he was heroic, but he had no intention of becoming a lonely rebel. He needed success.

He had plenty of money – the sale of one watercolour paid his year's rent at Harley Street, and he could have kept his father, his mistress, her four children and his own two, easily on the sale of one oil painting a year. In fact, he usually sold at least three and he had some hundreds of pounds 'in the Funds'. Of course it was only five years since he had been glad of 2s 6d a night copying for Dr Monro: neglect by his few titled and discriminating patrons could have ruined him. He might have feared this, just as he might have feared madness: we don't know. Certainly either fate could be extremely unpleasant in the early 1800s. But I think fear was not *his* spur: fame was. Fear would have made him retract, and this he did not. He did submit some 'safer' paintings to the Academy in the years immediately following 1803, but he didn't alter his style – only his tactics. He must have known roughly what the reaction would be to *Schaffhausen* ('this is madness') though he sent it to the Academy in 1805. But by this time he had his own gallery where he could show the work he had his heart in, whether crudely cataclysmic or sketchily lyrical.

He didn't compromise at all: he put his prices up and he broadened his scope quite surprisingly. *The Shipwreck* of 1805 was a popular success – the unspecialised public enjoyed sensation and cared little about superficial finish, it is clear. *Navcissus and Echo* and *The Garden of the Hesperides* (1804 and 1806) kept up his reputation with the dilettanti, who were probably reassured also by the smooth sea of the great *Sun Rising through Vapour* (1807) where Turner combined his coastal and his Claudian inspirations. He continued with the sea-pieces, perhaps avoiding too much 'chalky' impasto, and he branched out into patriotic journalism with *The Battle of Trafalgar . . .* and *The Victory beating up the Channel. . . .*

The most unexpected departure was his plunge into contemporary genre painting, *A Country blacksmith disputing upon the price of iron, and the price charged to the butcher for shoeing his pony* (1807), was an attempt to steal some of Wilkie's success in the field. Since Wilkie exhibited his sure-fire *Blind Fiddler* in the same show *A Country blacksmith* lost some of its effect – but it is a nice picture, genuine in feeling. Turner also planned a *Harvest Festival* or *Harvest Home*, a more ambitious attempt in the style of Teniers. *The unpaid bill, or the Dentist reproving his son's prodigality* (1808) was commissioned to be in the style of Rembrandt.

He had no commissioned 'houses' until in 1807 Sir John Leicester invited him to Tabley Hall. His compositions here were typically unconventional.

The bulk of his work was exhibited in his own gallery from 1804 onwards. This included the wonderful series of Thames landscapes such as *Walton Bridges* (1806); *Windsor Castle from the Thames* (1806 or 1807); *On the Wey* and *Clieveden on Thames* (1807); *Eton College from the River* (1808); *Windsor, ploughing up turnips near Slough*; *Harvest Dinner, Kingston Bank*; *Richmond, Morning* (all of 1809); and perhaps the most excitingly misty and back-lit, the *Dorchester Mead*, previously known to us as *Abingdon* (1808).

As we see from his sketchbooks, various classical subjects and perhaps the 'Dido and Carthage' theme emerged from these idylls on the Thames. Turner exhibited these larger works at the Royal Academy. Such grand conceptions, especially when, later, he was able to add authentic Mediterranean touches, made his work the fashion with the new rich.

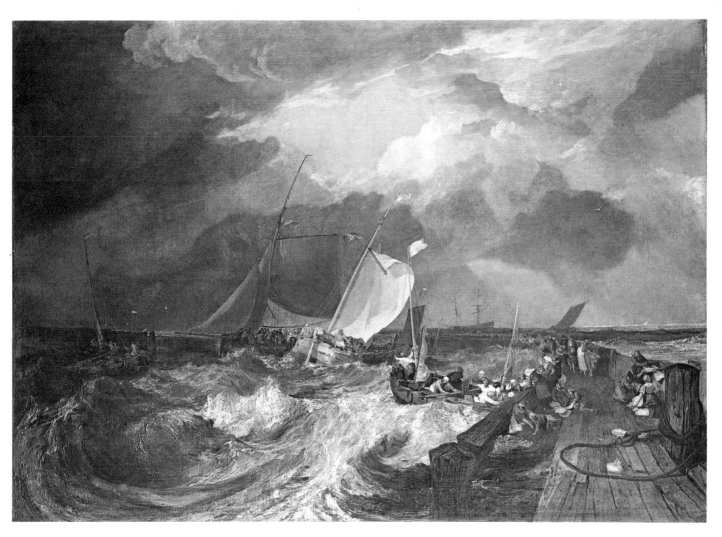

Calais Pier, with French poissards preparing for sea: an English packet boat arriving. 1803. 68 × 95 inches. Tate Gallery

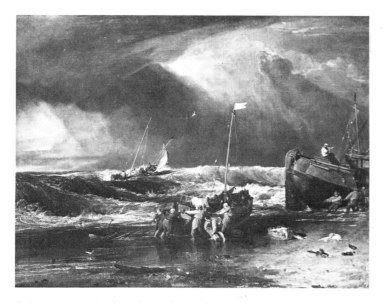

Fishermen upon a lee-shore, in squally weather. 1802. 36 × 48 inches. Kenwood

The Liber Studiorum

The Shipwreck was engraved by Charles Turner (no relation) on his own initiative, and sold fairly well (see the front endpaper). Turner's *Liber Studiorum* was started in 1806 perhaps to exploit the market for engravings, though Wells's daughter claimed that her father had persuaded a reluctant Turner to embark on the series. Finberg stresses that Turner's (and Wells's) motive was to make his reputation safe with posterity, but I wonder if this is quite true: the artist is likely to have been thinking of making his current reputation safe with a larger public than the capricious one which could afford his paintings. Sir John Leicester had exchanged *The Shipwreck* for *Schaffhausen* because his wife was upset by the sea painting. Now Turner had the painting on his hands while the engraver made a profit out of it.

Through the *Liber* plates Turner could expect to interest a wide public in the whole range of his work. The plates were published in groups of five: each contained a pastoral (rustic genre) subject and an 'Elevated Pastoral', or landscape, subject, the other three being 'Mountainous' or 'Marine' or 'Historical' or Architectural. The engraver of the first twenty, published between June 1807 and March 1809, was Charles Turner. JMW etched the plates himself, as I have mentioned.

For the first few pastoral plates Turner reached an all-time low in conception. The children and animals in conventional rustic settings were obviously designed to appeal to sentimental taste. Many of the landscapes are similarly crude and conventional, especially when engraved by the heavy-handed Charles Turner. (Some of them, particularly those engraved by Dawe, later in the series, are successful and charming.) Even in the class of 'Marine', Turner lowered his sights to the level of the *Marine Dabblers* – boys sailing toy boats, sickeningly aquatinted by W. Say.

The original wash drawings are right enough: it's the hardening of the line in etching and the, usually, ham-handed interpretation of the tone in mechanical terms that ruin the effect. So much might have been predicted: the really skilled school of interpreters, in metal engraving or wood, was yet to arise. What is remarkable is Turner's sustained and cynical effort to vulgarise his work. Where he didn't dream up, or drag up from his early years, special subjects for the series, he *pastiched* his own best-known oil paintings, like Egremont's *Ships bearing up for anchorage*, now called *Ships in a breeze*. The proportions of the original are completely altered, bringing the ships close up – and dangerously close to a ruinous quay which appears unexpectedly in the left-hand corner. We can at least admire the drawing of the rigging in the etched state (p. 16).

In some of the later plates Dawe and Turner himself engraved some interesting and exciting work – my criticism applies mostly to the earlier plates. It is interesting that Turner was so determined to sell his work, while being under no financial pressure. It is part, but a curious part, of the complexity and energy which made him a genius.

a Pastoral plate, *Pembury Mill*, engraved by Charles Turner. *Liber Studiorum*, 1808. $7\frac{1}{8} \times 10\frac{7}{16}$ inches

Conclusion

In all these ways Turner marshalled his forces like a great general facing or anticipating a setback. This was his reaction to criticism. He didn't draw back – he continued the assault, but used his ingenuity. He opened his own gallery, published his own work, and moved into new fields to make his reputation secure.

In the process he improved his already superb drawing skill and he enlarged his understanding of people by drawing them at work in the fields and in their boats. He produced masterpieces, and he produced sentimental pot-boilers. How much was one influenced by the other? How much were his most typical and inspired investigations of ethereal light suppressed by his constant production of ambitious work in five or six different fields? The answer to both these questions, the sketchbooks tell us, is – not a bit.

In his sketches he is completely himself, reacting to the one thing he really respects: nature. He is consistent, though his scope is wide, and like all geniuses he wastes nothing. While his exhibited and published work, as I have shown, presents a confused and not always respectable image, his drawing remains always pure and captivating whether it is careful or slight. Taken in total the story of the sketchbooks is again, as in the early period, entirely a good one.

This somewhat dark period in Turner's working life, from 1802 to 1820, was necessary. It may seem unnecessary to us, by hindsight, for the painter of the Thames oil sketches to produce *A Country blacksmith*, but it did not seem so to Turner, in his time.

The ages 27 to 45 are commonly those of consolidation. Turner needed not just a good living but a broadly based success: partly because he was vulnerable, for social, psychological, and physical reasons, and exposed because of his originality; partly because painting as he saw it was a public art and his ambition was more than personal. He hoped, as he said in a lecture of 1814, that the British would 'rise Superior to the rest of the world in the polite arts as they have already in the Sciences'.

I am tempted often to compare Turner with Beethoven, his near contemporary and at least his equal in greatness. Until he began to go deaf in his early thirties, Beethoven's main efforts were directed towards piano virtuosity and works which were vehicles for his piano performances. By no means all his work or even all his piano writing was of this sort however, nor did virtuoso show ever take precedence over content: he was always Beethoven. So with Turner; equally consistent and powerful, he was able to put his best into all that he did. His vision remained clear, or was further clarified, in the variety of work he threw himself into. He responded to criticism in his own way – that he *could* respond is shown by the way he repeatedly modified his lectures (so Gage tells us). But he did not let adverse criticism alter the nature of his more important productions.

Turner believed, at least until 1818, when he said so

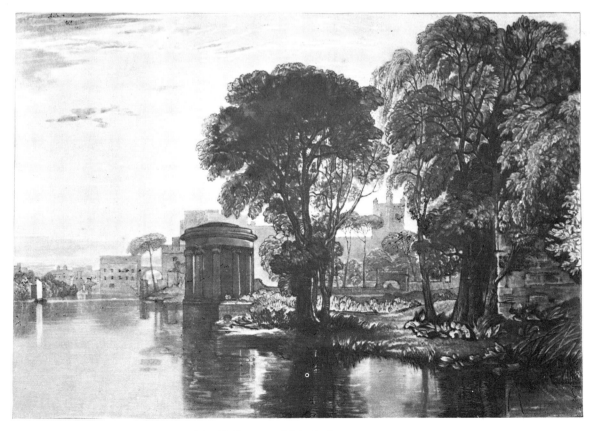

Isleworth, Elevated Pastoral, engraved by H. Dawe, published 1819

in a lecture, that drawing was more important than colour. '. . . A picture designed according to the rules of Perspective and the principle of anatomy will ever be held higher in esteem by good judges than a picture ill-drawn, be it ever so well coloured.'

In Rome in 1819–20 he did not neglect to study some of his subjects in light and shade rather than in line or colour. As in the brown *Grenoble* sketchbook at the beginning of our study, so in Rome seventeen years later he filled up a largish book of grey-washed paper with 'C. Studies' – the 'C', says Finberg, standing for chiaroscuro. The 60 or so somewhat boring studies of ruins depend neither on line nor on colour.

Strong construction in whatever medium is indeed the keynote of this whole period. As Turner said in the lecture quoted above (from Gage, p. 112), 'The cell of the Bee and the Basaltic mass display the like geometric form, of whose elementary principle all nature partakes.' (Properly edited, Turner's prose is reminiscent of Sir Thomas Browne's.)

This was therefore a period of sustained self-establishment but also of self-discovery. His one weakness, his schizoid refusal to come to terms with people (while taking refuge, in his case with blessed results, in things – or places, or atmospheres) was conquered during this time – if not in his life, then sufficiently well in his work. The fusion of his mythological themes with the real scenes of pastoral life, contained in the sketchbooks, allowed his life-room classical females to be replaced eventually by real people, quaint though they often appear.

The great panoramic *England: Richmond Hill* of 1819 is the apotheosis of these years of Turner's early maturity (aged 27–44). His visit to Rome closed an epoch, and it should have opened a new one. But *Richmond Hill* was followed in 1920, not by torrential visions of Mediterranean colour, but by another allegory more complicated, unconvincing, and as large as the first. This painting, *Rome from the Vatican. Rafaelle accompanied by La Fornarina, preparing his pictures for the decoration of the Loggia* is, I think, undervalued; but it must be admitted that it tells us more about Turner's dreams of greatness than it does about the new world of colour we are expecting to move into. The transformation, when it does occur, is more gradual; we should have known, for Turner is still preoccupied with being Turner, R.A.

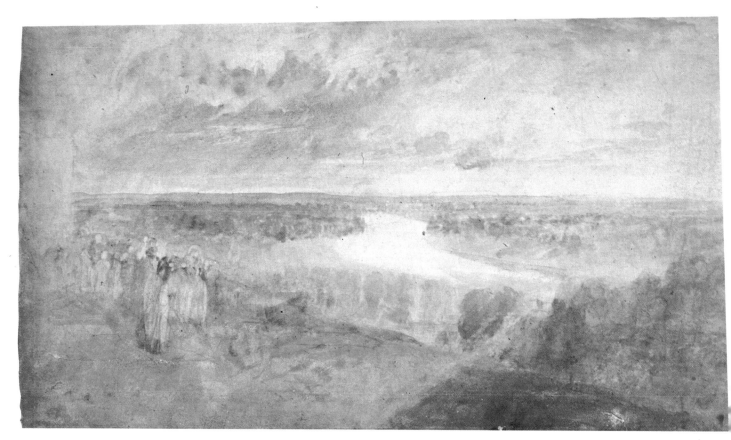

colour sketch for *England: Richmond Hill* from 'Colour Beginnings', CCLXIII (number 348). $12\frac{1}{2} \times 22\frac{1}{4}$ inches

LIFE AND POETRY

No one knows whether Turner took his mistress Sarah and their family to Hammersmith when in 1806 he took a house at 6 West End, Upper Mall. Falk assumes so.* Finberg says his father lived there with him, on the evidence that his handwriting appears in Turner's correspondence.

Turner's mother had been admitted to Bethlehem Hospital in December 1800. The signatories to her committal were, curiously, not her nearest relations but two neighbours. She died in 1804 in the home for incurables. William Turner presumably tried to continue his business, described by Dayes as 'respectable', but it may have declined – there had been a wig-powder tax which had changed habits. Young Turner was certainly able to keep him, and there are records later of his working as his son's assistant.

It is surprising that the painter did not pay for special treatment for his mother – in Dr Monro's private nursing-home – instead of leaving her in the common madhouse. Of course Turner had his own responsibilities. He had taken several rooms in Harley Street – the house was shared with a well-established painter, J. Serres. Another house, in Norton Street, off Portland Road, was also in the name of William Turner. Again it was shared, this time with one Roch Jaubert, known to have been a friend of Sarah's – a professional friend, for he published her husband's posthumous work. It has been suggested that this William Turner was JMW's father, but with no particular reason. The painter used the name William Turner at least until his election to full Academician in 1802, and he gave the Norton Street address in the Academy catalogue. Sarah is supposed to have continued to live at 46 Upper John Street, close by, but I think she lived with Turner.

By April 1804 Turner had added a gallery 70 feet by 20 to his house in Harley Street. It sounds as if Serres had gone. He had got into financial trouble while trying to start the British Institution in 1803 and he was separated from his wife in 1804. She became 'landscape painter to the Prince of Wales', and later claimed to be a princess (Lindsay).

At some stage Hannah Danby, a poor, or crippled, or both, relation of Sarah's, became housekeeper at 64 Harley Street. Hannah remained in Turner's service all her life. She gave her age in the Census of 1841 as 40 and in 1851 as 64, the latter being the likely truth. She is also recorded by the viciously unreliable Thornbury as having given the Reverend Trimmer, a friend of Turner from about 1811, an account of Turner's mother. Hannah would only have been thirteen when Mrs Turner was put away. How did she know the Turners? There is one possible explanation: that she was already helping in Sarah's household.

Perhaps, after all, the Danbys and the Turners were old family friends, Sarah and her husband dropping in at Maiden Lane after performances, perhaps at the Cider Cellar below the Turners' shop? It's an attractive

one of many sketches for the design of the house Turner built at Twickenham, Sandycombe Lodge

* B. Falk: *Turner the painter: his hidden life* (Hutchinson, 1938).

theory and quite unprovable – it would certainly explain Sarah's rapid acceptance of Turner after her husband's death. Perhaps he had admired her for years, a shy young painter adoring the charm of a singer?

Perhaps, and equally unprovable, the Turners, father and son, and Mrs Danby and her four children, and Turner's two, and Hannah the servant, all lived at Hammersmith – while Turner went off in his boat to get away from the noise. Such speculations have no place in a serious work, but I offer them simply because they are more sensible by far than most of the drivel that has been written about Turner and his affairs. For the facts we are indebted to Jack Lindsay, the only writer since Finberg to have done any serious research on Turner's background.

There are two facts, and two only, on which we can rely. The first is that Turner's father wrote out a letter dated 14 December 1807 from Hammersmith, signed by JMW. The second is that Callcott, a follower of Turner, spoke to Farington in February 1809 and Farington put in his diary: 'A Mrs. Danby, widow of a musician, now lives with him. She has some children.' This was ten years after the probable date of Evelina's birth. Evelina was married in 1817 – that is another fact, but one recorded much later, by her husband, Dupois.

Whatever the family set-up it is fairly clear that Turner's years at Hammersmith were happy ones. His exhibited paintings are a good biographical guide because they usually reflect the previous year's drawing – and, to some extent, thinking. Between *The Shipwreck* of 1805 or the *Schaffhausen* of 1806 there is a lull in his production of violent or dramatic works until 1810, when he showed the *Wreck of a Transport ship. Hannibal crossing the Alps* followed in 1812. The lyrical and pastoral themes reached a crescendo in the Exhibition of 1809. Add these titles to the list and you have Turner's mood in 1808.

Cottage steps, children feeding chickens.
Union of the Thames and Isis.
Thomson's Æolian Harp (with a verse to a Gentleman at Putney, requesting him to place one in his grounds).

The very inspired Thames oil sketches belong to this period. As for the sketchbooks, it is impossible to escape the sense of happiness and the idyllic mood of those concerned with the Thames and the Wey. The shipping scenes, further down river, are all as lively as can be, and Turner's other theme, of pastoral life and work, is hardly disturbing – in spite of what we know of the poverty suffered by the workers under the Speenhamland system.

The Thames was the background (and often in the foreground) of Turner's most felicitous compositions. It served his hobbies too: fishing and poetry. His verse, though well within the category of bad, is the best guide to the states of mind which lay behind the changing directions of his painting.

He loved the Thames. As a child he had lived close to the river in London. During his sister's fatal illness he had been sent up the river to his uncle's at Brentford, where his earliest signed drawing is of Isleworth Church. He would very likely travel to and fro by boat. In view of his lifelong passion for water, who can doubt that the boy's earliest poetic feelings derived from the misty,

detail from *Frosty Morning*, said to portray one of Turner's daughters

romantic, busy London River?

When he moved to Upper Mall he had a view of the great curve of Hammersmith Reach. In these years, instead of slogging round the North-east on foot, or in the Welsh mountains on a borrowed pony, he could row or sail, with his rod and his sketchbooks – and sometimes with wood panels and oil colours even canvases. When the weather was bad, he wrote poetry.

Alas another day is gone
As useless as it was begun
The crimson'd streak of early morn
Checks the sweet lark that o'er the corn
Fluttered her wings at twilight grey;
Expectant eyed the morning ray
Twitter'd her song in saddened mood
To calm her clamorous callow brood
In hope of less inclement skies. CXI, 1809

And, also in 1809: *Written at Purley on the Thame.* *Rainy morning – no fishing*, a comment on his sketchbook:

Vacancy most fair but yesterday
O'er these pure leaves maintained her sway
Until the pen did immolate
But with a stain inviolate
The spotless innocence retreats
From every leaf as fancy beats
Pure as under April shower
That gives each brook a double power
Hope still accompanies and sighs
Hope that with ever sparkling eyes
Looks on the yellow melting skies
Yet still with anxious pleasing care
Makes every leaf appear more fair

Delusion sweet thus tempts us on
Till all the leaves are like to one
Yet Hope looks back as heretofore
And smiling seems to say encore.

Another rainy day poem is from the *Derbyshire* sketchbook of about 1808 – here he fished the Dee and studied reflections for his lectures.

Few the sweets that Autumn yields:
The enfeebled Bee forsakes the fields
The drooping year, the shortened day;
No glittering rays o'er fallows play.

The humid air bedecks with drops the thorn.
Few gilded mornings cheer the skies
But fog or mist o'er Uplands flies,
Sighs through the Beeches, mossy grown.

In sallow weeds the deluged campagne lies
The driving rain denys the eye to trace
The Pineclad height

But the summer weather is often more kind to him, and inspiring:

Sweet as the fragrant gale that blows
O'er dewy morn or opening rose
Sweet as the flower that calls the bee
To revel deep in Luxury
As wild thyme sweet on sunny bank
That morn's first ray delighted drank
Sweet as the honey'd drop that holds
The wanton fly in treach'rous folds

Such sweets does Summer daily pour
O'er Man o'er field o'er hill o'er flower. CII, 1808?

His journeys on the Thames were not always above
the tidal reaches. He went to Greenwich for its
architecture and the Thames barges, and Sheerness
(*Blythe-Sand*) and further, for the excitements of shipping
(*Guardship at the Nore*, 1809). And of course, *London*, 1809:

Where Burthen'd Thames reflects the crowded sail
Commercial care and busy toils prevail,
Whose murky veil, aspiring to the skies,
Obscures thy beauty, and thy form denies
Save where thy spires pierce the doubtful air,
As gleams of hope amidst a world of care.

It was here perhaps that the creative confusion began
in Turner's mind between this great city and port, and
the rich and powerful city of Carthage. Sketches for
London Bridge in the 'Hesperides I' sketchbook (p. 72)
have almost heraldic colouring, at variance with the
greys of our city. The connection is well established in
the *Studies for pictures, Isleworth* book, along with,
significantly, some royal barges, drawn from life with
Turner's usual attack and elegance. In the *Wey,
Guildford* book we are not surprised to find a group of
Phoenician ships sweeping in among the pages of
classical villas that *could* be at Twickenham.

Hail Silver Thames far famed Augusta's pride
On thy broad waves the crowded navies glide
Far on the flat horizon trace the extended sail
That commerce sends to brave the Winter gale. CII, 1808?

But Turner's favourite classical theme, in the sketches
and the paintings, was to emerge later: *Dido and Aeneas*
(1814); *Dido building Carthage* (1815); *The Decline of the
Carthaginian Empire* (1817), and it is my theory that
their intense golden light is reflected from the Thames
of 1806–11, as much as from the mirror of Claude. I
love the mixture of subjects and styles that is stirred
around in the sketchbooks of what I feel sure were
Turner's most inspiring years.

It was a very busy period. He gave up his regular
habit of long sketching trips in the summer, but various
journeys brought him into contact with new material.
He was on the Medway in the winter of 1805 to draw
the battle-damaged *Victory*, and in the late autumn
of 1807 went to Portsmouth to await the arrival of the
Danish ships which had been stolen to get them out of
Napoleon's reach. Such winter journeys were not in the
style of the Picturesque-hunters: Turner was becoming
a realist.

Commissions took him to Cheshire and Derbyshire in
the summer of 1808, and to Cumberland and
Lancashire in 1809. He made good use of his time in
these northern counties, as we can see. Also in 1809 he
was at Petworth for the first time. His sketchbook
called *Frittlewell* (probably Frittleworth, near Petworth)
contains very evocative Sussex landscapes (p. 103). He
was to visit Sussex again in 1816. He had commissions in
Oxford in 1809 and 1811, and he had a series of sepia
drawings for the *Liber Studiorum* ready to exhibit in 1808.
In the winters he was at work on half a dozen, some-
times more, oil paintings. The style varies from rather
tight, in the classical pieces, to broad and vigorous in
the Thames landscapes, but it is consistent and

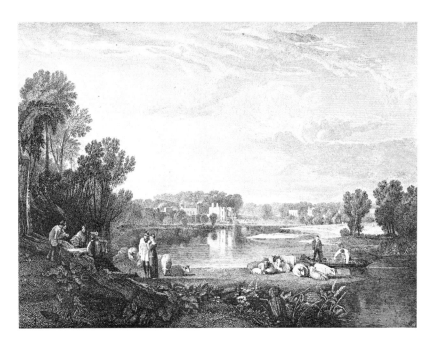

Pope's Villa at Twickenham, during its dilapidation. Engraved by John Pye in
1811, two years after Turner exhibited the painting

controlled. In the early summer of 1808 he had no less than fifteen paintings to show, only two or three of them exhibited before. He had, or found, purchasers for half of them. The reviews were good.

Coarse flattery like a Gipsey came
Would she were never heard
And muddled all the fecund brains
*Of Wilkie and of Bird**
When she called Wilkie a Teniers
Each tyro stopped contented
At the alluring halfway house
Where each a room hath rented
Renown in vain taps at the door
And bids them both be jogging
For while false praise sings to each soul
They'll call for t'other nogging. CXI, 1809–11

A few pages after this poem he notes a favourable criticism. It is of a classical picture of 1811 and written by the Mr Taylor of the *Sun* who five years before had joined in the cry of 'madness'.

Highly as we thought of Mr. Turner's abilities he has far exceeded all that we or his most partial admirers could expect from his powers. We will not attempt to describe this admirable picture but we can confidently recommend it to the attention of our readers as one of the most excellent efforts of the artist, in colouring lightness truth elegance and all the qualities of natural beauty animated by genius and rendered more interesting by a kind of classical charm which characterises the whole composition. We now turn from the best landscape to the best portrait, 113 of West by Lawrence.

Turner was not averse to 'coarse flattery'. Perhaps he needed a boost to his morale in 1811. In this year the house at Hammersmith was closed. Was it because, as he had written ten years ago when first in love with Sarah:

Love is like a raging ocean
Winds that sway its troubled motion
Women's temper will supply
Man the easy bark which sailing
On the unbles't treach'rous sea
Where cares like waves in fell succession
Frown destruction o'er his days . . . ?

For in the same sketchbook as the praise from Taylor we find him quoting:

World, I have known thee long and now the hour
When I must part from thee is near at hand.
I bore thee much good will, and many a time
In thy fair promises repos'd more trust
Than wiser heads and colder hearts w'd risk . . .

This need not be taken too literally. He had other means of escape as some poems, dated 1809–10, suggest:

Be still my Dear Molly dear Molly be still
No more urge that soft sigh to a will
Which is anxious each wish to fulfill
But I prithee dear Molly – be still

By thy Eyes when half closed in delight
That so languishingly turn from the light
With kisses I'll hide them I will
So I prithee dear Molly be still
. . .
By the touch of thy lips and the rove of my hand
By the critical moment no maid can withstand
Then a bird in the bush is worth two in the hand
O Molly dear Molly I will
. . .

In the same sketchbook:

The sweets of the bee and the bloom of the Rose
Did dear Josephine in her May-day disclose
Content she had known as the day roll'd its round
But Josephine's Cottage Love at last found
. . .

In the *Lowther* book, of about 1810, he writes, perhaps as the heading of a poem that was never written, *Woman is Doubtful Love*. A page is torn out. A few pages later is a long string of verses with the heading: *Broach as a jewel guarding a Lady's breast*:

The sparkling gem upon her breast
Shines not so bright as Laura's tear
Formed through compassion quick distres't
I kiss the jewel and its influence fear.

All the poems are quoted in full in *The Sunset Ship* by Jack Lindsay.

The Fallacies of Hope

By 1812 the house in Hammersmith stood empty. In the following few years Turner spent much less time on the Thames, though he still chose to live on its banks. He records in a sketchbook labelled *Studies for pictures, Isleworth* a new address: Sion Ferry House, Isleworth. This is a temporary home. In 1813 the Academy Catalogue gives his address as 'Queen Anne Street West and at Solus Lodge Twickenham'. Queen Anne Street West was simply a new entrance to his Harley Street house and gallery, which he had extended slightly. Solus Lodge – the house he designed for himself – soon became Sandycombe Lodge. There are many experimental façades and plans in the sketchbooks, as well as notes of materials and costs. The name 'Solus' has been taken by biographers to suggest that he intended to live there alone: it could just as easily refer to the isolated position of the house by the river. In any case his father lived there too.

The son of a neighbour and friend, the Reverend Trimmer, gave Thornbury his memories of the house. While Thornbury can never be trusted, Trimmer's childhood memories sound truthful.

It was an unpretentious little place and the rooms were small. There were several models of ships in glass cases, to which Turner had painted sea and background. They much resembled the large vessels in his sea pieces. Richmond scenery greatly influenced his style. The Scotch firs [or stone pines?] around are in most of his large classical subjects, and Richmond landscape is decidedly the basis of *The Rise of Carthage*.

Here he had a long strip of land, planted by him so thickly with willows that his father, who delighted in

* Edward Bird, three years senior to Turner, became an R.A. in 1815. Wilkie was ten years younger than Turner and became an R.A. in 1811.

the garden, complains that it was a mere osier-bed. . . . Trimmer's reminiscences carry on for several pages. He dwells on the humble character of Turner's entertaining. When they went fishing, Turner gave the boy the fish they had caught. 'These little incidents mark character', says Trimmer. 'I have seen him start on his sketching expeditions. From a boat he painted on a large canvas direct from Nature.'

Trimmer describes other sketching expeditions in a gig with Turner's 'old crop-eared bay horse' which he immortalised in his *Frosty Morning*. Twice immortalised, for there are two horses from the same model. 'The girl with the hare over her shoulders, I have heard my father say, reminded him of a young girl whom he occasionally saw at Queen Anne Street, and whom, from her resemblance to Turner, he took to be a relation. The same female figure appears in *Crossing the Brook*. There follows a lot of not very convincing chat about methods and pigments. Trimmer mentions that 'Mrs. Danby was his housekeeper, and had lived with him many years. She had some fearful cancerous malady which obliged her to conceal her face, which did not add to the charms of his domicile.' This was Hannah – the title 'Mrs' was usually given to housekeepers. '. . . To be appreciated he required to be known. Though not polished, he was not vulgar. In common with many men of genius, he had not a good flow of words; and when heated in argument, got confused, especially, I am told, in his lectures on Perspective, though he was master of his subject. He was rather taciturn than talkative. His hair was dark brown, bordering on black; and his complexion sallow.'

The passage concludes with Trimmer hinting that Turner was 'smitten' by a sister of his mother. He hints at a mysterious letter. But this letter apparently was one written in 1815 trying to persuade Trimmer's father to encourage the lady to make him an offer for Sandycombe Lodge, for, wrote Turner: 'Sandycombe sounds just now in my ears as an act of folly, when I reflect how little I have been able to be there this year. . . . Daddy seems as much plagued with weeds as I am with disappointment.'

Nothing at all is heard of Sarah apart from Farington's note of 1809, until Turner himself mentions her in his will, along with Hannah and his two daughters.

In a penetrating analysis of the forces acting on Turner's mind about 1810, Jack Lindsay writes of his 'Personal Crisis'. 'One contributing factor' in Turner's sense of alienation, he writes, 'was his inability to achieve any settled relationship in love. Sarah Danby remains a figure lost in the shadows; we cannot estimate with any clarity what part she played in Turner's life. But we are not likely to go far wrong if we consider that elements of fear, doubt and suspicion, generated by Turner in his early home life, wrecked the relationship before it began, or at least harshly limited the area of its possible development.'

I think this is rather a drastic view. It depends on the theory that Turner's mother, because she was taken to hospital in her early sixties, and in the state of psychiatry of 1800 could not be cured, was gradually going mad throughout his childhood. This is not proved – we don't know what was wrong with her. Wells's daughter suggests that young Turner was a frequent visitor to her parents' house because he had to get away

from home troubles 'too sacred to mention'. She sounds a silly woman, here and elsewhere. It isn't unusual for an art student to want to be out of the house. The only other known possible cause of trauma is the boy Turner's stay in Brentford, linked with his sister's illness and death. But death in infancy was very common in those times and we do not know how long the separation was. One would imagine that some temporary absences from his mother for a boy of nine or ten would not result in permanent psychological damage.

Every biographer of Turner, except Finberg (who was either too prudent to draw any conclusions from the slender facts, or, more likely, too prudish to allow such themes to enter his head) has tried to saddle Turner with a sad, romantic love-affair. Surely, he was romantic – but, I suspect only in short spasms, just as long as it took to write a poem, when he was tired or the weather unkind. Intuitively I feel that his affair with Sarah and their two daughters, of whom there is no reason to suppose he was not very fond, had satisfied, more or less, the relatively small part of his ambition that he was prepared to devote to family life. I have said earlier that his personality was of the schizoid kind: he had all the power and the vulnerability of this type. But it was not a pathological state. His constant and consistent production of drawings and paintings suggests a basic stability and points to his true central drive. The storms of life buffet him but wash over him: all finds expression, in sublimated form, in his work. It never fails him. Such colossal productivity on a high level demands almost total personal involvement. It cannot ever be explained away as any sort of 'escape'.

From the time he left his parents' home in 1800, and for most of the rest of his life, Turner was careful to have two addresses. Since he wasn't interested in 'gracious living' this can only suggest one thing – that he attempted, like many another creative person, to keep his domestic life separate from his work. No sooner is he installed in Harley Street than we find his address given as Norton Street, and so on.

The fact that he and Sarah never married is plausibly explained by Jack Lindsay: she was most probably a Roman Catholic. But whether they had married or not, domestic bliss was not going to be a large part of Turner's interest and she on her part, with six children to look after, was bound to be neglected while Turner lived the life of a dedicated artist.

As an artist – and as we know him best, by his work – Turner was a rational being, until his art led him by its own logic into the transcendental. We do well, I think, to seek rational explanations for the vagaries of his career. His later position, of being quite beyond the complete understanding of his contemporaries, put him in the Victorian category of respected-but-eccentric genius. Consequently a tradition arose among biographers of attributing eccentric behaviour to him throughout his life; but it was only as an old man that he was actually eccentric.

For other causes of Turner's 'personal crisis' in 1812 Mr Lindsay draws on more of the artist's poetry – this of the introspective and opaque sort such as made up parts of the long poem *The Fallacies of Hope* which Turner quoted for his pictures right until the end of his life – but never attempted to publish as a whole.

Mr Lindsay blames the critics and the changing state of patronage in the early nineteenth century for Turner's increasing isolation, and for what I have already described as the split in his work between what would sell – watercolours and engravings of more or less topographical or sentimental content – and what the painter must have regarded as his real work. The big history paintings seem to fall between the two extremes; they formed a sort of stage from which Turner attempted, ambitiously, to speak directly to his public.

Lindsay also quotes some revealing notes Turner made in his copy of Shee's poem *Elements of Art*, among them the following very clear statements; [The artist] *will dare to think for himself and in that daring find a method. . . . Choice should, even a beggar, stand alone. . . . This stand is mine and shall remain my own.*

But not all the indications are of 'isolation' in this second decade of the century. On a different level Turner was becoming more aware of contemporary life and politics. His genre subjects and scenes showing workers in the fields were perhaps the start of this: his winter travels had shown him a new aspect of the countryside. In 1810 he first stayed with his friend and very loyal patron, Walter Fawkes of Farnley Hall, near Leeds. Fawkes, while a typical country gentleman and dilettante, was a Radical and an 'anti-slaver'. In the years of the Luddite actions in the North, Turner can hardly have escaped a good deal of political discussion. He stayed at Farnley very often, usually in the late summer – the shooting season – and from there went on various travels in the North of England.

In 1811 he went on a long, lonely journey to the South-west, collecting material for a series of engravings to be published in Cooke's *Picturesque Views on the Southern Coast*. He attempted, in many pages of sketchy verse, a poetical commentary – which the publishers later refused with contempt. Two of his poems are inspired by the wife of a fisherman captured by the French and by the fate of an innocent country girl seduced by the soldiers whose job was to guard the coast against invasion. The gloomy prison-ships – the *Hulks on the Tamar* – provided another, very potent, source of inspiration. He went again to Devonshire in 1813. A contemporary account shows that, on this visit, he was no lonely wanderer but very sociable (see p. 134).

In 1816 his only two exhibited works at the Academy were intended to celebrate the cause of Greek independence, the cause for which Byron later sacrificed himself.

Turner paid his homage to Napoleon through his *Snowstorm: Hannibal and his army crossing the Alps*, exhibited in the early part of that fateful year, 1812. He had a piece of *The Fallacies of Hope* ready to attach to the title, in the Catalogue. This was the first appearance of a quotation from that poem. His 'sufferings and broodings', says Lindsay, 'came to a head' in this painting. Large and savage, it was exhibited, not in the comparative backwater of the Harley Street gallery, but in the full glare of the Academy show. Apart from some discussion as to its proper hanging we hear of no direct attack on it: there should have been, for it is more daring than any of his sea-pieces, even the wrecks, up to this date. Perhaps it was safe in the 'Historical department'. But Turner was no longer quite the *enfant terrible*.

I leave you to judge whether in fact there was a personal crisis or merely a natural shift in emphasis. The years between 1812 and 1820 produced some dull, some pretentious, and some serenely masterful works. Among the last are the unique *Frosty Morning* (1813) and *Hulks on the Tamar*; the golden, luminous *Dort packet boat becalmed* and a truly monumental 'house' painting, *Raby Castle, the seat of the Earl of Darlington*; these two of 1818. Any apparent lapse in the years between is easily explained by the amount of work he had in hand for the engravers, and by the large number of watercolours which had been accumulating at Farnley and which were exhibited together in 1819.

In 1817 Turner spent a few weeks travelling in what is now Belgium, to the field of Waterloo, and along the Rhine. Fifty watercolours and the important *Dort* picture resulted from this visit, as well as a rather ambiguous (unheroic) picture of Waterloo. At last he managed to get away to Italy in 1819, returning in February 1820.

I hope that the sketchbooks themselves, with as much explanation as I can add, will fill in the rest of the story at least to sufficient depth to complete our understanding of this complex formative period in Turner's working life. The year 1820 is only a useful place to stop: his life, like everyone else's, merges from one phase to another. Most of the activities I have described here continued into the 1820s, but the germ of something very new was then working that was to turn the middle-aged, successful, little painter into a giant. But not yet . . .

Turner aged 41, by C. R. Leslie. National Portrait Gallery

THE SKETCHES 1802–20

Calais, 15 July 1802

The excitement of the rough landing at Calais resulted immediately in the series of scribbled pages which we reproduced at the end of *Turner's Early Sketchbooks*. These drawings were not merely rapid or hurried: they were, are, bold expressions of freedom and pleasure. In that uncalculating moment Turner evolved a new sketching manner which he later used again and again on his travels. His well-trained hand would, as it were, change up into overdrive, to produce a calligraphic minimum of notal flourishes. The lines are joined, as with rapid, cursive handwriting. Speed results as much from reducing the number of times the point is lifted from the surface as from the reduction to a minimum of the marks themselves – indeed the latter requires deliberation. He had practised the technique, particularly on the Scottish tour of 1800 or 1801, but had been nearly always as much interested in tonal emphases as in line and movement, so had scribbled in patches of tone here and there, giving an impression of haste and superficiality. It had required a small crisis – excitement, escape – for him to first achieve this typically Turnerian gesture: throwing tones overboard and relying on sinuous line only for the statement of masses. Twenty or more years later he made the same gesture in favour of pure colour.

This calligraphic style was of course only one of his ways of sketching. It often became mannered, the elegant handwriting concealing rather than explaining the message, but it has also left us many vivid images which otherwise we should not have had. It is peculiarly modern and many examples of the style are in this volume. Certainly no other artist was drawing like this in the early nineteenth century.

Calais Pier left an image on his mind which remained clear throughout his foreign travels and his month in the Louvre. '*Our Landing at Calais. Nearly swampt*', worked out during the following winter on the blue paper of his large study-book, was one of several studies leading up to the Academy picture which was to bring such a storm on his head.

In the town he drew a few buildings, desultorily it seems, the pencil hardly visible over the unsuitable sepia-tinted paper. He never knew when to stop drawing: but one can suppose that he was restless, interested in everything, this being his first time across the Channel. Some less windy views of the harbour may have been done just to pass the time or for possible backgrounds in the picture he would paint.

Paris to Grenoble

In Paris he bought a small sketchbook of pleasant warm-tinted paper; it still has the label *Coiffier, Rue du Coq Honoré*. He had several sketchbooks with him of course; this one he used on the journey. He joined in the purchase of a 'Cabriole' with one or more other travellers – I think only one; an English cabriolet was a two-wheeler. They paid 32 guineas and sold it again on returning to Paris. They had a Swiss 'servant'. Turner's companion was most probably another artist – who else would have put up with the vagaries of his search for Romantic scenery? Like the Mr Smith who accompanied him to Scotland we know nothing of the man or of his influence. All our scraps of information come from Farington's notes in his diary when he met Turner in Paris later in the year.

Farington, normally only interested in how much things cost and in Turner at this stage only for his professional ideas, gives us a rare note of human interest: 'he found the Wines of France and Swisserland too acid for his constitution being bilious. He underwent much fatigue from walking and often experienced bad living and lodging. The weather was very fine. He saw very fine Thunderstorms among the Mountains.' So he did! Farington pumped Turner about the scenery: was it better than Wales? It surpassed Scotland as well. Perhaps Farington, more at home in the salons and ateliers of the city, felt he should have gone too.

We need not make much of the hardships. Probably Turner, with the English habit of drinking a pint of ale or porter with his meals, drank too much new local wine; and was pushed into poor lodgings by that Swiss servant.

His biographers will have it that he was taciturn, even silent. So he was in public, but we know that he was quite a jolly fellow with his family and friends. Probably the two of them had a good time in spite of the fatigue of walking.

'The Country to Lyons was very bad', Turner told Farington. What this means I don't know: poor roads, high prices, or unfriendly natives – perhaps all three; or lack of Picturesque views. Turner's labelled pages map the route at intervals of about

71 brigantine

9 street in northern France

twenty miles. The drawings show little interest: *Fontainbleu, Sens, Joigny, Auxerre – walk upon the ramparts, Avallon, Do (ditto, folio 12, on the right), Saulieu, Cercy (Chissey), Gevrey (Givry), Chalon sur S.* (Saône). Then, equally laconic, *Macon*. But at Macon there was more of interest than the scribbled page suggests, for the painting called *The festival upon the opening of the vintage at Macon*, a large work nearly eight feet wide, was exhibited in the Academy nine months later. In it the artist's memories of the scene are heavily overlaid with compositional device and Poussinesque atmosphere.

They stayed three days at Lyons, where the buildings were 'better than those at Edinburgh . . . nothing so good as Edinburgh Castle'. Turner did little there; 'the place was not settled enough' and 'very dear – 8 livres for a bed'. Turner wasn't interested in the buildings: in the three days he did only half a dozen light sketches.

Soon they were in the mountains. *The First View of Mont Blanc* had been duly recorded between two sketches at Autun. Sketches of Geneva turn up out of order in the sketchbook. The one on the right (folio 42) labelled *Do* is of Geneva, the *ditto* referring to the previous page. At Bonneville, a few miles on in the Haute Savoie, Turner gets down to work in earnest and with great success, as we see on pages 45 and 55. Here he started two fresh sketchbooks that he had brought with him: one medium sized, of rich brown paper for the most vivid chiaroscuro, and a large one of Whatman paper for watercolours. The Parisian book (LXXIII) continues as a sort of travelling record: *Nangy* (below, right) submerged in calligraphy, *Villeneuve, before Bonneville, Cluses, Magland, Above St. Martin, Bonhomme*; various mountain outlines with their attendant clouds; then *St. Bix, St. Mch.* (St Michael, near Chamounix) and *I think St. Bix* (folio 62). Twenty more mountain scenes, of which two are reproduced here, take us to *Part of Grenoble* and *Vale of Isère, Grenoble*, and complete the sketchbook.

After this Turner's labels become much less frequent. He is not so much journeying as exploring in various directions, and he has usually more time to spend on each page. He did about 400 drawings on the tour and it is surprising that he was confident of remembering every unfamiliar place, for he labelled only about 10 per cent of them. More were labelled than now appears: many drawings were cut down when, at Ruskin's behest, they were mounted. This applies particularly to the next book. The strips of paper bearing Turner's captions were preserved in a separate parcel, quite uselessly.

12

42

62

73a

74a

Chalk and charcoal

Tinted paper, so much a part of the drawing technique of most artists from Raphael to the Pre-Raphaelites, seems to have been hard to find in London. Possibly supplies had always been imported from Paris and had ceased during the war years. Turner had been at pains to tint the pages of many of his sketchbooks, the washes 'taking' badly on the somewhat unsympathetic Whatman, or fading unevenly on the cheap blue paper that was available.

The paper of the *Grenoble* sketchbook is a solid terracotta brown, and of a matt, absorbent texture; a charcoal or pastel paper. It was new to Turner. The unusual proportions – it is about twice the size of the previous book with the Paris colourman's label – suggests that it was bought in Paris too, and along with it, we may guess, some prepared black and white crayons of far better quality than mere charcoal and chalk. Paris, after all, was the home of Conté. In spite of the freedom these chalks gave, Turner still used pencil on nearly all the pages of this book, and about one-fourth of the total is in pencil only.

The sketchbook was broken up and lost its covers. There are at least 124 drawings, 27 of which escaped Finberg's catalogue and are now numbered LXXIV A–Z, and *a*. The original 97 were variously trimmed and pasted down, and exhibited at the National Gallery and at Oxford, when Finberg brought them together again into more or less fortuitous order.

It is therefore impossible to trace any clear evolution of style throughout the series; as it happens it would have been useful in this case, for the style of the drawing varies between extremes of violence and solemnity, with, in between, some very strongly constructed pieces as well as a scattering of that hooked and sinuous line already remarked in the previous book. All have one characteristic in common: they are broad and lively in approach.

The uncatalogued parcel of drawings A–Z (ignoring *a*) was probably Ruskin's pile of throwouts. One can see why. Lively and vigorous they certainly are, but so dis-organised that my reaction on first seeing them was that they could not be by Turner. I was not looking for evidence of his anonymous companion – no contemporary of 1802 would have been so daring – these crudities are more suggestive of a post-Kokoschka student. I think the explanation is that Turner was experimenting with his new chalks.

The thunderstorm (sheet R) somewhat resolves the over-vigorous technique into a dramatic unity as Turner works in the sun while the storm advances from the mountains. In sheet I a mist over the water compels some serenity: but the foreground figures are

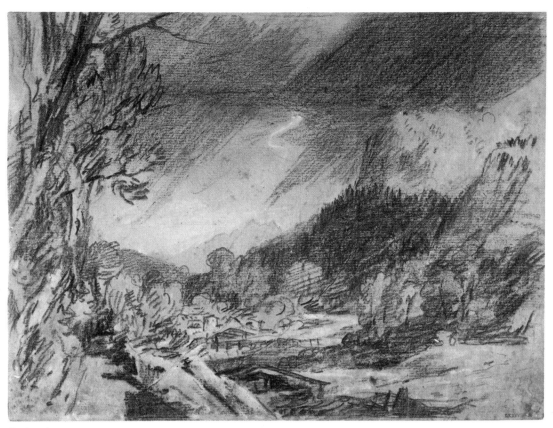

R thunderstorm

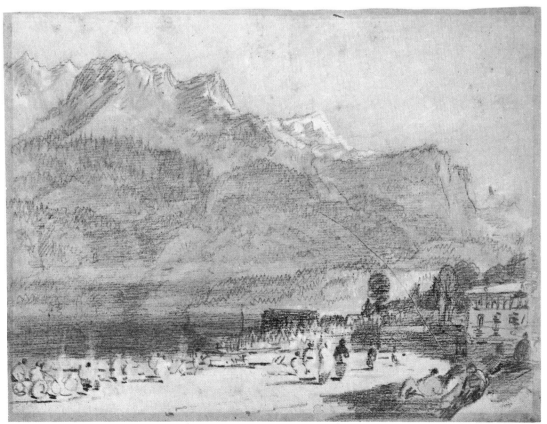

I Lake Geneva?

61 Hospice of the Great St Bernard

crude and have strangely heavy shadows. Perhaps we should remember that the wines were causing discomfort.

The scenes of the drawings range from Voreppe, on the River Isère near Grenoble, round Mont Blanc and the St Bernard to the eastern end of Lake Geneva. There is no way of putting them in order, no link between styles and places. It is a natural assumption that, over a period of perhaps two weeks Turner gradually settled into his stride and was ready to give of his best in the sketchbook which follows. Meanwhile, the seven pages I have chosen are representative of the *Grenoble* book, and attractive. But they are only seven out of more than a hundred.

Finberg remarks on a 'conscious striving for massiveness, squareness and stability of design in this series' – not the whole story, but the drawing above (folio 30) described as *The Little Bridge, Chartreuse*, is an example of the stability at least. It strikes me as a foretaste of the dovetailed finality of some of the *Liber Studiorum* compositions – which were worked out in the studio and not in a foreign ravine.

I chose the Hospice of the Great St Bernard (folio 61) for its immense economy, and the drawing below it (folio 65) for the sense of lively movement in the wind-lashed trees against the permanence of the crouching buildings and the great mountain.

The two remaining drawings are not so much sketches as pictures – not complex ones, but satisfying, and impossible to leave out. A mixed bag, these 124 drawings of the *Grenoble* sketchbook, but deserving of study. And what a difference from the gloomy Scottish Pencils of a year or two before!

30 Little Bridge, Chartreuse

46

32 St Huberts Well (St Humber, Grand Chartreuse)

The Alpine style

The large book in which Turner did his
Swiss watercolours is of Whatman paper
(watermarked 1801) and it obviously came
with him from England. Some of the pages
have a ground wash of grey, others are left
white. Ruskin was at work on it – 'quite
stupendous!' – cutting it apart for exhibition,
so that only 6 pages out of 96 remained
between the covers when Finberg got to it.
For the dozen or so pages in watercolour
only admiration is possible. It is more
difficult to praise than to criticise, and
Turner needs none of my praise. I agree with
Ruskin – and with Finberg, who says,
perceptively: 'The design of the drawings
made in the Grindelwald and the St Gothard
Pass seems . . . to belong more to the life of
the scenes themselves than to have been
imposed from without. The composition may
be described as vital, rather than architec-
tural. Turner's imagination was stirred by
these scenes, and imagination has an
organising capacity of its own.'
 One remark of Finberg's I cannot agree
with: he says that none of the watercolours
appears to have been coloured on the spot. I
think they all were at least broadly coloured
in the open air. Several later versions in
more 'finished' watercolour found honoured
places in the Farnley Hall Collection. These
are large, and I don't think Turner would

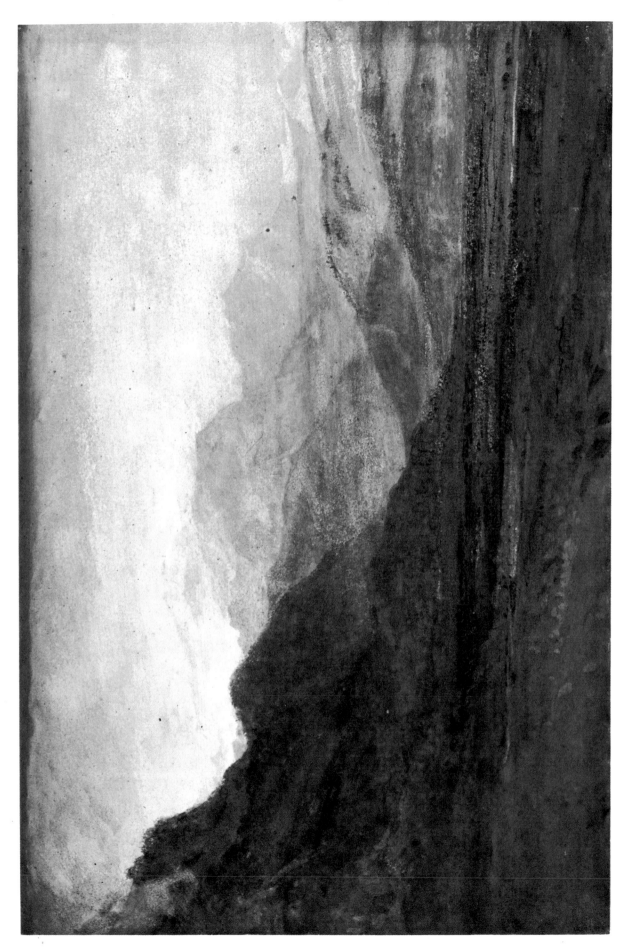

27 River Arve with Mont Blanc

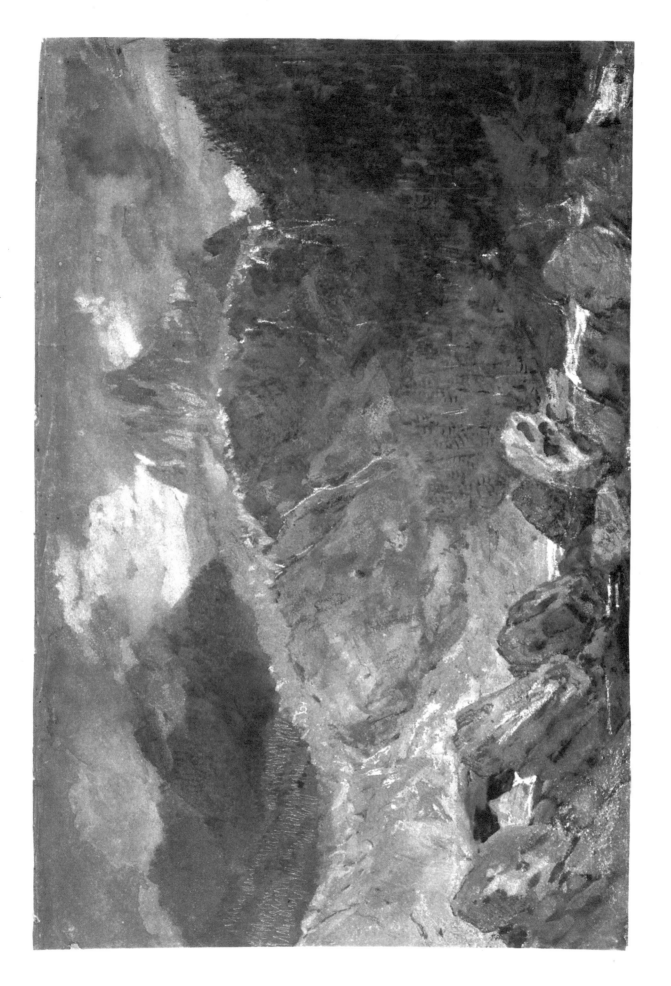

21 Source of Arveiron

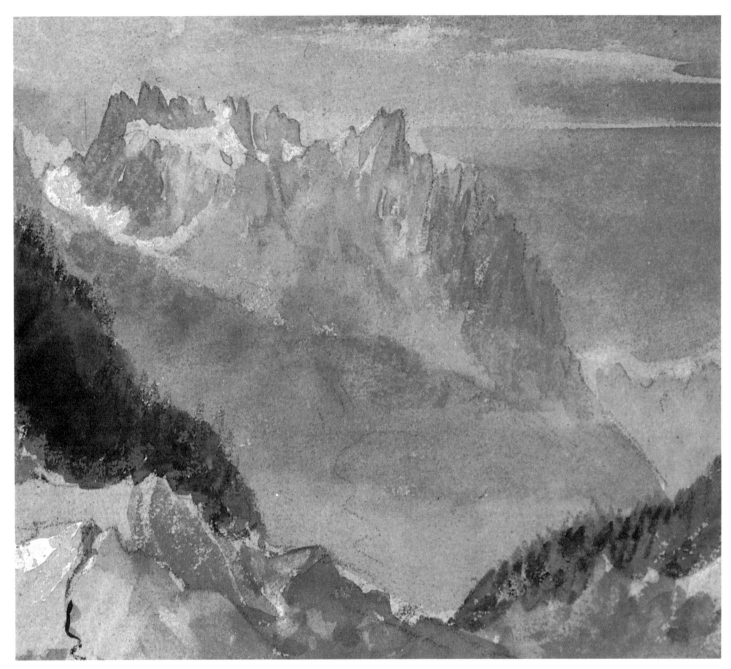

22 *Mer de Glace*, two details

have wasted his time colouring the smaller versions in the sketchbook unless they had been done on the spot. There is, also, an air of spontaneity about some of the sketches which is lost in the large watercolours. The best known are *Mer de Glace with Blair's Hut*, *Source of the Arveiron*, and *The great fall of the Reichenbach*. The Farnley Hall collection was broken up years ago and scattered, so that the sketchbook pages are all the more valuable – in any case, they are better. At least one page was taken out of the book during Turner's lifetime.

In an attempt to transmit the essence of these watercolour sketches I have chosen widely differing examples, including three full-size details. The right-hand half (not

quite half) of *Bonneville*, (p. 45), with its
'Norham Castle' cows, stands for depth and
serenity. It was used as the basis of a water-
colour for Fawkes, as well as for an oil
painting, and drawn again for engraving in
the *Liber Studiorum* in 1816.

The other full-size details are of the *Mer
de Glace* sketch (p. 48). Those mountain
peaks are the nearest thing to Wagner at this
early stage of Turner's career. You might
miss their icy, floating remoteness in a
reproduction of the whole drawing with its
rather too solid trees in the middle distance.
'The trees in Switzerland', Turner told
Farington, 'are bad for a painter, except for
the walnuts': these would be further down
the valleys.

The third detail is of just a few brushstrokes
near the bottom edge of this picture, to
illustrate Turner's bold, direct technique in
these Swiss landscapes. There is more of this
emphatic brushwork in folio 21, *Source of the
Arveiron*, while folio 27, entitled by Finberg
'The River Arve with Mont Blanc', probably
quite badly faded, reminds us of Turner's
Scottish and Lakeland works in its immense
scope and the subtlety of tone. Like all his
best outdoor work it is an honest drawing
with no special striving for effect – and he is
quite undaunted by the difficulties of taking
in such a large expanse of country.

These two drawings are reproduced
approximately half size (as are most of the
reproductions in this edition). It was
necessary to turn them sideways to get them
in reasonable relation with other drawings.
The sketchbook was a large one for mountain
work and Turner was ambitious as well as
successful in what he set out to do. The
material he collected provided him with
subjects for several years, and his 'Alpine
style' in watercolour was as much admired as
any of his work until our own times, when
interest has centred on his later work.

The pencil drawing on the right is a detail,
nearly life-size, from another page in the
St Gothard sketchbook. I must admit that it is
the best part of the drawing – but a large
reproduction helps one to assess the quality
of this and other pencil drawings. This
section has a, for me, very satisfactory fugal
pattern, and it reminds us, after all those
cloudy mountain tops, of Turner's gift for
accurate rendering of architectural form, and
of his fondness for abstract rhythms.

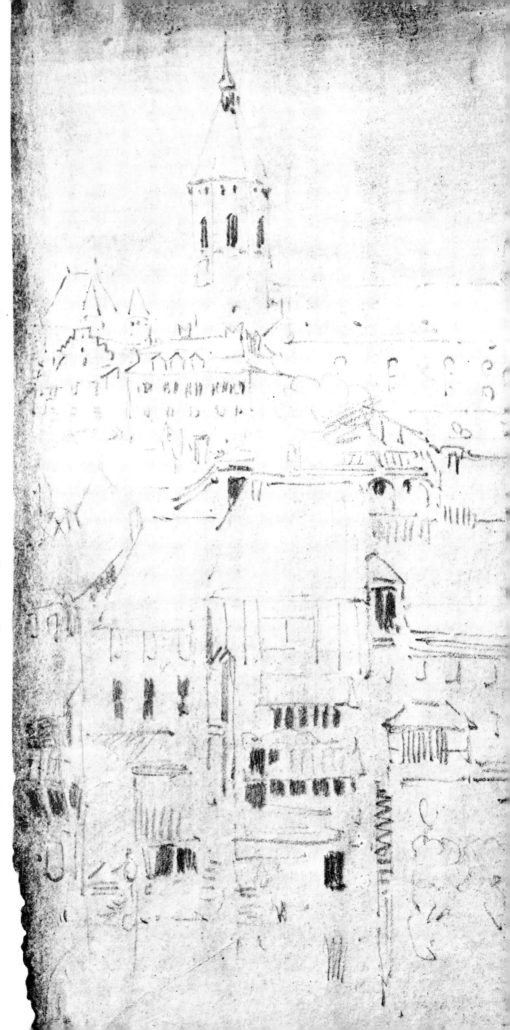

30 Thun. Detail, about actual size

After the fine watercolours of the Chamounix
area in the *St Gothard* book, and some heroic
efforts in the Pass itself, Turner seems to have
relaxed a little, working in pencil only, and
starting a smaller book of white paper. This
notebook is known as *Lake Thun*. We don't
know how Turner labelled it because the
covers are lost, for the usual reason: Ruskin's
enthusiasm. It is almost a typical travelling
sketchbook, most of the drawings slight and
all in pencil: his sightseeing manner, but
with not quite his usual careless zest; more
tentative. In what may be construed as the
second half of Turner's stay in Switzerland,
when he seems to have been based on
Interlaken, he produced nothing but pencil-
work, some of it in the large *St Gothard* book
in a form obviously intended as the ground-
work of watercolour.

The *Lake Thun* book contained 75 drawings
– the leaves were separated and put into two
parcels by Ruskin, so that we can only guess
at the original order. There are a few of
Turner's captions: *L. Thun, L. Lucerne,
Grindelwald, Schreckhorn, Mieringen*. Mostly, he
stayed by the lakesides. Many of the
compositions have a grandeur at variance
with their slight treatment and one feels that
if only he had been able to work them out in
greater depth they would have much more
to say to us.

One page was used for a Farnley Hall
watercolour, one other for a *Liber* plate
(*Ville of Thun*). The unusually thorough
kitchen interior (folio 68), though ruined by
the badly drawn figure, makes one wonder if
he was planning some genre work, though it
was some years before he ventured into that
field of painting. An inscription on the back
of this drawing, in a firm native script,
identifies the Castle of Kussenberg, near
Schaffhausen.

The oil painting of the *Falls of the Rhine at
Schaffhausen*, which was exhibited to the scorn
of the Press in 1806, was based on some light
pencilwork in another large sketchbook
which Turner had brought with him. This
was the half-filled *Fonthill* book, XLVII, started
in 1799. The fact that he took it all the way
to Switzerland to use up some blank pages
has been taken as a prime example of his
frugality, but the book contains some of his
finest architectural drawing, of a building
which was famous all over Europe, and it is
quite likely that Turner wanted to have with
him some good specimens of his draughts-
manship.

56

7 *L Lucerne*

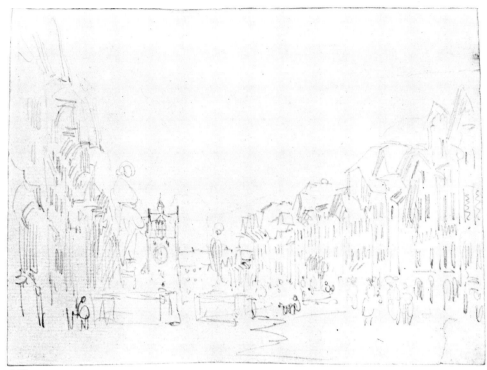

6 Thun

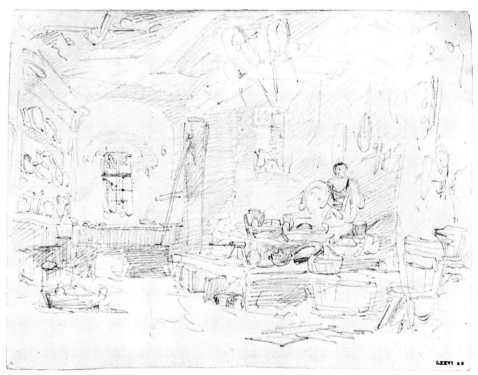

13 Ligny a Ba (Ligny-en-Barrois)

43a study for *Apollo and Python*

Return to France

There are in fact no drawings of Strasbourg. After some sketches of Grindelwald, the Lake of Brientz, and Basle in this book, there is a geographical gap until we are back in France – Nancy and Ligny-en-Barrois (folio 13, above).

Once again the leaves of the book were cut out and distributed round the galleries, to be reassembled by Finberg. Some sketches of Oxford are probably of later date, as are three studies of assorted mythological subjects, these perhaps preliminary work for *Liber Studiorum* plates.

The beautifully lit and proportioned church interior (folio 43) is unidentified. It looks too grand for an Oxford church, but the level cross-hatching of the drawing is not typical of 1802.

43

8 Oxford

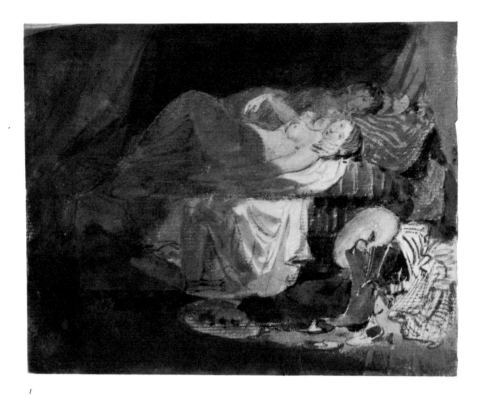

1

The watercolour above is unique among Turner's work until the grander intimacies of Petworth about 1830. It occupies one page of this book, which is of squarish proportions like the other small Swiss books. Other pages contain a spontaneous record of a procession, rapidly coloured, and some rather weird-looking peasants, arranged in groups, inexpertly drawn and unexcitingly coloured. One hundred and eight pages are left blank and one is missing. Inside the cover are the words of a song, *I am a friar of orders grey.*

The nineteen drawings represent the total effect of the Swiss nation on Turner's work.

'The people were well inclined to the English' he told Farington, though the country was in a very troubled state. Their houses made 'bad forms, – tiles abominable red colour'.

13

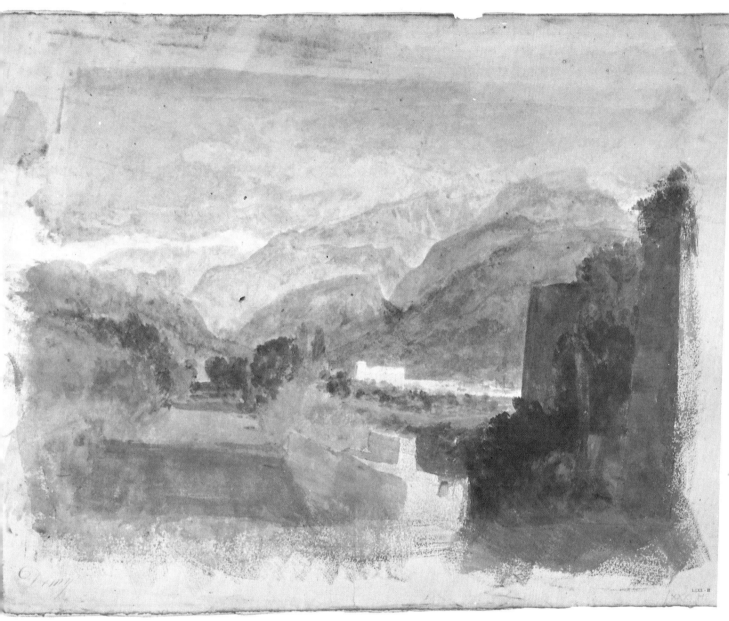

LXXX—H

This is possibly a *plein air* study for the oil painting *Chateaux de St. Michael, Bonneville, Savoy*, exhibited in 1803. The engraving (right) done for Ruskin, is a fair representation of the picture now this has been cleaned.

The drawing is on what looks like a paper-merchant's sample – *Demy* is a traditional English paper size. The colours are very painterly and functional and the drawing has a twentieth-century look, except for some habitual browns and the artifice of the dark foreground.

In the painting the colours are toned down to levels acceptable to his contemporaries. But under the glazes there remains some evidence of a polychromatic method, as if the airy harmonies of the drawing had been merely transposed, not rejected. It isn't just a brown picture with a blue sky. The vermilion of the woman's dress still shines clearly in the shadows: a challenging note.

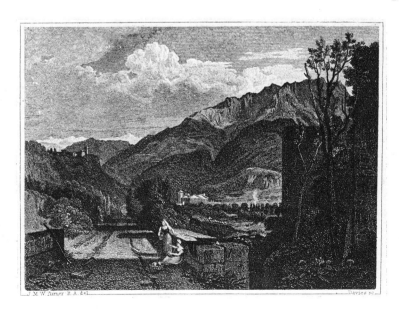

Turner got back to Paris towards the end of September 1802. Farington and several younger British artists were there, chiefly interested, it seems, in the work of David and of other French painters who are now forgotten. The Louvre was crowded with paintings 'acquired' from most of the cities of Europe, and Turner took the opportunity of studying some of the old masters. He made notes and copies in this small calf-bound notebook, of which the pages had been prepared with washes of grey and brown – rather dark, like the 'Wilson' book of 1797. The pictures that claimed his attention were by Ruysdael, Raphael, Titian, Giorgione, Poussin, Correggio, Domenichino, Guercino, Rembrandt, and Rubens. He noticed (on paper) only one contemporary, the Salon prizewinner, Guérin, who was later to teach Géricault.

He coloured some of the copies and he also made some abstract plans of colour schemes using initials scattered over the page. These are unintelligible, but they show how seriously he approached the question of colour organisation – as do his written notes. The many pages of writing are difficult to read on the dark-toned paper. Finberg gives a full transcript in his Inventory.

The quotations here are intended to indicate merely the general character of Turner's comments. The artist he gave most attention to was Titian: but he took nothing for granted. Of Rubens and Rembrandt he was disapproving and his feelings about Ruysdael were mixed: *Landscape by G. Rysdael. A fine coloured grey picture, full of truth and finely treated as to light which falls on the middle ground. All beyond is a true deep ton'd greyish green. The sky rather heavy, but well managed – but usurps too much of the picture and the light. The objects near to the light are poor and ill judged and particularly about the windmill inclined to be too chalky . . .*

Sea Port. Rysdael. A brown picture which pervades thro the water so as to check the idea of its being liquid – altho' finely pencil'd . . .

Titian and his Mistress. (Now called *Alphonse de Ferrare et Laura de' Diante.*) *A wonderfull specimen of his abilities as to natural color, for the Bosom of his Mistress is a piece of Nature in her happiest moments.* He discusses in detail the colours as they were applied by the painter in relation to the red ground, which *pervades thro' the Portrait.* Of Titian's *St Peter Martyr: This picture is an instance of his great power as to conception and sublimity of intellect – the characters are finely contrived, the composition is beyond all system, the landscape tho' natural is heroic. . . . Surely the sublimity of the whole lies in the simplicity of the parts and not in the historical color . . . the Assasin is brown and full of color – fear is full – when Nature rather demanded less . . . therefore the nuterlizing tint, alias historical color, has been partially removed.*

By the copy of Titian's *Entombment*, folio 32 (reproduced here) he writes at length: *This picture may be ranked among the first of Titian's*

51a, 52 copy of Titian's *Christ crowned with thorns*

pictures as to color and pathos of effect, for by casting a brilliant light on the Holy Mother and Martha the figures of Joseph and the Body has a Sepulceral effect. The expression of Joseph is fine as to the care he is undertaking, but without grandeur. The figure which is cloathed in striped drapery conveys the idea of silent distress, the one in vermilion attention, while the agony of Mary and the solicitude of Martha to prevent her grief . . . are admirably described, and tho' on the first view they appear but collateral figures yet the whole is dependent on them. . . . Mary is in Blue, which partakes of crimson tone, and by it unites with the

31a, 32

Bluer sky. Martha is in striped yellow and some streaks of Red, which thus unites with the warm streak of light in the sky. Thus the Breadth is made by the 3 primitive colours breaking each other . . . connected by the figure in vermilion to the one i. crimson'd striped drapery; which balances all the breadth of the left of the picture by its Brilliancy. Thus the body of Jesus has the look of death without the affected leaden colour often resorted unto . . . and so on, always entering closely in to the method of the artist. This is obviously not amateur criticism: it is a painter's appraisal. In almost every case Turner starts his observations with a note on the colour of the ground. It takes a professional eye to pick this out. (Working into a white ground was unknown in oil painting, until Turner himself changed the tradition a few years later.)

He moves on to other Italian masters: *St. Jerome by Correggio. Painted upon a rich ground rather green, so that the first colour produces a neutral tone approaching to Green or Brown as cold or warm colours are used; thus arrises the Beautiful cold grey through all the flesh of the infant and Virgin. . . . The Resurrection of Lazarus* by Barbieri (called Guercino) brings another reference to 'historical colouring': . . . *the sombre tint which reigns thro'out acts forcibly and* [emphasises] *the value of this mode of treatment, that may surely be deem'd Historical colouring; which in my idea only can be applied where nature is not violated but contributes by a high or low tone to demand sympathetical ideas.*

Turner's copies of works by Rembrandt are in monochrome. Of the *Good Samaritan* he writes: *rather monotonous, being painted on a brown (asphaltum) ground, which pervades thro' the sky. The lights are spotty. . . .* Of *The Susanna. Finely coloured in shoulder and loins, the piece of white drapery is admirable – introduced to extend the light, but rather artificially as to breadth. Miserably drawn and poor in expression.*

He is scathing, too, about Rubens's *Landscape with a Rainbow. The eye is led by the yellow within the trees to the sky and thence to the Bow, which is hard and horny by the use of the vivid Blue in the distance, which is another instance of his distorting what he was ignorant of natural effect.* The *Tournament* of Rubens, though the sky is beautiful, is all . . . *one continual glare of colour and absurdities . . . but captivating. So much so that you are pleased superficially, but to be deceived in the abstract.*

Colours are the main characters on Turner's stage – he gives them capital letters – but it is to be some years before his pigments emerge from the shadows of 'historical' colouring, closely concerned though they are with every movement and action.

84, 85 Mr Dobree's Lee Shore

The large study book

The illustrations which follow are from the large book of thin blue paper which Turner used in his studio. It contains working drawings for most of his pictures painted between 1802 and 1805 and one of 1812 (*Hannibal*). There are studies too of some subjects which as far as we know were never painted: *Willm Tell escaping from the Boat*, *Mr Dobree's Lee Shore*, *Whirlwind*, and *Water turned to Blood*. The captions are all in Turner's handwriting, in pen, and it looks as if he kept the book as a record of pictures planned, and pictures sold. *Lord Egremont's Picture* for example, which we reproduced as an endpaper in *Turner's Early Sketchbooks* was the *Ships bearing up for anchorage* exhibited in

1802 and sold from the Exhibition. The sketches were Turner's only record of it – he later used the subject in the *Liber* engraving, reproduced on p. 16. A few of the sketches are detailed pen drawings, but most are black and white chalk of the broadest, most trenchant style. Most of the drawings go across two pages and the reproductions here are considerably reduced. The book starts with some early life drawings, none of them very convincing.

In the double spread above the chalk has offset from one side to the other, producing a nearly symmetrical pattern which Turner may or may not have found stimulating.

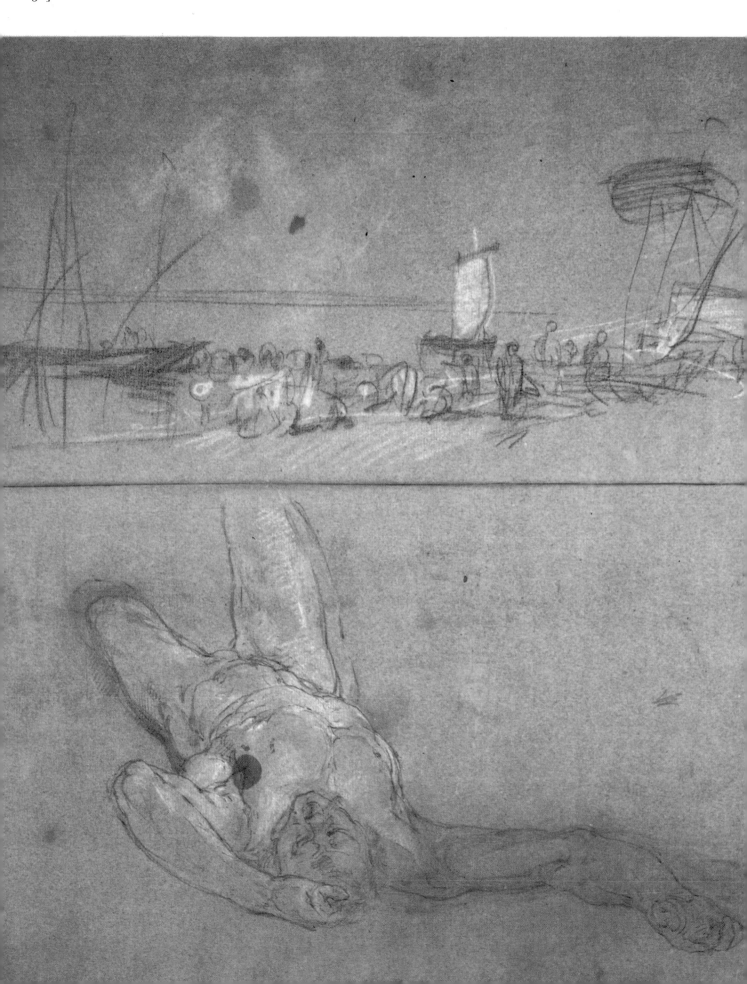

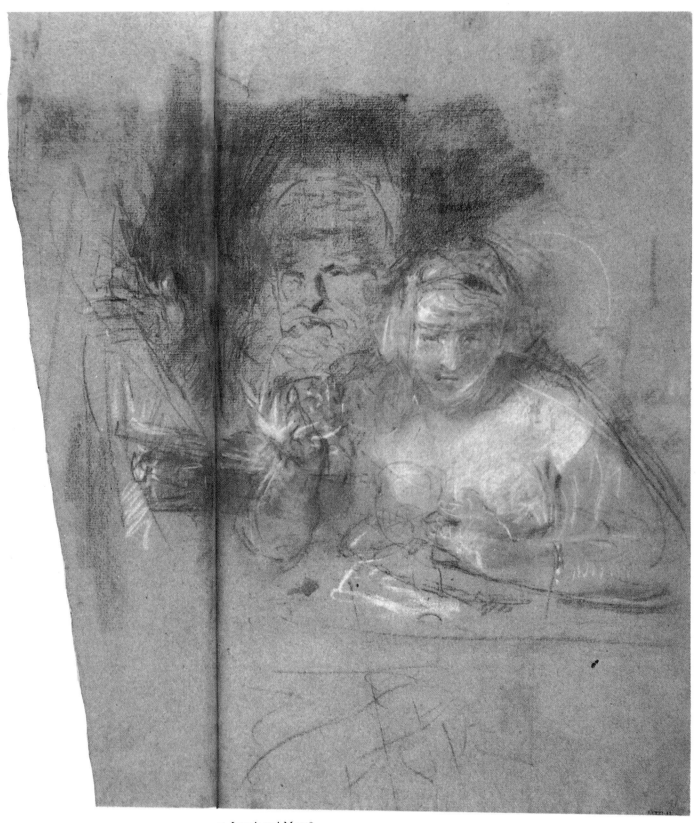

41 Joseph and Mary?

20, 21 study for a picture of the Lake of Geneva; life drawing

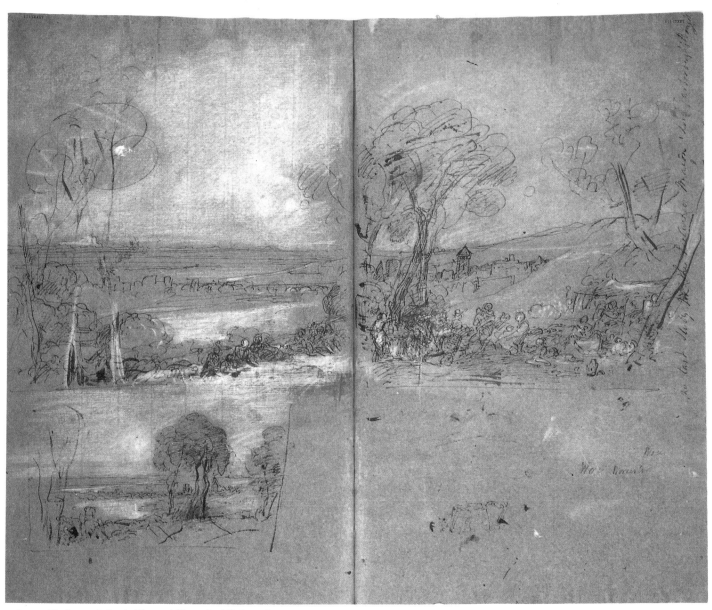

116, 117 The last study for the Picture of Macon Lord Yarborough Bought

136, 137 study for *The Shipwreck*

62

64

The years 1803–4 are not well documented in Turner's sketchbooks. It is fairly clear that he gave up his summer routine of touring to collect topographical material: he no longer relied on topographical work for his daily bread. As an R.A. he intended to take his full part of official responsibility – late in 1802 he was already urging Farington to support him as one of the Visitors to the Schools – and he was soon involved in Council politics.

He had a store of subjects to paint and by 1804 he opened his own gallery, so we can

assume that in 1803–4 he was mostly hard at work in London. The sketchbook featured here is of no help in establishing continuity. Turner's label reads *36 Yorkshire. Pickering Scarboro'* and he wrote *Chester* on the cover. We do not know whether he visited Chester before his stay at Tabley Hall, Cheshire, in 1808. The style of most of the drawings in the sketchbook, including some of Chester, is mature, but some drawings could date from 1800.

Part of my purpose is to provide a visual guide to the drawings in the Turner Bequest.

This sketchbook is dated 1801–1805 by Finberg and placed in his Inventory immediately after the *Calais Pier* sketchbook, so I have followed his lead.

The ruin on a crag (folios 62, 64) shows Turner moving in to his subject, just like a photographer. Folios 3 and 4 again show how thoroughly he covered the ground, taking a side and a front view of a ruin that interested him. These two drawings could be as late as 1815.

5 Helmsley Castle 6 side view of 5

35 Chester?

2 the Mausoleum

Dated 1800–1804 by Finberg this is a
collection of seven very dirty pages water-
marked '1794'. Brocklesbury Hall,
Lincolnshire, was the scene of watercolours
of 1798, commissioned by Lord Yarborough.
The watercolours were later destroyed in a
fire.

Two sketchbooks, LXXXV *Eclipse* and
LXXXVI *Harvest Home* are not included here.
The eclipse, a partial one, happened in 1804.
The drawings, in chalk, are light, and are
rubbed and faded. *Harvest Home* is dated
1804–9. It contains some large groups of
rustic figures presumably intended for a
genre-piece *à la* Teniers – not very inspiring.

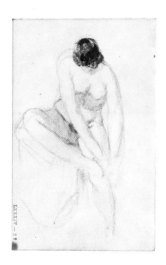
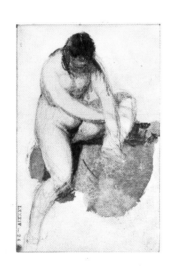
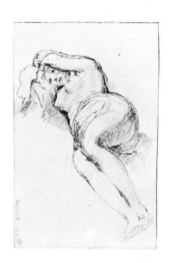

'Academy study' is apparently Finberg's euphemism for nude. Most of the drawings which fill this little book, less than three inches by five, are ordinary life drawings – few without their faults. Some have a more intimate, domestic air. They vary from slight pencil to pencil with ink added, and five are coloured or partly coloured.

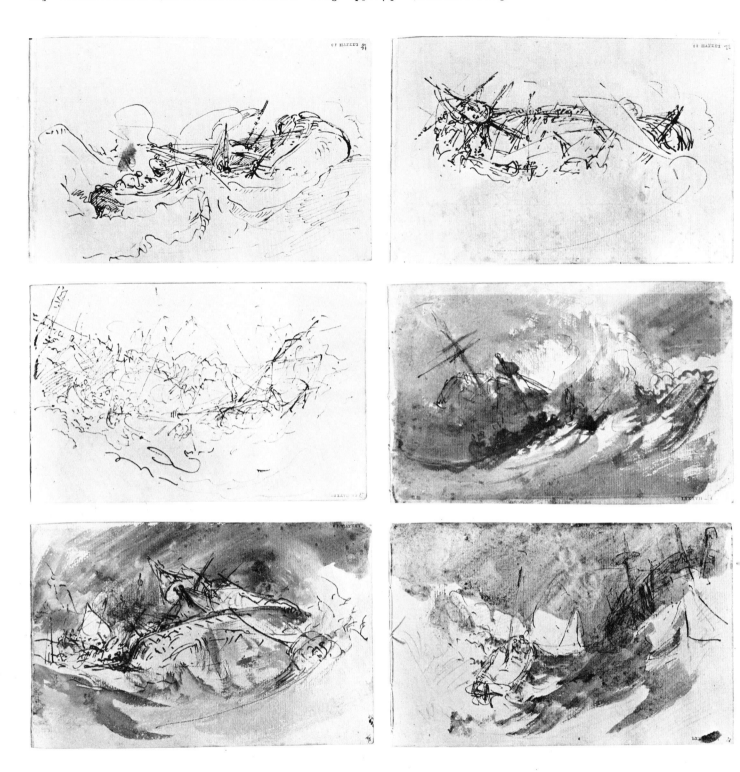

The Shipwreck, 1805

The theme of shipwreck and the vaguer, larger, themes of Turner's *Fallacies of Hope* epic are connected by obvious symbolism, but *The Shipwreck* picture anticipates the first appearance of lines from the poem by six years, so there is no point in labouring the connection. But some sort of orientation is necessary for us, or at least for me, to understand Turner's choice of the subject.

Géricault (by this time a boy of thirteen) is more understandable as a full-blooded Romantic, a sort of art-hedonist who could place the raft of the *Medusa* in a theatrical context of heroism.

Turner's *Shipwreck* was not a celebration of an almost legendary event: it was just an anonymous ship breaking up in heavy seas, while half a dozen boats collected survivors. Nobody is actually drowning, and the general impression is that, in spite of nasty conditions and extreme discomfort for all,

tragedy will be largely avoided. Thus reassured we can enjoy the fury of the storm, and the magnificent panache of Turner's wave painting, with an added shiver of sympathy for people unfortunate enough to be exposed to the reality.

The picture was famous in its time simply because it was the closest that any representation had come to realism in treating a real-life catastrophe. It gave a visual thrill which in our day is administered via wide screens in darkened auditoria. For Turner

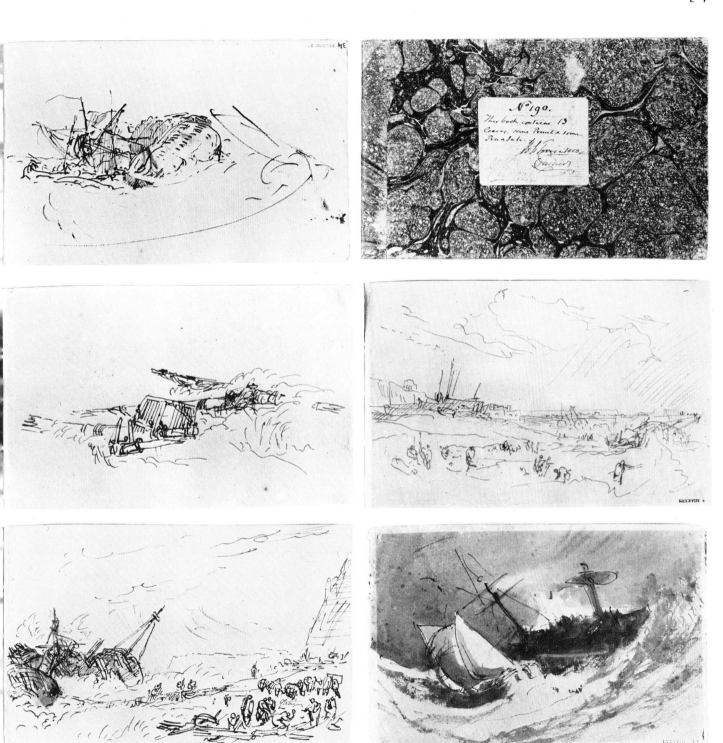

it was the natural sequel to the *Lee shore* and
Calais Pier: a challenge met, and another
tour de force, one stage in the journey from
van de Velde sea-pieces to the mysteries of
the *Snowstorm at Sea*. As such it can be more
or less disregarded except as a 'landmark' in
his career (to use an inappropriate cliché).
The sketches show some of his difficulties in
arriving at an effective composition. They
also show that, typically, he studied a real
shipwreck, and stood with his little notebooks
among the scavengers on some debris-strewn
beach. A shipwreck, with the suffering of
its victims and the bravery of the rescuers,
was no mere spectacle to Turner: it moved
him, and as many later pictures show
unmistakably, it continued to move him,
even as he translated the scenes of disaster
into colour symphonies of the greatest
splendour. The dichotomy is, I suppose, at
the root of all Romantic art.

LXXXVII			LXXXVIII
18	22	34	cover
23	9	4	6
16	21	10	17

The Battle of Trafalgar, near the Strait of
Gibraltar, in which Nelson, commanding
27 ships of the line, broke up the fleet of the
Napoleonic allies, was fought in October
1805. The threat of invasion, after two years
of vigilance, was over. Nelson, already the
nation's darling, died of wounds after the
battle. The half-dismasted *Victory* with his
body aboard was brought home to
Sheerness, at the mouth of the Thames, just
before Christmas. Turner was there with his
notebook.

One page shows a rough sketch of the
composition of the picture he painted, *The
Battle of Trafalgar, as seen from the mizen
starboard shrouds of the Victory*, exhibited at the
Academy in the Exhibition of June 1806. It
was not universally admired. Another
picture, *The Victory beating up the Channel, on
its return from Trafalgar*, was bought by
Walter Fawkes.

27

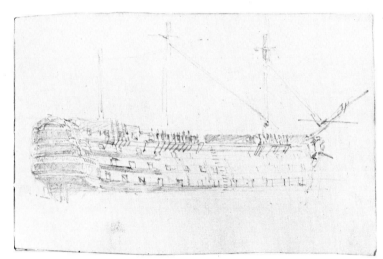

18a

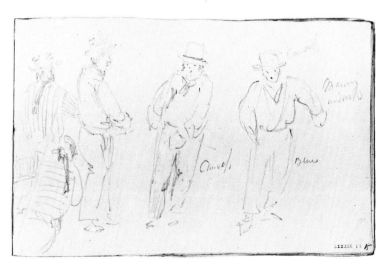

15 sailors

26 study for *The Battle of Trafalgar*

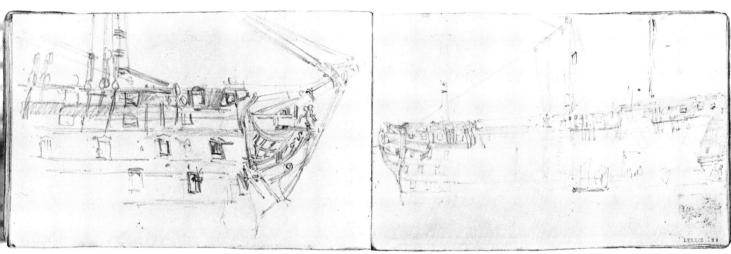

28a, 29

9

XCI *39* Hurstmonceux Castle

Sussex *1804–6*

Two books of sketches in Sussex, on
Whatman paper, washed in various greys
and ochre, are dated approximately by
Finberg. The reason for the artist's visit to
the Sussex coast on this occasion is unknown,
and the character of the drawings suggests
a holiday rather than a commission.

There isn't much to see of the drawing in
the first book, on a dark grey background
heavily spotted with raindrops. Turner
labelled the book *Coast, Lewes, Hurstmonceux,
Pevensey, G., Winchelsea*. It also contains
Beachy Head and Bodiam Castle, including
the kitchen and cellar. But it yields little to
our eyes.

The second book is much more lively.
Centred apparently on Winchelsea and Rye
are some solid, tonal studies for *Liber* plates
engraved in 1812 and 1819, nos. 42 and 67.
These are unremarkable 'Pastoral' plates:
the drawings, though somewhat opaque, are
more satisfying. (I can't see what reason
Finberg had to date the book as early as
this, but it is of course quite possible that
periods of seven to fourteen years elapsed
between sketches and the engravings.) The
first set of sepia drawings for the *Liber
Studiorum*, exhibited in 1808, probably
included *Winchelsea*. The *East Gate* engraving
and its 'cartoon' are in a somewhat severe
and detailed style, certainly later than 1808;
they bear little resemblance to the drawing
here.

XCII *44* East Gate, Winchelsea (*see Liber* plate 67)

42 Winchelsea (see *Liber* plate 42)

The rest of the book is filled, or half filled, with boldly scribbled landscape calligraphy that only just emerges from the blotchy, colour-washed paper. What use these could be is not at all clear, but they do evoke a mood of excitement and inspiration, as if landscape images crowded in on Turner almost faster than he could note them down. If the date 1806 is correct, it coincides with the first conception of the *Liber* idea, at the cottage of his friend W. F. Wells at Knockholt, Kent, in the late summer. Did Turner then stride off into the Sussex hills with his head full of ambition to rival Claude? It seems quite likely. The larger the conception, the more heady when it first begins to form.

19

16

21

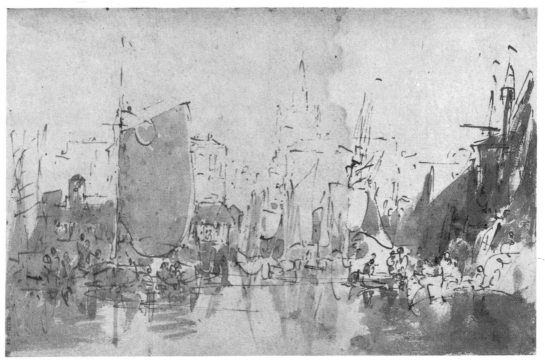

14 study for a picture of London?

27a

Hesperidean?

These two books, one slightly larger than the other, contain the preliminary work for several early Thames paintings and, mixed in, some studies for classical compositions.

They hint at a creative state of mind in which Turner hardly distinguished between the two categories, even though his river scenes are mostly conceived in colour and his mythological ones in a more cerebral pen and monochrome.

The Garden of the Hesperides (full title *The Goddess of Discord choosing the apple of contention in . . .*) was one of Turner's ambitious pieces (eight by six feet) exhibited in the new British Institution – in its early days a home of established connoisseurship. A particularly hideous serpent, containing all the features of current palaeontology, is a major element in the picture and was sketched on folio 3a in this first book, thus, with other studies, providing Finberg with a

XCIII *12* London Bridge?

title to follow an *H* scribbled on the cover by
the artist. But Hesperidean is a good
description of the atmosphere of the sketches
as a whole, which range up and down the
Thames from the Medway to Abingdon,
often in glowing colour, with rainbows,
elegant groups of figures, bridges, barges,
Apollos, Dianas, wading cattle, mills, locks,
and willow trees. Windsor Castle is glimpsed
in more than one view, and there is a
London Bridge, in strong Venetian colours,
which Turner took no further than the
sketch (folio 13).

Tucked away in the middle of the
Hesperides I book is a not very revealing
interior of a blacksmith's shop – the painting,
20 by 30 inches, the first in Turner's
contemporary genre vein, was exhibited in
1807.

Hesperides II, the smaller book, is entirely
in monochrome. The paper of both books
had been tinted grey. In the second one
Turner works consistently with a pen –
unusual for him. The Abingdon bridge is
quite recognisable, and Culham Bridge (still
there, though by-passed by a new bridge and
very much less open in aspect). The also
superficial (but deceptively so) sketch of
cattle in the water, apparently, here, at
Abingdon, was the basis of the beautiful
picture once called *Abingdon*, now called
Dorchester Mead. The misty-morning effect
of this picture owes nothing to the sketch.
Such slight notes were all Turner needed to
recover the original inspiration for one of his
most evocative pictures of this period. Yet
we find him working in much more detail in
the larger book which follows.

XCIV *13* Death of Achelous

below: *36a* *Lock* on the Thames

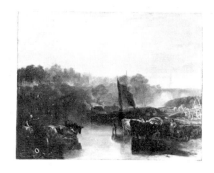

4a sketch for *Abingdon*, the picture now called *Dorchester Mead* (above)

40a Abingdon Bridge and Church from Abbey Meadow

39a Culham Bridge

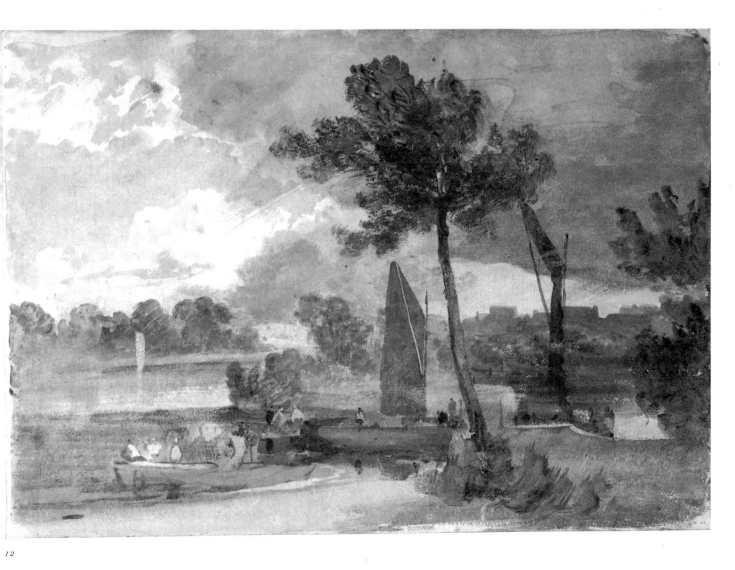

12

22 Three sketches of Walton Bridges

Thames watercolour sketches

It seems that Turner was continually changing his method of working on the river. A certain amount of experiment is understandable when we realise that this was a sustained effort in the expression of landscape ideas *out of doors*: not merely note-taking of topographical and other subjects, occasionally interspersed with more poetic work. Here he is actually composing his pictures on the spot. In this large book he completes eight or nine watercolours, while the pencil drawings are really compositions, using the whole surface area. Some of the pencilwork is bolder and freer than one might expect if it were to be the framework for watercolour. At least one page formed the basis of an oil painting and perhaps some other sketches were intended for this purpose.

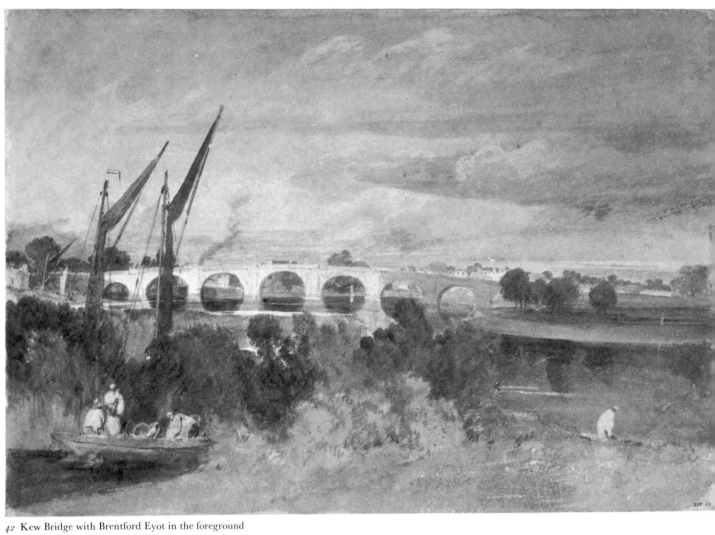

42 Kew Bridge with Brentford Eyot in the foreground

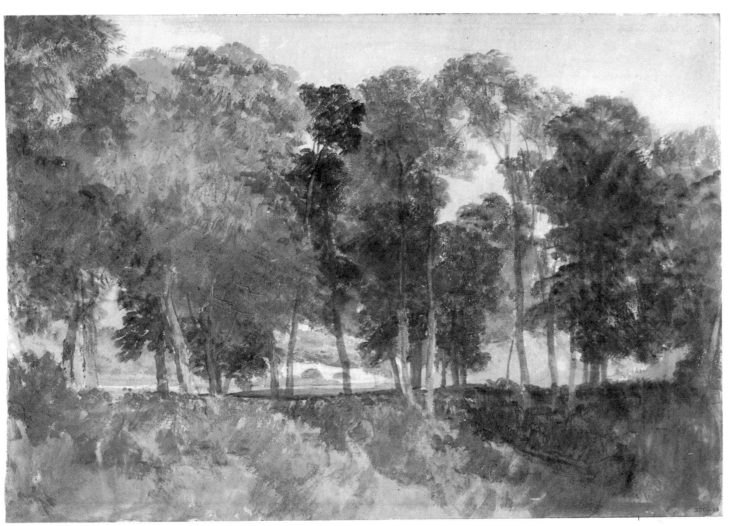

46 On the Thames

16 Pangbourne Lock

About this time Turner also began experimenting with oil sketching from his boat. The oil sketches proper are on mahogany panels, but there is a record (p. 35) of him taking large canvases aboard, and some direct, unfinished works now in the Tate Gallery (see page 13) could be the results of this early attempt at *plein air* painting. The Thames oil sketches on panels are some of Turner's best and most exciting work, in spite of Wilenski's attempt to damn them as thoughtless exercises. They *are* paintings and, as a series, outside the scope of this volume: the coloured pages of this large *Thames* sketchbook form a close parallel in watercolour, quite distinct from watercolours finished for exhibition. The intensity and weight of the pigments approach the solidity at least of lean oil colours (i.e. diluted with turpentine). There's no question here of a tinted drawing – in fact, it is the 'Alpine' style of the *St. Gothard* sketchbook adapted to subtler effects. One can see, at least by

18 Cleve Mill

15 horse ferry

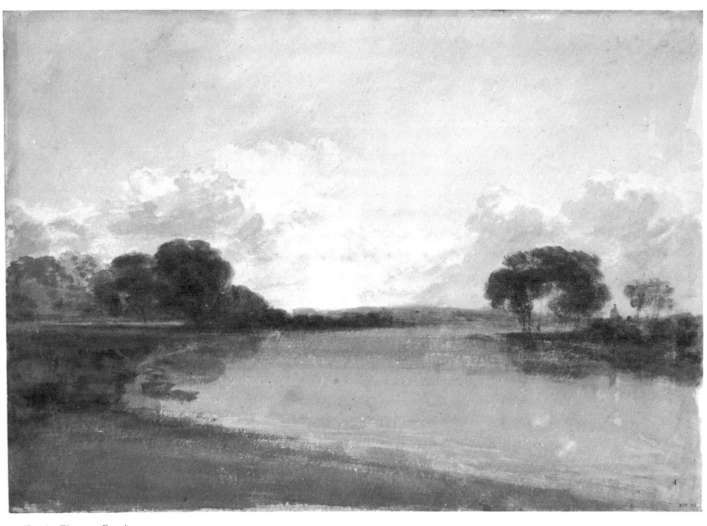

33 On the Thames: Evening

hindsight, that oil sketching was a logical next step.

There is an oil sketch, not on a panel but on paper, filled with the dark green foliage of high summer, very similar to the watercolour, folio 46. This oil sketch is one of six listed as 'Knockholt Studies', xcva, supposedly dating from 1806–7.

The composition of xcv 33 with its odd intervals and uneasy horizon perhaps takes it out of the first rank. But it has the true Turner evanescence and represents a mood or theme of the river – the way it continues the brilliance of the sky – which he still pursued in 1818 (*Richmond Hill*) – and found again in some Italian meanders, in the year after.

A partly finished drawing from this *Thames* sketchbook, folio 48, is divided (daringly or disastrously according to your taste) into two sharply contrasting halves, and gives me the opportunity of a full-size detail of most of the right-hand half. Every gesture of Turner's brushes can be traced here; his use of watery colour blotted out, and almost dry colour dragged over the grain of the paper. Some of the pigment, in the reedy part of the

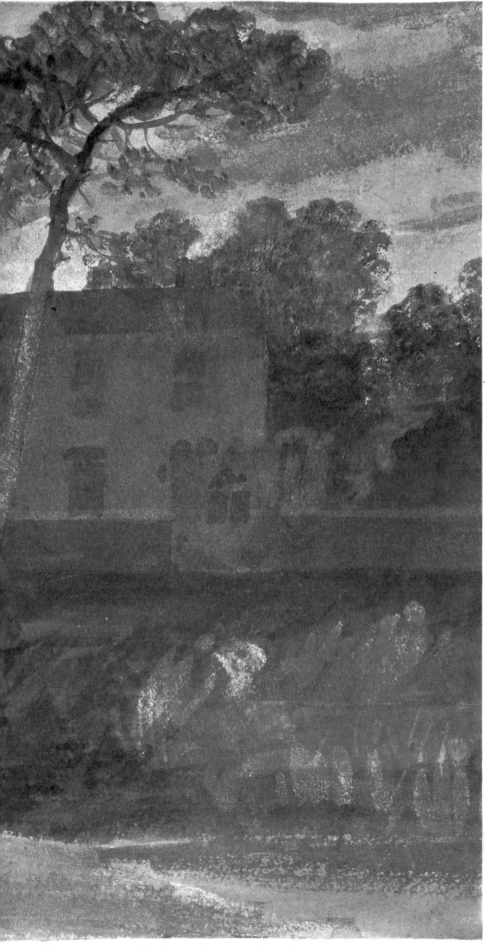

foreground, seems to contain more than its
normal quota of gum. Turner is known to
have added this to give his medium more of
the plastic quality associated with oil colour.
Certainly there is little insistence on the
typical transparency and fluidity of water-
colour, though he exploits this too when it
suits his purpose. His complete disdain of
style and mannerism is to me his most
engaging quality. He is always striving – and
always confidently – towards some end, and
never, never sidetracked or seduced by the
means.

Rustic figures

Turner did not use the large pages of the
Thames, Reading to Walton book for classical
composition studies and these are also absent
from two pocket-books of about 1807: *River*
and *Windsor, Eaton* as Turner labelled them.

After the *Hesperides* and a *Narcissus and Echo*
(a painterly landscape with more than
usually acceptable figures, at Petworth) of
1806, he exhibited no mythological works
(apart from resurrecting the *Jason* of 1802)
until 1811, when he showed two. These were
Mercury and Herse, a fairly stodgy Claudian
effort, heralding a sequence of ambitious
classical works that included the Carthaginian
epics, and *Apollo and Python*, in which Turner
finally, and rather elegantly, got rid of that
serpent.

So in the period 1805 to 1810 during which
time he lived at Hammersmith and Isleworth
his gaze could have rested entirely on the
present and in particular on the banks of
his beloved river. But various classical
studies in the sketchbooks of this period
show that he was turning ideas over in his
mind.

The sketchbooks themselves are hardly ever
to be accurately or wholly linked with
particular years, but the *River* book has an
1806 watermark and Turner's Hammersmith
address (which dates from 1807 onwards).

Among the barges and river scenery are
three old beggars, a blacksmith shoeing a
horse, and some cottage interiors with
people, vaguely drawn but annotated in
Turner's handwriting: *Girl breaking off sticks
and putting them on the grate*, and *Girl filling the
tin kettle out of a large brown jug*. These notes
and some other groups of figures are the first
signs that Turner had begun to come to
terms, in his work, with the folk who
populated his landscapes. Obviously he had
to do this if he was to attempt genre
pictures, and of course he always needed
figures for his foregrounds: but in these
notebooks he shows that he now had time to
be interested in how people worked and
lived. He would no longer be able to add his
figures as afterthoughts in the studio.

In this notebook are also a dozen pages of
almost illegible drafts of poems.

48 House on the bank of the Thames: Sunset. Detail, actual size

15

49a

10 *Light clouds with Blue at the Bottom*

47

52a

65c

XCVI *11*

17

XCVII *67a*

Sixteen pages devoted to Windsor and Eton bear out Turner's label, but the ones I have chosen continue the themes of the *River* book. In 67a the practical artist makes an unusually explicit note to himself: *Bargeman hanging up cloak &c on the shrouds – good incident to avoid the long line of shrouds.*

The page below, left, perhaps shows Turner's house in Upper Mall – from the river. It certainly looks like Hammersmith. The cows, outlined for later colouring, caused Ruskin to write a schoolmasterish comment in red ink.

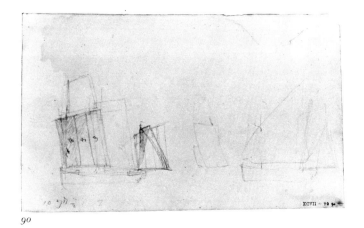

90

31

58

89

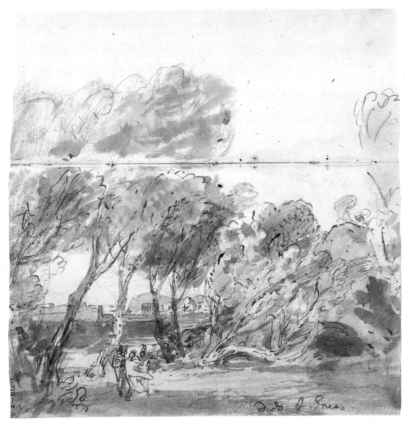

1a, 2 Dido & Aeneas

This sketchbook, containing some fluent pen
and wash drawings, many of them classically
orientated, is related to the *Liber* cartoons,
exhibited in 1808, of *St Catherines Hill* and
Guildford, by several sketches of this area. The
classical subjects are related by their titles to
pictures exhibited in 1811 and after. The
pages have been numbered in reverse order
to that in which the drawings were done, or
so I think: the pencil work probably belongs
to 1807 and the pen and wash to 1810. The
wash drawings reproduced here and on the
next three pages all come from the first (or
last) fourteen pages, and are separated from
the Windsor and Guildford sketches by 70
blank pages.

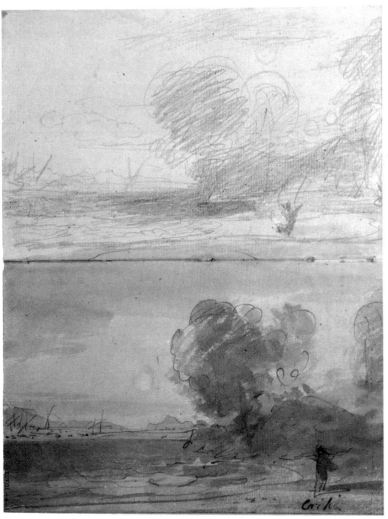

3a, 4 studies for *Chryses*

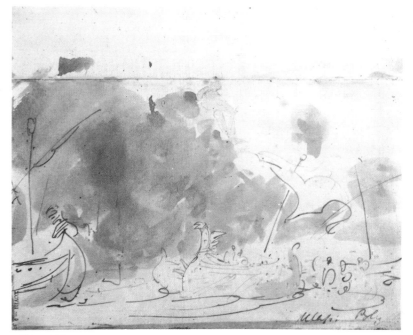

5 Ulysses Poly . . .

Folio 5 is labelled, *almost* unmistakably, *Ulysses Poly* [phemus]. The famous painting of *Ulysses deriding Polyphemus* was painted in the late 1820s, so this germinal sketch, if that is what it is, took over twenty years to bear fruit. We may wonder what was the origin of the idea, for Turner draws the antique ships as carelessly as if he knows them very well.

The diagrams (opposite below) are also of some Mediterranean craft – probably from a model. He used models in his shipping compositions, according to the account by Trimmer, recorded by Thornbury (p. 35).

The buildings in folios 11 and 14 are classical with a faint air of Twickenham, and the group of trees (folio 10), whatever it was intended for, is unmistakably English parkland.

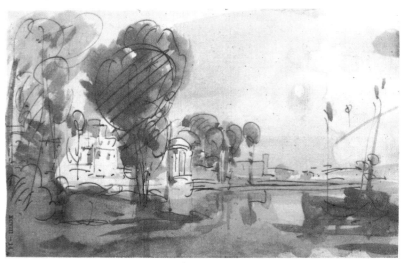

14

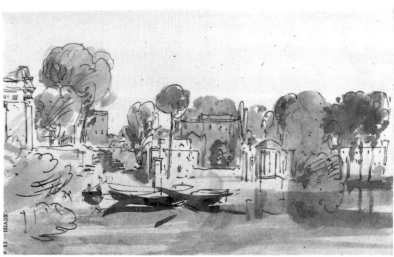

11

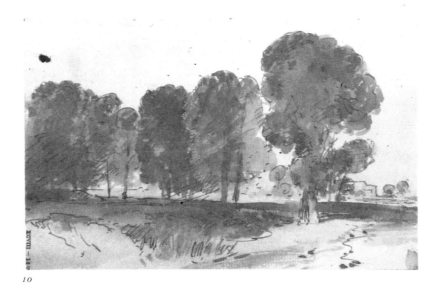

10

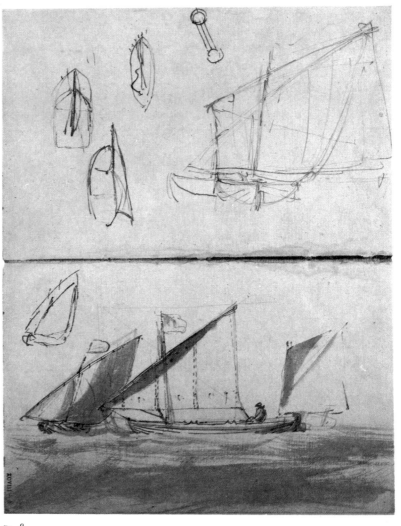

7a, 8

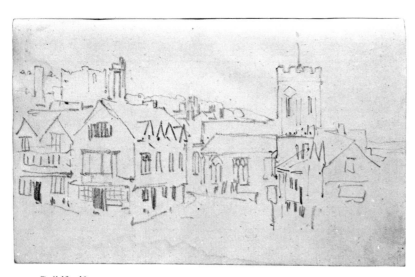

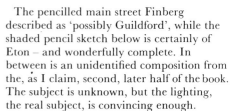

The pencilled main street Finberg described as 'possibly Guildford', while the shaded pencil sketch below is certainly of Eton – and wonderfully complete. In between is an unidentified composition from the, as I claim, second, later half of the book. The subject is unknown, but the lighting, the real subject, is convincing enough.

Here you have in miniature the three styles of Turner: a clear architectural statement; a dramatic projection of mythology; a landscape of breadth, form, and atmosphere.

117a Guildford?

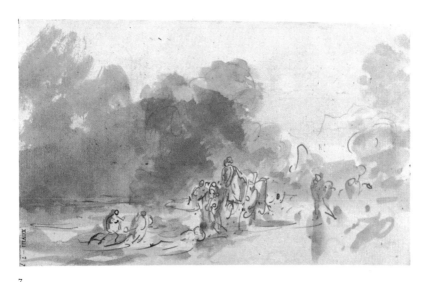

7

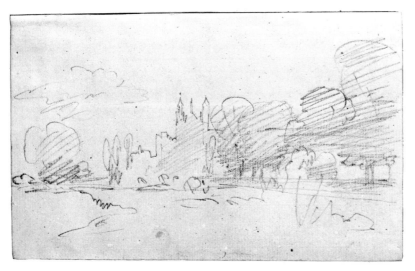

129a Eton

A view of Margate was exhibited in Turner's Gallery in 1808 and sold to Lord Egremont. Finberg mentions that it is presumably the *Sea piece, probably Hastings*, in the Petworth Collection. In 1808 Turner had some welcome support from the Press in the form of a new quarterly review run by John Landseer, a perceptive critic and an advocate such as Turner was not to have until Ruskin (born 1819).

'We had not imagined that any View of Margate, under any circumstances, would have made a picture of so much importance as that Mr. Turner has painted of this subject: but, by introducing a rising sun and a rough sea; by keeping the town of Margate in a morning mist from which the pier is emerging; and by treating the cliffs as a bold promontory in shade, he has produced a grand picture. . . . Margate acquires a grandeur we should look in vain for at any other time and under any other circumstances. . . .'

The sketchbook contains several strips of coastline, labelled: *Southend: Foulness: Oxney light*; and so on. Turner had made a survey of the coasts in the Thames Estuary. The sketches, like the coasts, are not eventful, and like Landseer, we 'had not imagined they would have made a picture'. Also included are sketches of a *Hastings Herring Boat* which got into the picture of Margate.

This is a busy little book full of all sorts of things, but permeated with the atmosphere of the river – chopping waves are everywhere. Plentiful captions add to the interest; besides those reproduced is a sunset: *Beautiful Grey Purples. Light P. Brown, Bt. Sienna*; and, scattered over the sky of another: *Warm. Grey. Blue G. warm light*, and *Sun like an Egg's Yolk*.

Further literary entertainment is provided by the draft of a letter inside one cover. Turner was now Professor of Perspective at the Royal Academy, and had been procrastinating about his lectures. A newspaper had reported an Academy meeting, and a reader had accused the Academicians of spending their time feasting instead of lecturing. Turner was feeling guilty.

It is hard you cannot have a few friends today and if you please give them turtle soup and venison without giving umbrage to a constant reader who, by the following address to the Examiner of to-day to tickle up the Professors, seems to be spleenic in affairs of taste.

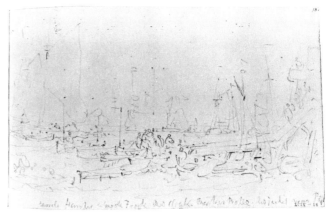

18
ships' boats taking in stores: *Barrels, Hampers*, etc.

34

81
Hastings Fish Market

17

2

14

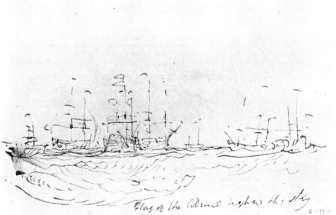

17 *Flag of the Admiral light on the sky*

18

Winter scenes

Turner's label says simply *Shipping*. This book
can be dated accurately by sketches for the
picture *Spithead: Boats Crew recovering an
anchor*. The ships in the picture were
actually part of the Danish Fleet which the
English Navy had seized in Copenhagen
Harbour and brought to Portsmouth to be
out of Napoleon's reach. Some politicians
had objected that this was unfair, even in
war, and Turner, though he had gone to
Portsmouth specially to draw the Danish
ships, cautiously left out any reference to
them in the title of the picture, exhibited at
the Royal Academy in 1809.

It was late in the year, October or
November, as Turner made his way back
from Portsmouth – not the time of year for
Picturesque travellers. He made notes of the
country people ploughing and sowing, and
investigated another cottage interior, and
Woman cutting turnips; Interior of a Barn;

24

Cows eating at the entrance, a *Wheelwright's*,
a *Pigg's sty*, and *Liphook – Cow rambling
among furze*. He drew several outlines of
Hindhead Hill (described by Cobbett as
certainly the most villainous spot that God
ever made'), which became a plate in the

Liber Studiorum. Finberg traces another plate,
Hedging and Ditching to a note in his
sketchbook.

One page (folio 70) contains the elements
of his *Sun rising through Vapour* redesigned for
second version he was to paint.

70 study for *Sun rising through vapour*

50

River scenery, fishing-boats, sunsets: Turner's
river again but with (overleaf) some
extraordinary scenes of packed ice – can this
be the Thames Estuary?
 Turner investigates *Fleet of Fishermen,
Smelting* and notes on another page *One
throws out the net – then rows round and while
[he] is pulling up, another net runs out, so one net
is always down*. Smelt, and pack-ice, are not

CI *89*

4

22

29

typical of the mouth of the Thames. But if
Turner had been further afield there would
surely have been some evidence in other
sketches or pictures, and there is none.

The Professor notes some reflections in
water – three times the height of the object,
and he records a sunset with *Orpiment edge
round the sun*. Orpiment is, or was, bright
yellow, a sulphide of arsenic, difficult to use
because it could not be mixed – therefore
always a brilliant pure pigment. It is now
replaced by the more reliable cadmiums,
not so poetic-sounding.

	31
14	9
18	17

39 Boat behind throwing the spray R by the one in shade

12 Greenish Black in Shadow Ice white and grey

The last of the group of River notebooks is the very small *Greenwich* – Finberg's title. Turner was, I think, planning a composition, perhaps of fishing-boats, at river-level in Greenwich. But the view from the hill, looking back to London, which turns up frequently in his sketchbooks, is the only one that he used.

There are several pages of relatively articulate verse in this notebook. The deer were at Greenwich. The fishermen in a punt – *Driving down Lamprey's stops* – are presumably in some muddy estuary such as Barking Creek, which eels now shun?

We may see a hint of future splendours at Cowes in the massed sails of fishing-boats (overleaf).

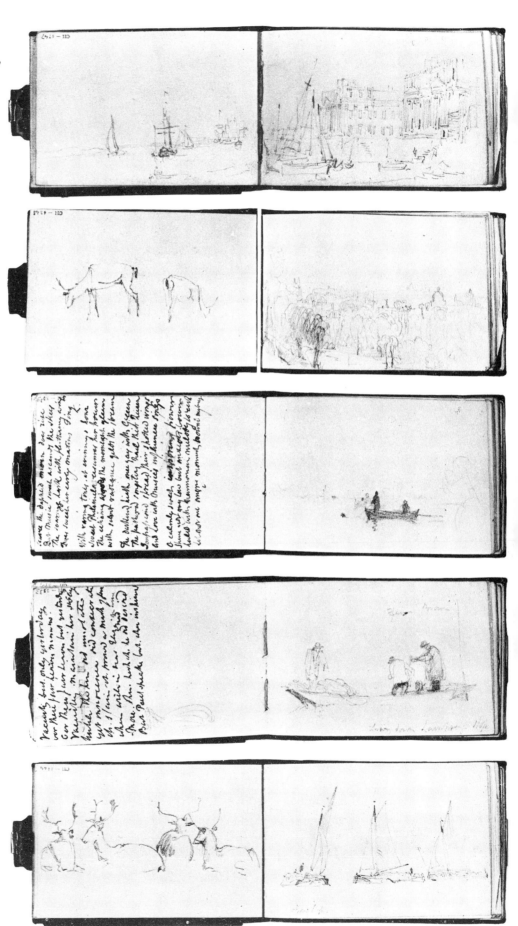

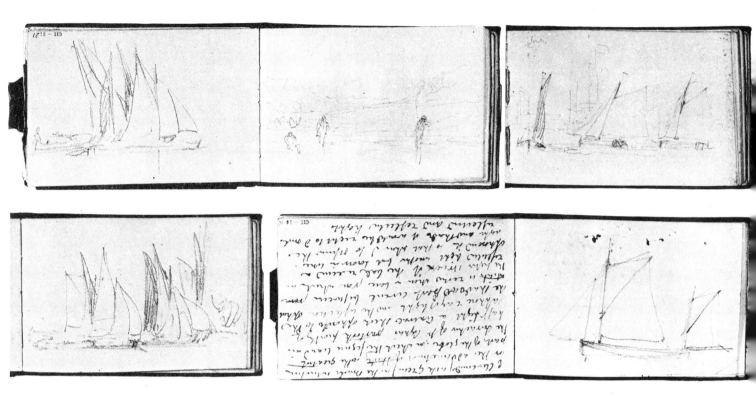

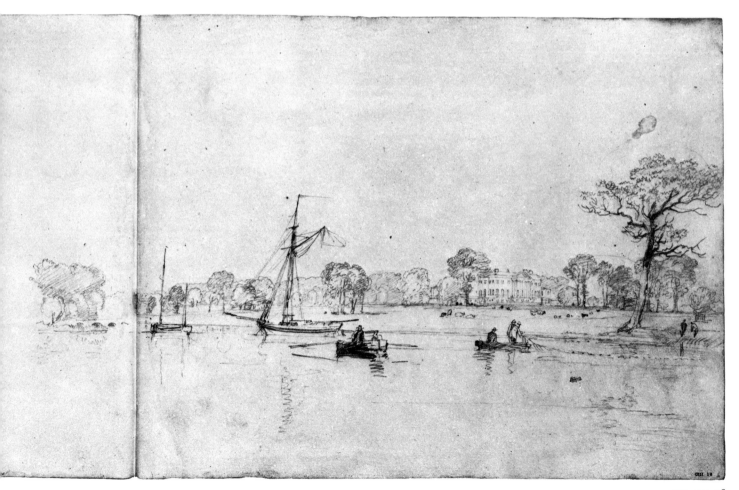

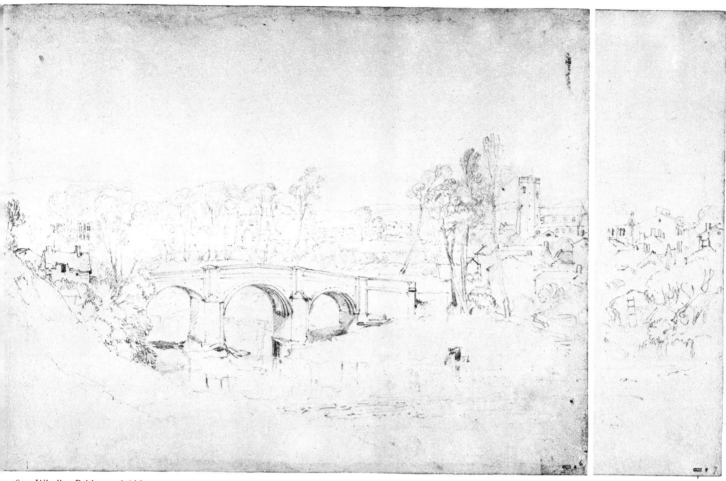

6, 7 Whalley Bridge and Abbey

Tabley, 1808

Turner visited Tabley Hall, near Knutsford in Cheshire, in the summer of 1808, to do the groundwork for two paintings commissioned by Sir John Leicester. A fellow Academician, who was also staying, reported, cattily, that he spent most of his time fishing. But he got through three or four sketchbooks in as many weeks.

The largest book, with some careful layout work (folio 18) for the client, was taken apart by the executors. It now begins with some drawings in the Ribble Valley – by no means adjacent to Knutsford. A painting of Whalley Bridge was exhibited in 1811. Whitaker, the historian, whose works Turner illustrated before 1800 and after 1816, was the Vicar of Whalley. Whalley Bridge is drawn first as it was and again as Turner thought it should look – in fact a second drawing is a study for the picture, and not this one.

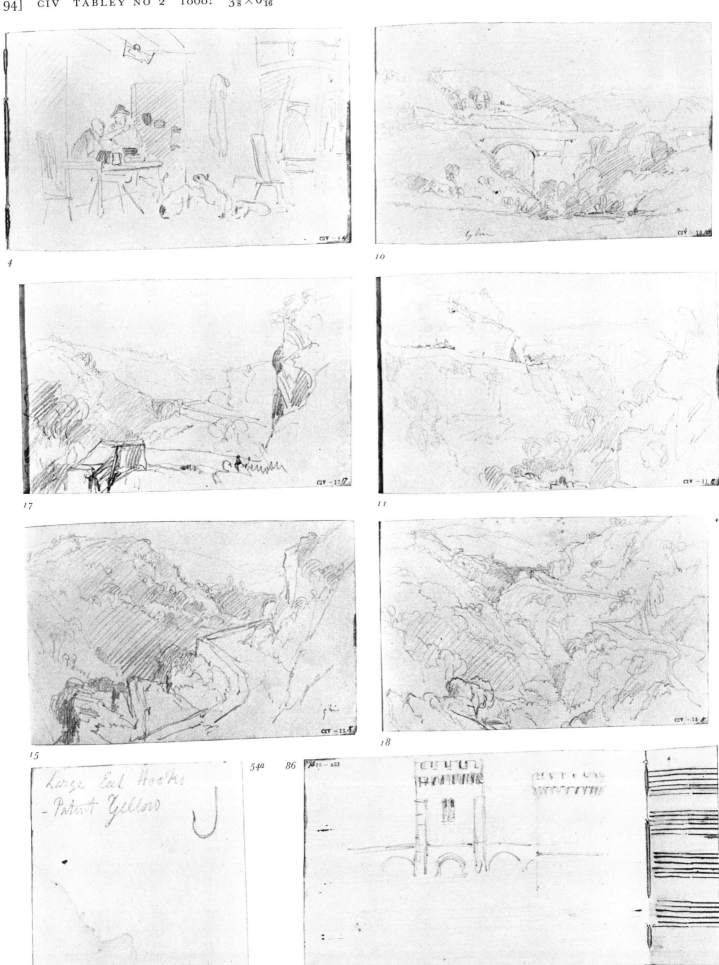

4

10

17

11

15

18

54a 86

Large Eel Hooks
- Patent Yellow

18

92

17

Certain elements of Turner's lazy fishing habits appear in the smaller books at Tabley. The first one, labelled *Tabley* by Turner, seems to relate to expeditions from Cheshire into Wales (the Dee) or Derbyshire. Turner was learning the flute, and several pages are ruled with staves – some correctly.

Notes on reflections, closely analytical but hard to follow – all have been deciphered and are printed in the *Inventory* – continue from one notebook to the next. Two germinal sketches for the Tabley Hall pictures are here, the water-tower now in evidence: *Morning Mist arising* (folio 7) and a lively ink sketch for the *Windy Day* version (folio 17). He seems to have been left then with some blank pages, filled up later with various plans for his gallery and then some drawings of the Custom House and London River which Finberg dates as late as 1820. The three-in-one Thames-side page (folio 92) must be later too – this was a habit he started on his Rhine tour of 1817. As it is so detailed (and attractive) I have given it a larger reproduction than the other pages, which are just above half-size.

loose leaves now bound into the book: Old Blackfriars Bridge? The Royal Academy (Somerset House)

The book now called *Derbyshire* matches the *Tabley* notebooks, but it continues their themes only approximately. It is half full of verses and was probably kept as a poetry-jotting book, taken from place to place – various landscapes, and barges are interspersed. One sketch is purely verbal (folio 15a): *Children picking up horse dung, gathering weeds, driving asses with coals. Milk carriers to Manchester. Yorkshires with barrels. Pigs, geese, asses, browsing upon thistles. Horses going to coal pits.* The large barges drawn on the very next page, and the mention of milk to Manchester, suggests that we are on the Cheshire bank of the Mersey. There are some philosophical notes, and some rough manuscripts of Reynolds's *Discourses.*

The subjects of the ink drawings are not identified.

29 of Boat relieved by shade Water light Ex . . . Ref . . .

78a

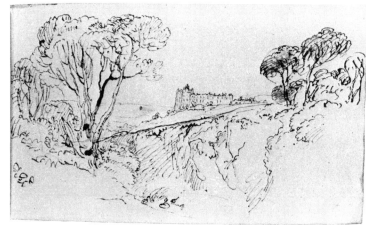

82a

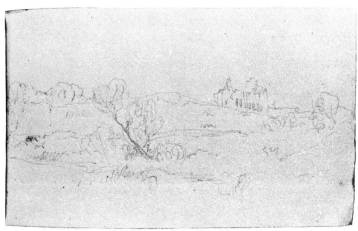

74a

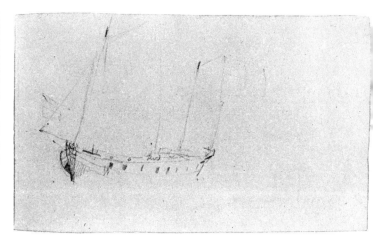

3

4

9

12

16

21

Turner's label is *Kirkstall*, and fifteen pages
of very consistent line work explore as many
compositional possibilities of the ruined
Abbey. He had been there before in 1797.
Some written notes on folio 1 of the sketch-
book trace alternative routes to Otley,
presumably to Farnley Hall; one is via
Manchester, not exactly on the way from
London to Leeds.

The drawings, fluent and controlled, are
unfortunately very faint on the page.

Another proof of power of secondary lights

The *Perspective* notebook is exactly what it is called, with the odd barge, and some notes for poetry – one of the poems addresses *Dear Molly*. This is 1809 or 1810. Turner once again put off his first lecture until 1811 with the permission of the Council. His delay was probably due to doubts of his own ability to deliver his remarks in proper style, rather than to any lack of research.

Egremont

This Petworth sketchbook records an early visit to the seat of Lord Egremont, where Turner gave the house and park much the same treatment as he had given Tabley – this may have been in the terms of the contract. The painting that resulted, *Petworth: Dewy Morning*, follows almost exactly the lines of the sketch except for having more sky, and less land at the left. The boat and fishermen at the left were moved inwards and the small island, left centre, disappeared. All in a day's work; but more mysterious is the church spire sprouting

from the roof of the house in the painting. Here the sketch is hesitant, showing only two pairs of parallel lines. Was there ever a spire there, or was it something that Egremont planned to build? Spires are not too common on Sussex churches.

Cowdray Hall (near Midhurst), ruined then as now, though preserved, also features in Turner's careful layout style. Another detailed drawing is of Whitewell. He had done some very similar (rather better) drawings of this tiny village on the Yorkshire-Lancashire border in 1799 for an engraving which was never used. Now perhaps he planned a picture for Fawkes.

4 drawing for Petworth: Dewy morning

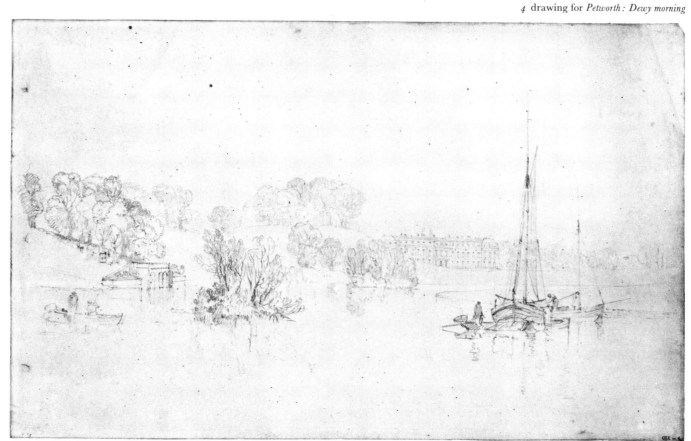

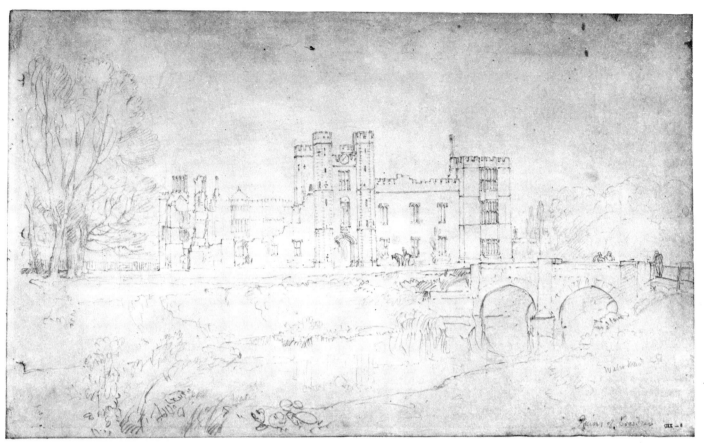

6 Ruins of Cowdray

10 Whitewell

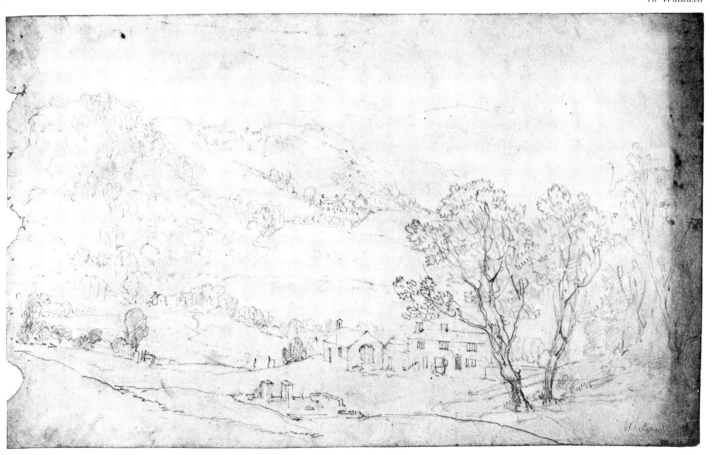

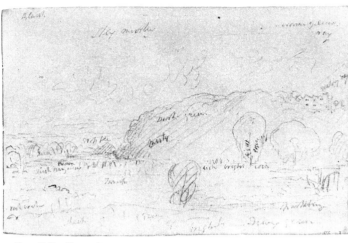

7 Cross Fell – Sky murky – etc.

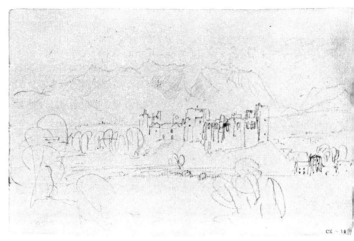

16 Cockermouth Castle

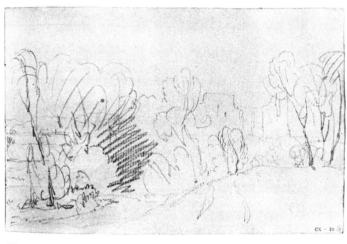

20

18

32 Calder Abbey

36

35

39

32a In wet weather etc

33 Calder Bridge

There are several pencil drawings of
Cockermouth Castle in the large Petworth
book. It was another subject commissioned
by Lord Egremont (there is a village called
Egremont among the pit-tips near
Cockermouth). It looks as if Turner again
had to submit a 'finished rough', though one
would have thought that the subject, a
Norman ruin with a background of Lakeland
hills, might have been safely left to the
artist, already a master of such material.
Possibly Egremont was concerned as to the
balance of the finished picture in the position
it was intended to hang. The painting is
still at Petworth.

 The small sketchbook which Turner
labelled *Cockermouth*, illustrated here,
concentrated on the Castle and its surround-
ings, with some notes on skies and a few
local people. *The women*, he notes, *wear black
stockings and clogs shod with iron*. Of some
farmers he writes that *in wet weather they wear
Blue Horseman Cloakes with Hoods*. The clogs
are familiar to me, but not the cloaks.

 This sketchbook, CX, was inventoried by
Ruskin in 1858 as 'Nearly Valueless'.

*40 Smoke like the Clouds : Orpiment and Blood : Blue clouds, yellow edge :
Golden : Yellow : Warm : Grey : Rain : light redish color'd clouds yet watery*

This so-called *Hastings* sketchbook is no more than a personal notebook with, as usual, a few drawings among the accounts, snatches of poetry, and other notes. It contains the poem beginning *Coarse flattery* quoted on p. 34 and *World, I have known thee long*, supposed not to be by Turner. Here also he copied down the favourable review of *Mercury and Herse* which I also quoted. There are notes on the sale of 90 Norton Street, bits about '*monstrous Python*', accounts connected with the proofing, printing, and subscribing of engravings – presumably *Liber Studiorum* plates – the beginning of an epitaph (two pages torn out). One disturbing note reads: *The Herb Stramonium – smoke 2 or 3 pipes every day and swallow the saliva.*

Some complicated personal accounts are in healthy four-figure sums. And in June (1810?) Egremont pays him £428 11s 5d and Lonsdale £598 18s 7d – each of these sums presumably refers to a pair of pictures which we know were commissioned, eight pounds and some odd shillings and pence being perhaps the cost of the frames.

65a, 66

20a, 21

29

71

79 Hastings, fishing boats

5 Frittlewell

7 Children getting sand

2

8

There is a village called Frittleworth, near Petworth, which may have been the subject of these charming studies: *Frittlewell*, *Chil[dren] getting sand* and the shaggy thatched cottage with figures in the foreground – some of Turner's most evocative and serene pencil drawings. Other pages are ordinary. Most of the book is blank, but there are some poems, including the one addressed to the sketchbook: *Vacancy most fair but yesterday*, and some perspective notes.

82a

A tiny notebook, not titled by Turner, contains, as well as details of Lowther Castle architecture, a heterogeneous collection of interiors, poetry, dogs, and nudes, a few of them with watercolour added. There is not much to be said about any of these: but they make a lively collection.

Two paintings of Lowther Castle, commissioned by Lord Lonsdale, were exhibited in 1810.

Some verse from this book is quoted on p. 34.

7a, 8

16a, 17

55a, 56

60a

52a

51a

50a

49a

40a

46a

43

A small notebook entitled *Windmill and Lock* (CXIV), dated 1810–11, does include a faint, rubbed pencil jotting of this, the subject of a painting and a plate in the *Liber*. The book is mostly filled with architectural details and some plans for Sandycombe Lodge – such plans and alternative façades turn up frequently in his notebooks of this period (see p. 31).

endpaper

It is assumed that Turner went to live at Sion Ferry House while his Solus Lodge (Sandycombe Lodge) was being built, and after he had given up his Hammersmith house. This was in 1811. Finberg states on p. 192 of his Turner biography that he believes he had been wrong in dating the 'Isleworth Studies' book as early as 1805–6, and that it should really be 1811, hence its position here.

These coloured pages clearly indicate Turner's ambitions at the beginning of the second decade of the century, ambitions which had taken their direction from his long study of the Thames combined with his determination to rival Claude in classical composition.

This is a book of good-quality grey paper. On folio 1 he is planning an 'embarkation', and thinking of possible titles:

Meeting of Pompey and Cornealia at . . .
Parting of Brutus and Portia . . .
Cleopatra sailing down to . . .

– or what you will? Another study (folio 21) resolves itself into the shape of the *Dido and Aeneas* of 1814. On folio 38a an 'embarkation' faces a view on the Thames at Windsor. The beautifully limned State barges of the contemporary, Georgian, Thames add the right note of pageantry.

On folio 33 is the fine study for *Windsor Castle from the Thames*, 1813, now at Petworth. On folio 34 *Ch . . . returns to Cyn . . .* He is still not sure of that title:

Eneas and Evander
Pallas and Aeneas, departing from Evander
Return of the Argo

and several others are suggested. On the last page are Antony and Cleopatra, on a barge.

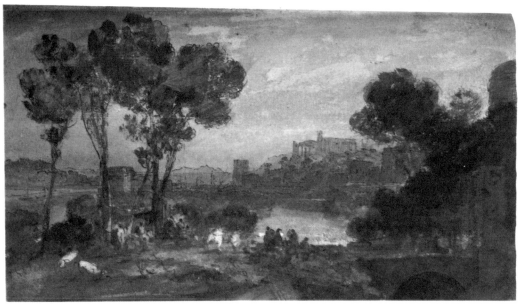

21 study for *Dido and Aeneas*

20 state barges

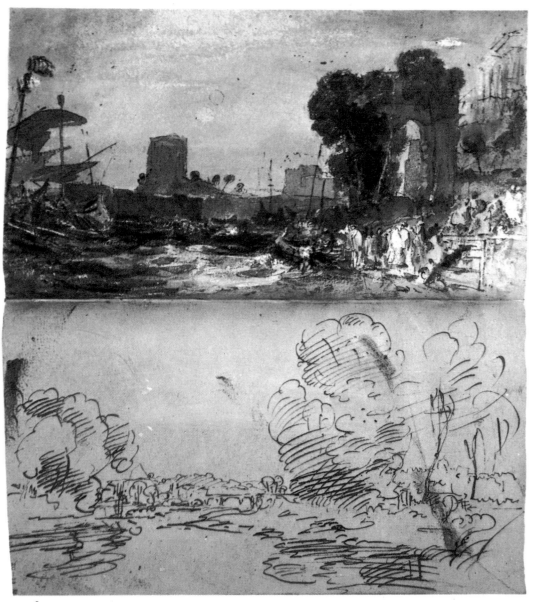

38a, 39

29a study for *Windsor Castle from the River*

14

11a

34 Ch . . . returning to Cyn . . . ?

LXXXVII *10* Turner's first note on the project, 1805

Turner himself provides the title to this section with an (uncatalogued) page from one of the Shipwreck sketchbooks in which he also made a list of subscribers to his first speculatively published engraving, *The Shipwreck*.

Early-nineteenth-century mezzotinted engravings, especially in sepia, have a fusty atmosphere, not attractive. But 96 mono-chrome works by Turner do add up to a considerable body of material, interesting in all kinds of unfashionable ways. No doubt

the plates are still collected and sought after, but, it must be admitted, they are not everyone's taste. The idea of Turner the colourist, in brown monochrome, needs adjusting to, to begin with. And it turns out, as you look through the proofs in the very comprehensive Rawlinson collection at the British Museum, that you are not really looking at Turner, but at the surfaces provided in their various capabilities by his engravers. Even when Turner engraved the tones as well as etching the line, he does

himself less than justice. See the reproductions on p. 63 of *Turner's Early Sketchbooks* and pp. 28–9 in this volume.

The drawings are a different matter. They vary enormously and they do suffer quite often from a certain tastelessness. At first, and particularly in some sentimental subjects, Turner was playing to the gallery, and anyway was a bit out of his depth with the figures. But once we are past this stage Turner's sheer consistent ability as a picture-maker leads us on, and we discover much

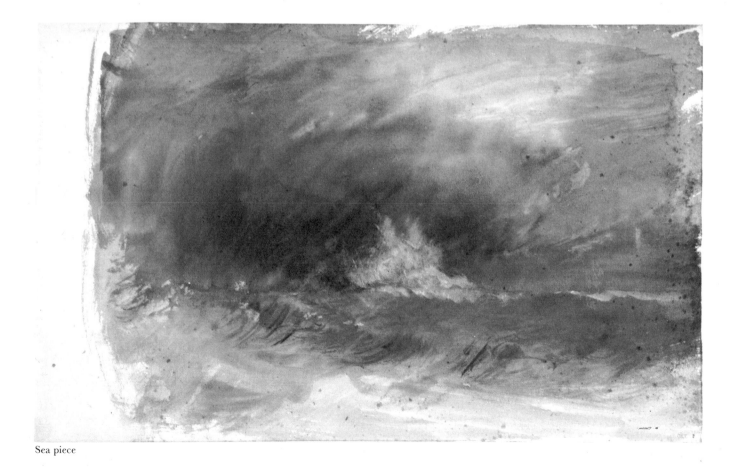

Sea piece

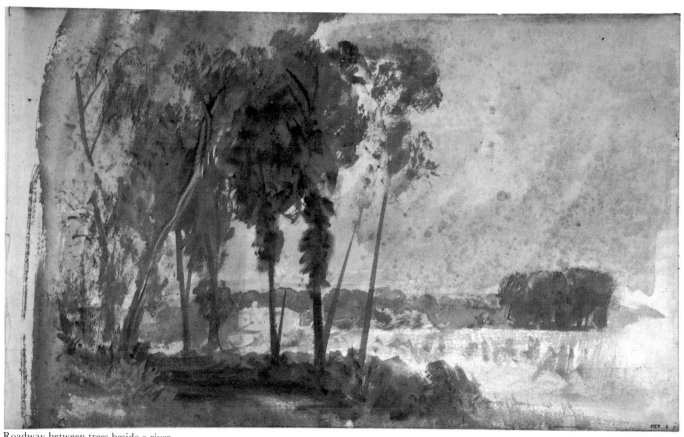

Roadway between trees beside a river

variety and some passion. It seems that the *Liber Studiorum* as a major project of Turner's, not merely a collection of more or less unsuccessful prints, is worthy of a fresh look.

A lot of the drawing remains as rough work, never finalised for the engraver. Some of the drawings were lost. In the selection that follows I have given the category under which the engravings, based on the drawings were published – where there is no category, there was no publication. The groups were Pastoral, E.P. (presumed to mean Elevated, or Epic, Pastoral), Marine, Mountainous, Architectural, and Historical. As it happens I have not chosen anything actually published under Historical or Pastoral, but *Glaucus and Scylla* would be a candidate for the first and *Crowhurst* for the second.

Turner made lists of subjects in 1808 and 1818 and these dates are given where appropriate. If no date is given the drawing may be of any date up to 1822, when the project was abandoned. The drawings with no titles are only assumed to have been done for the *Liber* because they are in sepia: their subjects are imprecise in the illustrative terms of the series, and they rise to greater heights of expression. Turner is happiest when his subject is elemental: the closer he must follow quotidian fact the more pedestrian is his approach. He had not yet learnt to exploit that 'indistinctness' which he later recognised as his own 'forte' and manipulated into his own sort of crystalline

definition. In fact he persisted as an illustrator until well into the 1830s – we can be glad of it – and in spite of his becoming the master of pure expression in landscape, he remained a subject painter to the end.

One great value of Turner's sketches is that because they were not done for public exhibition at a time when all painters were subject painters, they show him able to step aside, privately, into the modern world where he belongs. But in these brown studies, we have of course only glimpses of future magic powers.

The sketchbook called *Studies for 'Liber'*, from which we reproduce four pages here, contains twelve drawings. It had no less than 50 pages torn out, presumably by Turner. Finberg wrote in the Inventory of 1909: 'The sepia drawings are all studies for pictures, and are in various stages of definition.

'With regard to the number of leaves which have obviously been cut or torn out of this book, it is evident that some at least, if not all, contained similar studies to those which have been left. How many of these are in the present collection (among the exhibited 'Liber' drawings) it is impossible to say, as nearly all the drawings have been mounted and cut down.'

Finberg's titles, and of course Turner's, have been retained, and I have added some of my own. Turner's titles are in italics; Finberg's have a capital letter, while mine have not.

bridge in shadow

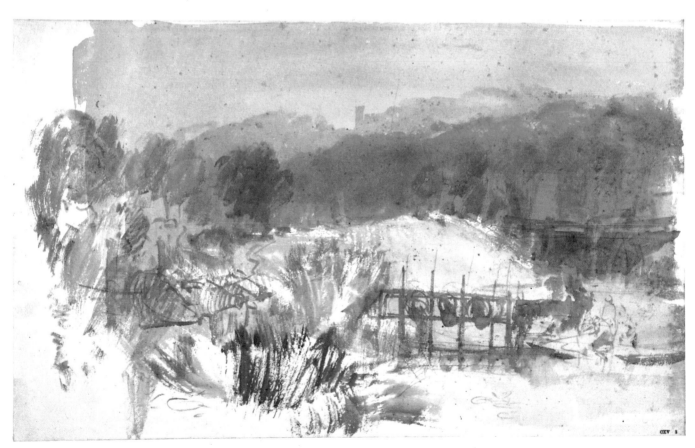

River scene with eel traps

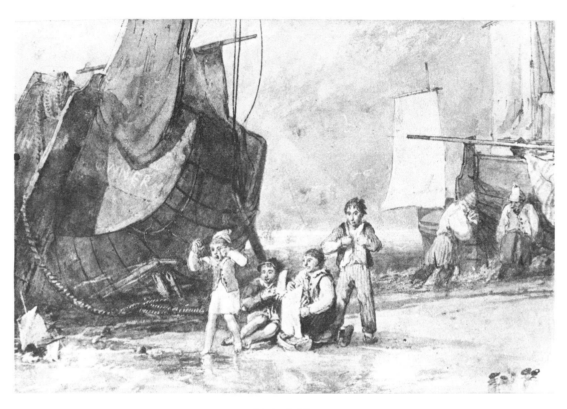

Marine Dabblers

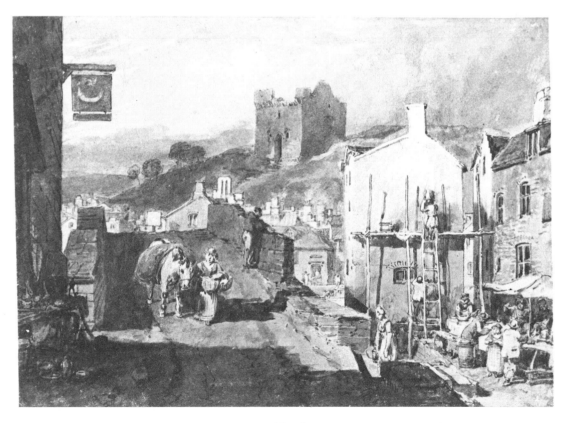

Morpeth

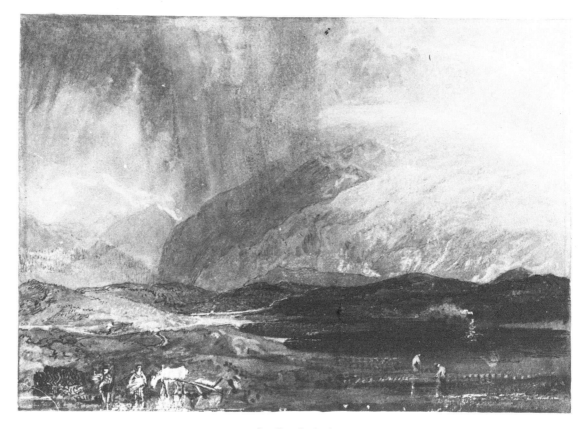

Peat Bog, Scotland

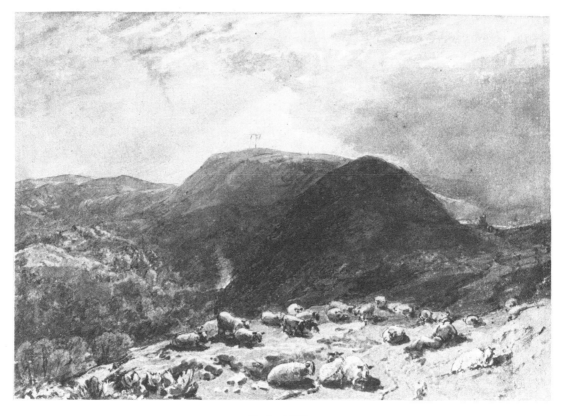

Hindhead Hill

sketch of a river with wooded banks

View of a River from a Terrace

Berry Pomeroy Castle

Mill near the Grand Chartreuse

Glaucus and Scylla

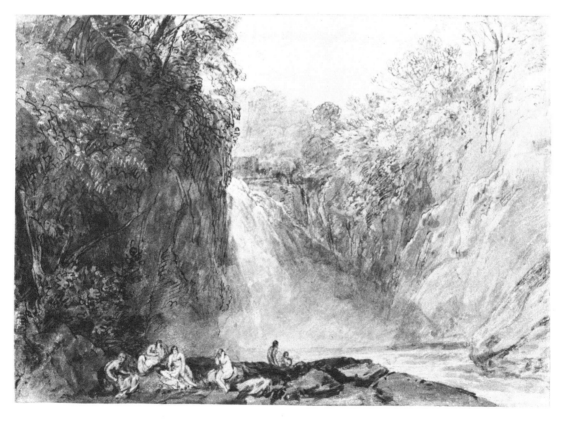

Fall of the Clyde

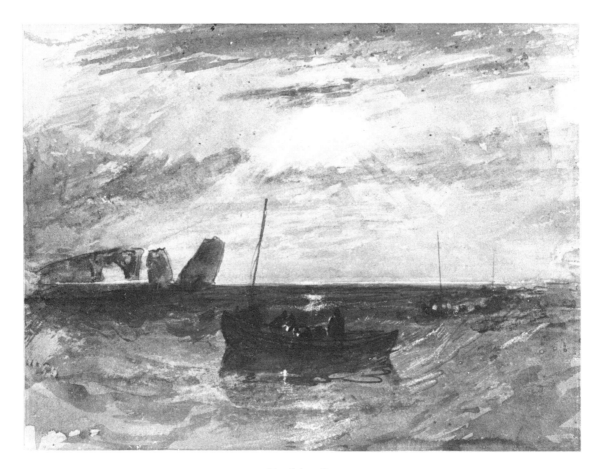

Moonlight at Sea

Silent pool

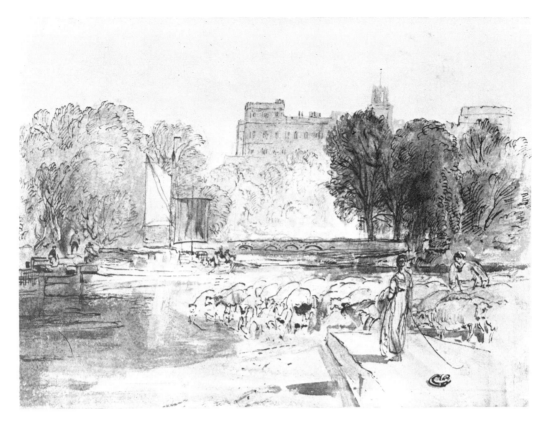

Windsor Castle from Salt hill, also called *Sheep-washing*, *Windsor*

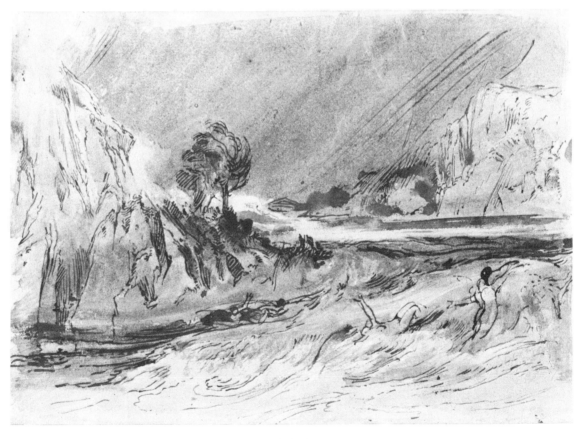

The Deluge

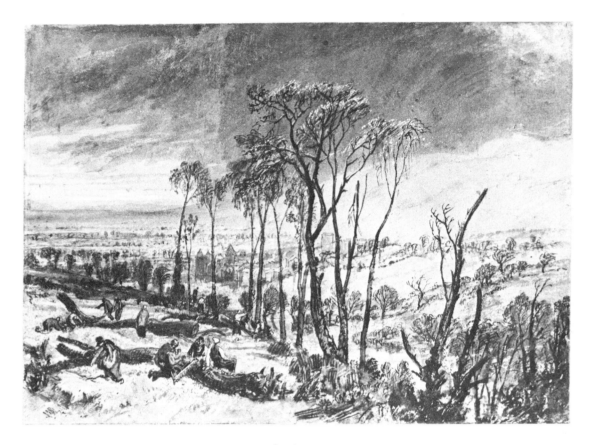

Crowhurst

CXV *47* Ploughing at Eton (Lincoln)

Miscellaneous drawings

Of 67 items classified as 'Miscellaneous
Black and White' (CXIX and CXX) in the
Turner Bequest I have selected only these
frivolous examples, from a collection
including both respectable studies and
pointless trivia. Certainly there is nothing
among the miscellaneous black and white
work that is not better represented in the
sketchbooks.

I don't know (and I don't think anyone
else does) what the *Bloomsbury Dispensary* was
meant to be. The Artists' General Benevolent
Society gave the Academicians the oppor-
tunity to grant moneys to dependants of
deceased artists, 'not necessarily exhibitors'.
Turner attended their meetings and contri-
buted. He was a great 'joiner' where the
Academy was concerned – he was a founder-
member in 1813 of the Royal Academy Club,
which still meets to dine four or six times a
year and traditionally celebrates the month
of May with, of all things, fried whitebait.
Considering his intention shown in his Will
to found a charity home for poor artists, it
would not be surprising to find Turner
involved in some plans for an organised
charity. But fashionable Bloomsbury was
hardly the place for it.

The jolly little girl, if not one of Turner's
daughters, was certainly drawn by him –
only he could have drawn arms without
hands, and got that left foot so badly out of
place. The script is trying to say 'My Dear' –
on the back (not shown) it succeeds.
The letter, limited as letters then were to a
single sheet for both cover and contents
(ecologists, please note), says on the other
side:

Cashiobury, June 10th 1808
Mr. Turner,
I have sent a Packing Case for the
Picture, the same as the other Picture came
in last year and I will send for it tomorrow
sennight to your House.
I am yours truly
Essex

While on this side we have a genuine
Turner doodle, reproduced by all the
wonderful accuracy of Ektachrome and
four-colour photolithography, 166 years
after it was doodled.

CXIX–K

CXX–O

CXIX–M

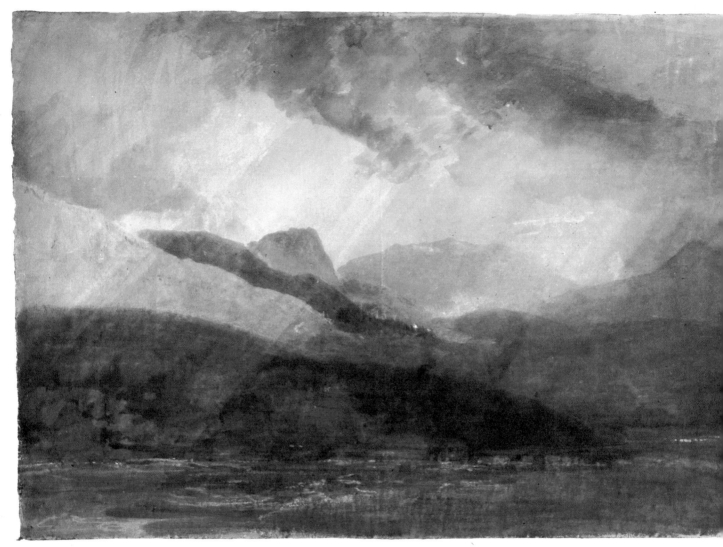

LXX–b 22 × 30 inches

The landscape above is one of 30 water-colours grouped as LXX, 'Miscellaneous', in the Turner Bequest and dated 1800–2. Several are identified as Welsh; most, like this one, on full Imperial sheets (22 by 30 inches), some even larger. In dimensions like these watercolour becomes a different medium, and this is no tinted drawing but a painting, by my standards, albeit unfinished and somewhat rubbed and faded. It is very firmly constructed and seems to me to belong more to the *Liber* period than to that of the Welsh tours.

The pen and wash drawings are sketches of about 1808. An oil painting, *The Garreteer's Petition*, was exhibited in 1809. A critic wrote that Turner had better stick to his first floor in Harley Street and 'never more wander in garrets to personify poets and their concomitant wretchedness'. The second sketch, which would probably have been called *The Painter's Apprentice*, never became a painting. Turner's verses are quoted.

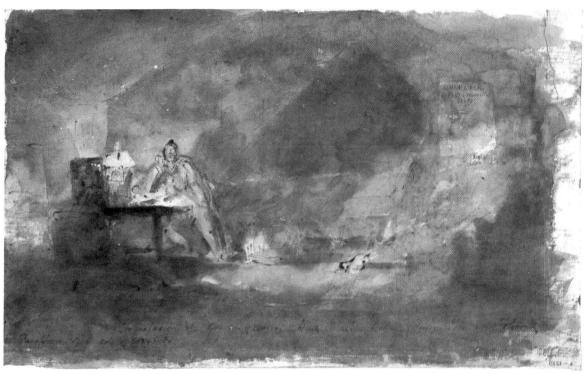

CXXI–A $7\frac{1}{4} \times 11\frac{3}{4}$ inches

And me, ye Powers! O bid my thoughts to roll
In quick succession, animate my soul;
Descend my Muse and every thought refine,
And finish well my long sought line.

Pleased with his work he views it o'er and o'er
And finds fresh beauties never seen before
While other thoughts the Tyro's soul control
Nor cares for taste beyond a buttered roll.

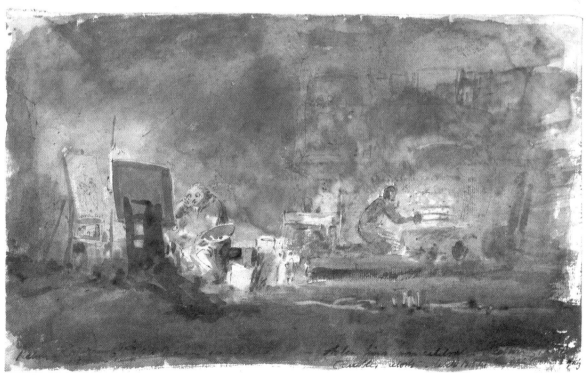

CXXI–B

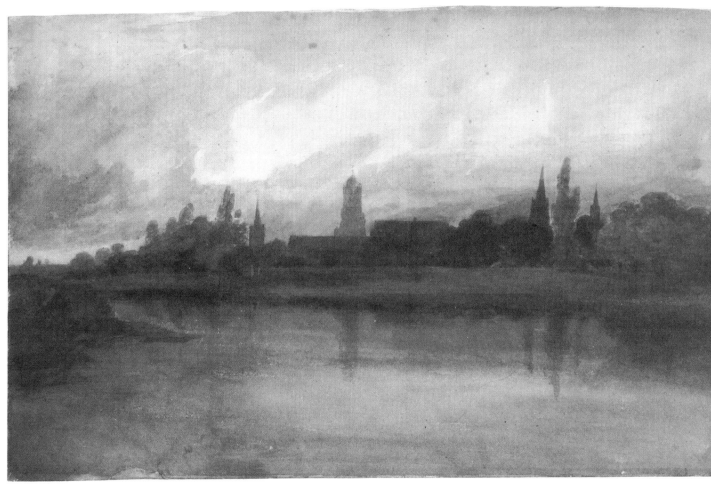

CXXI–G $16\frac{1}{8} \times 10\frac{1}{8}$ inches. On reverse: *Christ Church Coll. Oxford*

Fifteen unfinished watercolours, with the two genre sketches overleaf, and some oddments, make up section CXXI of Finberg's catalogue. The view of Oxford is one of the fifteen. Turner visited Oxford frequently – notably in 1809, to draw the High Street – for engravings to be published by Wyatt of Oxford. A letter of December 1809 to Wyatt says: *Will leave here some day this week*

for Oxford. I therefore wish you to get me a sheet of paper pasted down on a Board in readiness, about 2 feet by 19 inches. I think of coming by the Shrewsbury or Birmingham coach and therefore hope to be at Oxford by 12 of night – could wish you if possible to secure me a bed at the Inn.

In a pocket-book bound in black leather and measuring only $2\frac{5}{8}$ by $4\frac{1}{2}$ inches, a jewel of landscape art appears amongst pages of

accounts. Besides being very nice it is perhaps the first example of a coloured brush drawing from Turner's hand. His contemporaries would have called it a blot. There are some pencil drawings in this notebook, but they are very rubbed, and there is an ink scribble of two people copulating, but it is nothing worth reproducing.

The South-west

In July 1811 Turner set off to tour the south-western coast. He covered 600 miles in two months. His purpose was to illustrate *Picturesque Views of the Southern Coast*, to be engraved by W. B. Cooke. The commission was an attractive one: the Cooke brothers paid well, and the work was to be interpreted in the medium of line engraving on copper, produced in large numbers. The watercolours were to be exhibited in Cooke's gallery.

Turner did not need to make 200 sketches, as he did – only finished watercolours were required. But it was his habit to cover the ground thoroughly. He used an interleaved copy of a guide-book for rough notes, and for drafts of poetry which he hoped would be included in the proposed publication. While in Devonshire he visited some of his relatives on his father's side.

On his Southern Coast tour of 1811 Turner
consistently used sketchbooks of a squarer
shape than any since the Swiss tour. The
paper of one of them is watermarked
'Fellows 1808'.

Some views of Corfe Castle were coloured,
but have been exhibited and faded entirely
to yellowish brown. Turner used sketches in
this book of Corfe, Lulworth, Portland,
Lyme, Teignmouth, and Torbay for water-
colours which were engraved between 1814
and 1821. But the sketches of these subjects
are rather superficial.

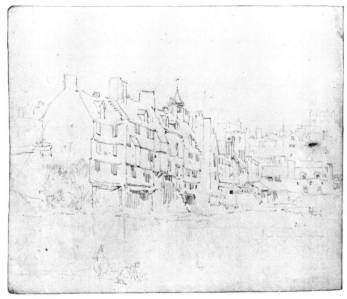

30a Exeter?

14 Swanage?

13

The *Ivybridge to Penzance* sketchbook
contains the first outlines of the prison hulks
in the Tamar, a subject he was to brood
upon to fine effect later – but it seems that
here he just noticed them in passing. In the
sketchbooks he sticks to his job of seeking
out Picturesque views, but on the blank
pages of Coltman's *Itinerary* he makes many
notes of groups of people – it's usually
difficult to say what they are actually doing.
In the verses too he shows that he was not
unaware of the lives and struggles of the
people.

Of the wife of a fisherman captured by the
French he mused:

> . . . o'erpowered
> *By hostile force in Verdun dungeon lowered*
> *Long murmured gainst his hard thought lot*
> *Rebelled against himself and even his wife forgot*
> *But she returned yet hoped, no tiding gained*
> *And fondly cherished chid yet hope remained*
> *Would sighing pass delusive many an hour.*

A girl seduced by the soldiers guarding the
coast:

> *Guileless and innocent as she passed along*
> *And cheered her footsteps with a morning song*
> *When craft and lechery and [?] combined*
> *Proved fit to triumph o'er a spotless mind.*
> *To guard the coast their duty – not delude*
> *By promises as little heeded as their good*
> . . .
> *Lo on yon bank beneath the hedge they lie*
> *And watch cat-like each female by*
> . . .
> *Wan melancholy sits the once full-blooming maid*
> *Misanthrope stalks the soul in silent shade*
> *On the bold promontory thrown at length she lies*
> *And sea-mews shrieking are her obsequies.*

He also wrote at length about antiquities,
such as Maiden Castle, on his route. Alas, it
is nearly all unintelligible. Apart from a few
quotations in Lindsay's *Sunset Ship* the only
long transcript in print is, badly edited, in
Thornbury.

38a
St Michael's Mount

8

11 Plymouth from Mount Edgecombe

Since Finberg's work two extra batches of
pencil drawings have been added to the
Turner Bequest collection. They cannot be
called sketchbooks since they are all separate
sheets. The two groups have the numerals
CXXVa and CXXVb. On these two pages is a
selection from CXXVa – good examples of
Turner's accurate and spontaneous line work.

45

49

63

76

67

Section cxxvb consists of a few sheets of
views of Stonehenge in rather faint pencil on
cream, crinkly paper. A drawing for a
projected *Liber Studiorum* engraving of
Stonehenge is in a private collection, and is
here reproduced from a photocopy.

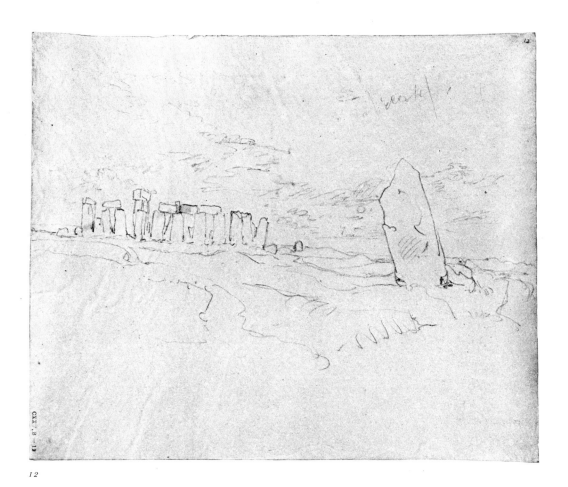

12

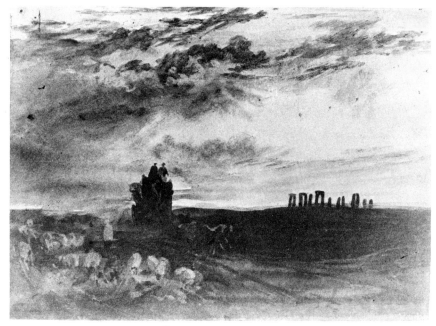

sketch for a *Liber Studiorum* plate

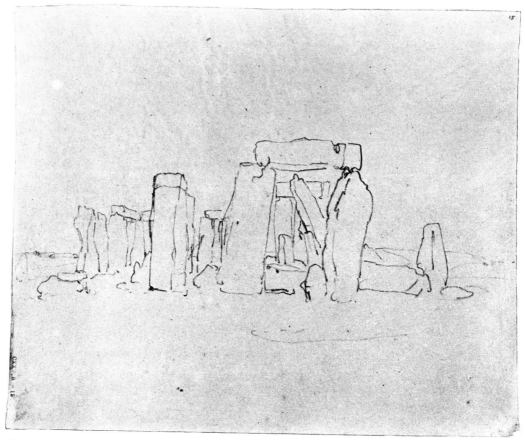

15

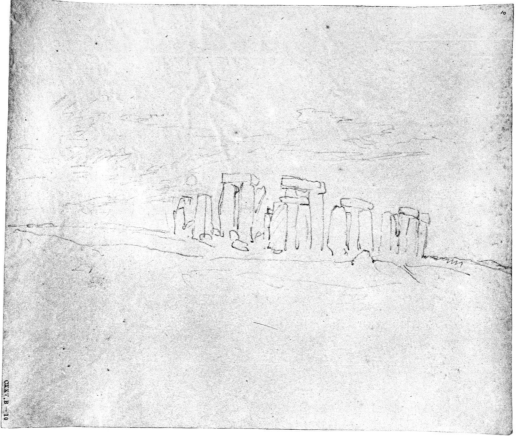

10

Two pages of a later sketchbook called
Vale of Heathfield (p. 160), dated 1815–16,
contain impressions of Eddystone Lighthouse,
reproduced here because it must have been
in 1811 or 1813 that Turner sailed out to see
the lighthouse. It is most likely to have been
in 1813, when, on his second visit to Devon,
he was apparently based on Plymouth.

The Eddystone is fourteen miles from
Plymouth, out at sea. Since 1700 two wooden
structures had been destroyed. The stone
building which Turner saw had been
standing since 1759. Designed by Smeaton,
it was popularly supposed to be based on the
shape of the trunk of an oak.

As a possible subject it must have appealed
to Turner, since it is a neat combination of
two favourite symbolic elements, and he
made several experiments in watercolour of
lashing waves and a dark sky. The second
drawing on this page is probably how he
actually saw it; though it is quite possible
that he stayed out at night in a fishing-boat.

A drawing by Turner of the Eddystone
lighthouse was engraved in mezzotint by
Lupton, 1824.

40

41

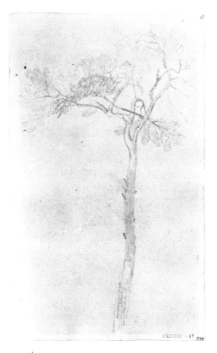

The 1813 visit to Devonshire resulted in no less than 500 small sketches, as well as some oil sketches on cardboard. These latter are much less exciting than the Thames oil sketches, and Turner himself described them as worthless. None of the sketchbook drawings, so far as I can gather, is directly connected with Cooke's *Southern Coast*, so it would appear that Turner was researching for his own purposes. All the drawings are small, most are scuffed and faint, and their purposes far from clear. Sometimes vast compositions of sea and distant ships are hinted at, in inches. Sometimes the ships compose miniatures, carefully shaded and smudged. All the elements of landscape appear, quite often in elegant compositions, sometimes rendered in subtle light and shade. There are dozens of bridges, many distant towns, several ruins, and seductive valleys among rounded Devonshire hills. There are sweet-looking houses among trees, frequently on the shores of estuaries, where people potter with boats and nets. The total impression is of a series of beautiful, sleepy

1 Hoarse on the rocky margin of the deep etc.

37 pine

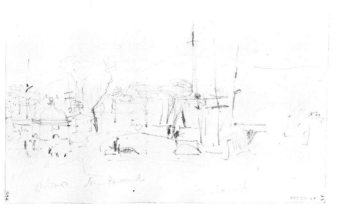

53 Dartmouth

77a Farnley Hall

5a Farnley

73a (*Wier*)

coastal settlements, with the inhabitants
going about their business quite as un-
troubled by thoughts of war as by tourist
traffic. It makes one a bit sentimental for
Turner's Devonshire coast.

'Pretty English things, good for division
and distribution' wrote Ruskin on one of the
packets, setting one's teeth on edge as usual.
Fortunately the 'things' are together still.
But they defy reproduction, and I have made
my selection only from the third of the 1813
books. At least twenty pages are concerned
with the hulks in the Tamar and Plymouth
Sound, some of which were prison-ships
housing captured French sailors. Again
Turner had found a potent combination of
themes: the dismasted, once elegant ships
were a wry variant on his best subject, while
the idea of hopeless incarceration always
moved him. Characteristically he arranged
for a magnificent inflorescence of cloud above
the gloom which absorbs the hulks into the
shape of the headland. The water, all dark
reflections and misty vapours, is beautifully
handled. This is a watercolour which
fortunately no one has thought fit to frame
and exhibit, and so it is not faded. Rough at
the edges it may be, but it is one of Turner's
great visual poems.

12 On the Tamar

14 On the Tamar

8 vessel with lifting gear

The 1813 visit to Devon is unusually well
documented. Turner was not on this
occasion a lonely explorer, but was among
friends who treated him as a guest, and with
deference. Cyrus Redding, then editing a
local paper, wrote his recollection of the
master in an unusual social setting. He even
describes a picnic provided by Turner, with
plenty of wine, for a party of eight or nine
ladies and gentlemen in what he calls 'that
English Eden'. Redding is quoted at length
in Finberg.

29 In Plymouth Sound

28a Plymouth Sound

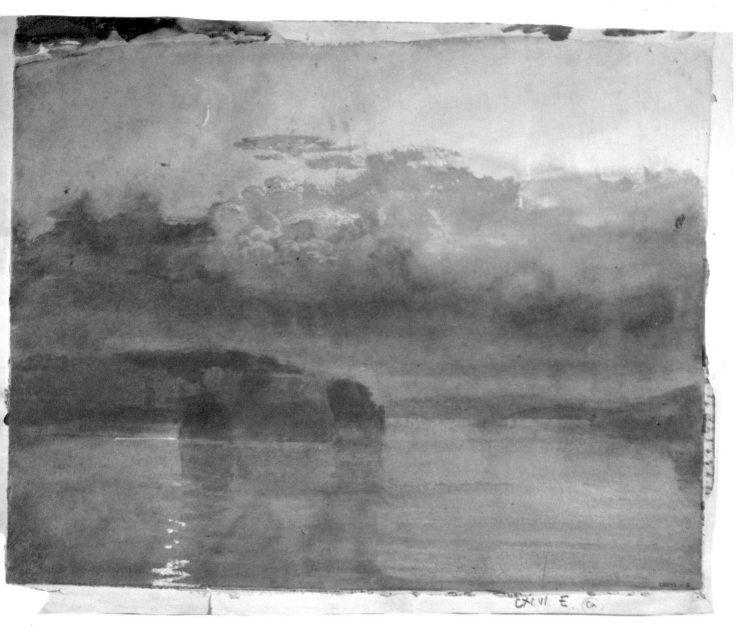

CXCVI–E Hulks on the Tamar. About 10 × 13 inches

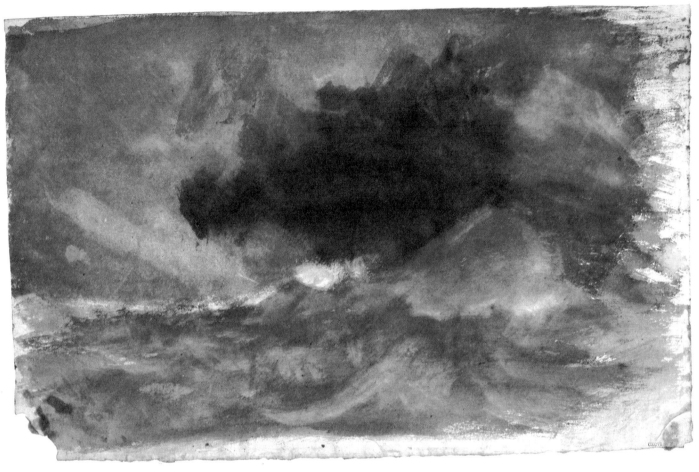

CXCVI–F The Mewstone. About $9\frac{1}{2} \times 15\frac{1}{4}$ inches

It was the habit of artists to produce coloured drawings for the engraver to interpret, even though the object was a black and white print. Part of the engraver's skill was to represent or somehow suggest colour by the texture and variety of the line work. From the artist's point of view the advantages were that the work could be exhibited, and it could be sold if it had not been bought outright by the publisher of the engraving. Thus it is no surprise to find Turner experimenting in broad colour masses for his composition of the Mewstone. He is at pains to control the contrast of the rock against the sky so that it is sufficiently remote, but he emphasises the angles of its bulk with every line of the composition. Most of this is apparent in the 'colour beginning'. The finished watercolour and the very lively and faithful engraving merely add the detail necessary to satisfy the public of the day.

W. B. Cooke was a little inclined to formalise and to cover the surface too closely with an even texture. He makes the maximum possible use of solid black that the process allows, but Turner was constantly applying chalk white to the proofs to get Cooke to 'bring out the lights'; sometimes he simply scribbles, 'too dark'.

Cooke very much admired Turner's art and he and his brother collaborated fruitfully with the artist for many years. The effects of working for the copperplate industry were two, in my opinion: his long exposure to black and white led to a reaction in favour of pure colour in his painting; the excesses of detail demanded both by the market and the technique of line engraving led to a reaction in favour of breadth in his other work. I think the production of water-colour for engraving and the careful overseeing of the work helped Turner to distinguish in his own mind the differing conceptual processes of illustration on the one hand and pure painting on the other. This distinction is not apparent in most of the *Liber Studiorum*, and indeed it only becomes evident in many of Turner's larger paintings in the 1830s – when he was still producing astonishingly detailed work for the engravers – look for instance at *Plymouth Hoe*, engraved in *Picturesque Views in England and Wales* (reproduced in Reynolds). The final truth is that working for the popular market of 'Picturesque views' Turner was able to satisfy his leaning towards naturalistic detail and folksy local colour while freeing himself for the monumental breadth of, say, a *Fingal's Cave* or a *Snowstorm at Sea*. The history paintings of course remained unavoidably illustrative, however grand in conception.

The whole complex process took a long time – all Turner's evolutionary processes did: but he evolved further and more independently than any other artist before or since.

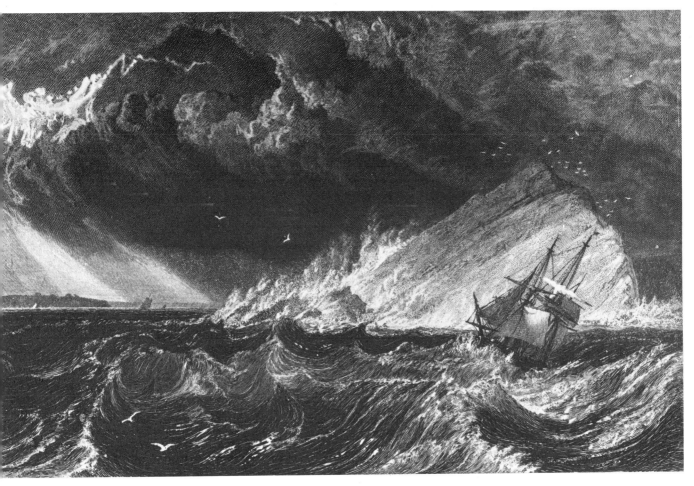

The Mew Stone, at the Entrance of Plymouth Sound. Engraved by W. B. Cooke for *Picturesque Views on the Southern Coast*, Part 6, 1816

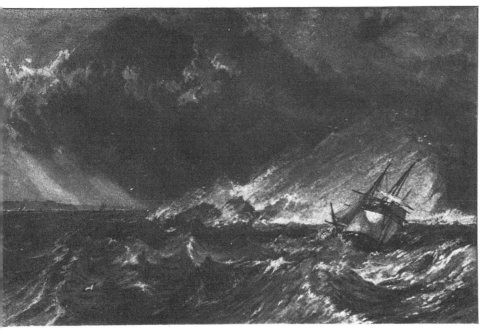

watercolour in the National Gallery, Dublin

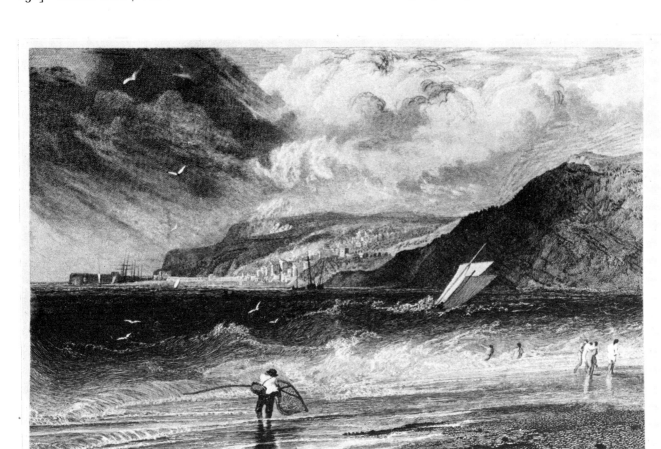

Lyme Bay. Proof touched by Turner and inscribed by Cooke

Turner was ill in the later part of 1812. He complained of nervous disorder with much weakness of the stomach. Everything 'disagreed with him – turned acid'. He particularly mentioned an aching pain at the back of the neck. His lectures early in 1813 were put off on account of indisposition.

The remedy for *Maltese Plague*, crossed out, has probably nothing to do with this. It is from a little notebook quaintly titled, by Finberg, *Chemistry and Apuleia*. Other chemistry takes the form of notes on dyes and pigments. *Apuleia* was a determined Claude-pastiche which Turner sent to the British Institution in a competition for the best imitation of a Claude or Poussin. Sir George Beaumont, Turner's arch-enemy, was one of the judges, and he was not won over on this occasion, more than on any other. The competition was won by one Hofland. Hazlitt, however, admired Turner's entry and wished he would always work in this style instead of his usual 'waste of morbid strength'.

designs for Solus (Sandycombe) Lodge

34 probably Scarborough

Yorkshire

Turner visited Farnley Hall, near Otley in
Yorkshire, almost annually from 1810 until
Fawkes died in 1827. By 1810 Walter Fawkes
had become Turner's most enthusiastic
patron: a lifelong friendship developed.
Farnley Hall and its moorland surroundings
became the scene of many watercolours
which Fawkes seems to have commissioned
on a *carte blanche* basis – or the two men
worked out the subjects as they went along:
scenery and landmarks, sporting pursuits,
and the house itself all feature in the
sketchbooks – including the family and their
servants in decorous and dignified situations.

The sketchbooks of the second decade
which are concerned with Yorkshire are
many and cannot all be accurately dated.
Turner made no attempt to keep his work
there separate – Yorkshire drawings are
mixed with Devonshire ones at first, and
Sussex subjects later, and classical 'roughs'
everywhere.

Fawkes bought a watercolour of Scar-
borough in 1811 and another drawing,
resembling the sketches here in general
outline, was engraved in *The Ports of England*
in 1826. This one is reproduced in Reynolds
who describes it as 'highly wrought' – also,
it is pure picture-postcard material. In the
businesslike pen work of the sketches here,
Turner is clearly attacking something much
more challenging.

'Sandycombe' and 'Yorkshire' were in fact
separate sketchbooks which were taken apart
and could not be distinguished one from the
other. There are various designs here for the
gentleman's villa Turner was building at
Twickenham, and a page of accounts from
which it appears that the total cost would be
about £1000.

33 Strewn fish boy with dogfish women sorting

*32 Sky darker Purples strong rolling clouds warm. Mdle Hill a warm lighter orange green
rocks warm ochre purple shadow on which the fishing relieved brilliant orpiment sails ex
cepting the ⋔ white beautifully reflecting in the sand w white figures streaming down*

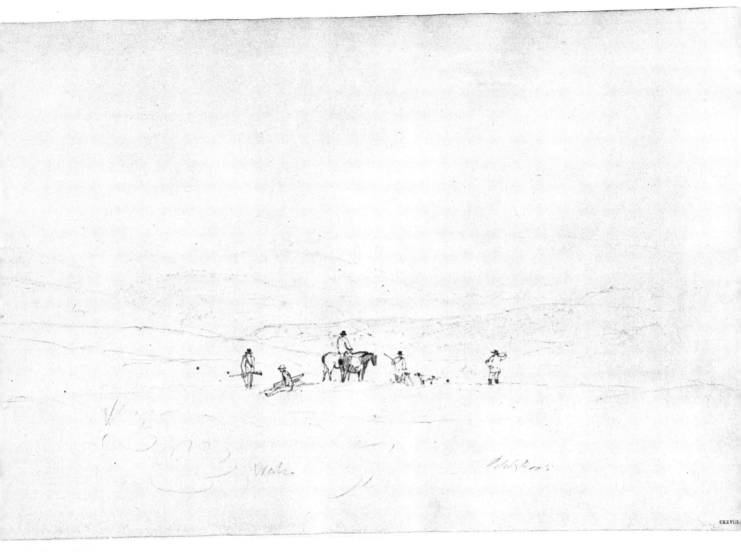

8 (Water–Black Dogs)

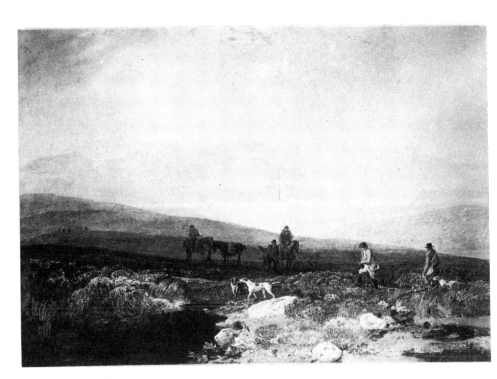

watercolour: *Grouse Shooting*.
Wallace Collection, London

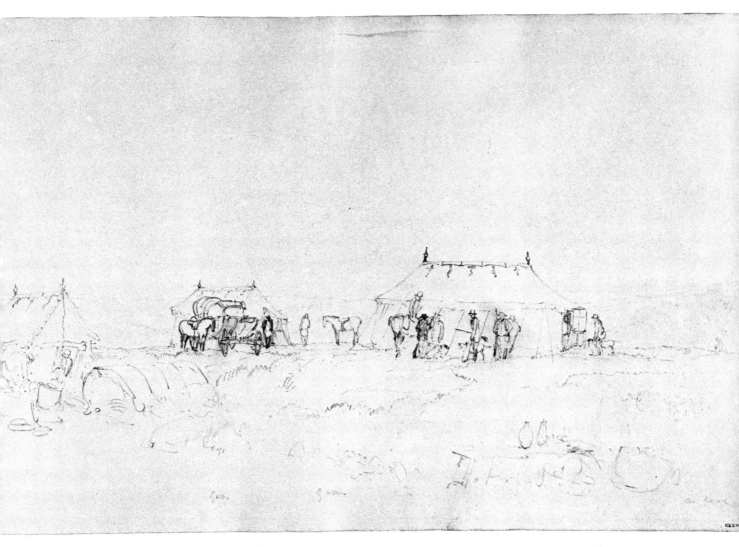

10 (Dogs – Guns – Game – Ale – Barrel)

Turner usually visited Farnley Hall late in
the year, not because he joined in the annual
bird slaughter – he disliked shooting – but
supposedly because the Fawkes did most of
their entertaining in this season. A sketch-
book which Finberg called *Woodcock Shooting*,
because one page contained a sketch for a
watercolour of that title, is mainly filled
with studies for classical pictures. The *Large
Farnley* sketchbook contains mostly blank
paper, some unfinished – and faded –
watercolour work and four rather careful
pencil records of sporting expeditions –
presumably the watercolours of these
subjects were part of Fawkes's brief. Four
equally careful Wharfedale landscapes are
more or less repeated in later books, and
more excitingly.

The study of woodcock-shooting takes the
form of a good pencil drawing of a wood
with conifers and some sportsmen with guns.
These drawings however were done with one
of Turner's hardest pencils and would be
hardly visible in reproduction. About
twenty pages of composition studies

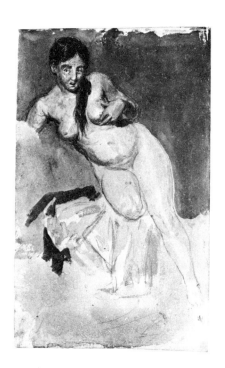

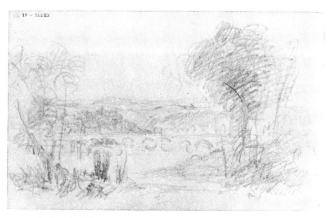

41 study for *Apuleia*

show Turner experimenting with the interchangeable units of a classical picture – an arid procedure, but it resulted in one of his most admired works, *Mercury and Herse*, exhibited 1811: the one which Taylor reviewed so favourably. Another little sketch, *Apuleia* (1814) (see also p. 138) shows an idea that was fairly firmly fixed. So, perhaps, passed a wet day at Farnley Hall – though it would have to be very wet to keep Turner indoors, according to accounts by the family.

A lugubrious watercolour nude with a red face appears on folio 116a – perhaps another wet-day diversion? The lighting and the pose do not suggest the life-room.

Turner's label for this book reads *Devonshire Rivers 3. Yorkshire. Wharfedale.* Ruskin took it apart and Finberg put it together again. The covers are in red leather and the leaves gilt-edged, as befits a distinguished Academician visiting a gentleman's seat. And it contains some of his most elegant drawings. The Devonshire subjects are in the minority of altogether 80 pages of drawing. Those reproduced here need no comment from me: clearly Turner is at the top of his form in the benign atmosphere of Farnley Hall.

13 Lindley Hall

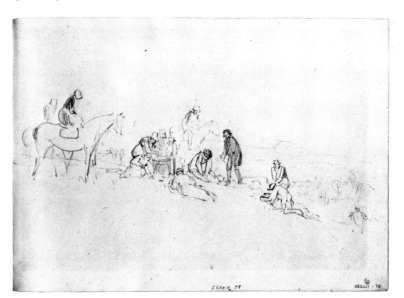

78

7

79, 80 Leeds, about 1812

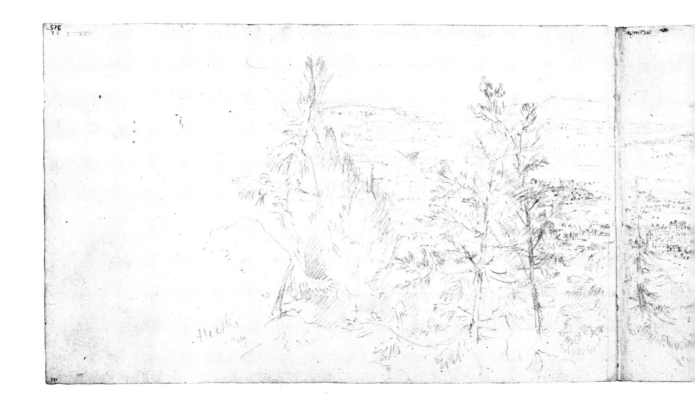

An early view of Leeds partakes of the consistent, relaxed inspiration of the series, and Turner spreads himself across three pages to include apparently every detail of the whole town – never in any sort of trouble about the placing of the minute houses and trees.

The masterpiece, *A Frosty Morning* was painted in the winter of 1812, while Napoleon retreated from Moscow. The picture was supposed to have been based on a scene Turner witnessed from the coach on the way from Yorkshire, but I think it is on the A40 to Oxford, near Postcombe. There are no sketches for this important picture; which is surprising even though, as we are told, the figures and horses were studied from domestic models.

Note: the reproductions from the *Devon Rivers and Wharfedale Book* are varied in size according to their detail and the space available. The panorama from the *Hastings* sketchbook, below, is placed here because of its shape. The subject matches, but not the date, which is 1815 or 1816.

CXXXIX *39a, 40a, 41* Wharfedale from Caley Park

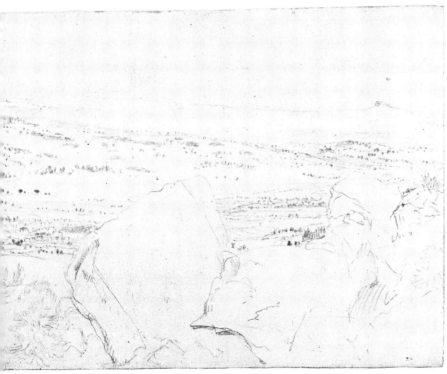

10

68

15

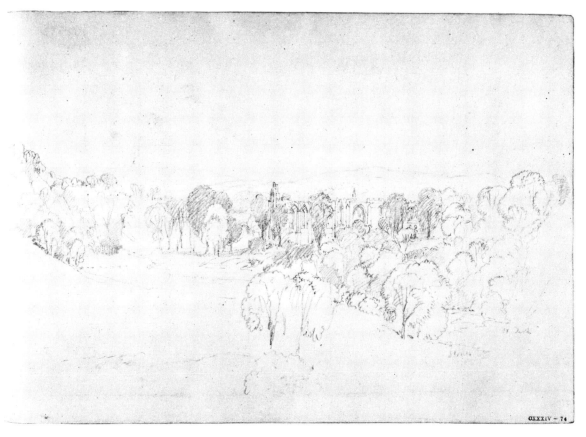

74 Bolton Abbey

3a Plumpton Rocks

46 *Jervaulx Abbey*

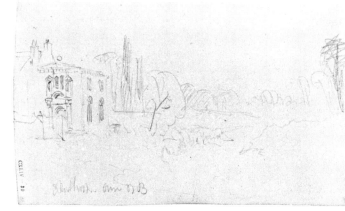

30 *Ellenthorpe Ouse BB* (Boroughbridge)

Six sketchbooks, a matter of 387 leaves actually drawn on, were marked by the artist *Yorkshire 1, 2, 3, 4, 5,* and *6* and all are dated about 1816. Fearing a gradual fade-out into half-tone fog I have left out many worthy drawings in faint, hard pencil and restricted the choice to those which will be visible on our page. The largest of the six sketchbooks is *Yorkshire 5*, measuring $6\frac{3}{4}$ by $10\frac{1}{4}$ inches, but it is the faintest. It includes views of the Lune and Lancaster (Turner did not recognise the existence of Lancashire).

Yorkshire 1 ranges in the countryside of York, Ripon, and Harrogate, supposedly in 1815. The Cowthorpe Oak (on the Nidd near Wetherby) was mentioned as a venerable tree by John Evelyn in 1662, a century and a half earlier. Since Turner can be counted upon to get every branch in the right place, visitors can check the tree's growth and decay.

Ellenthorpe Hall, BB may be Ellingthorpe or Alnthorpe, Borough Bridge, according to Finberg. *Plumpton Rocks* – Finberg's title – are presumably near Spofforth Castle, the subject of half a dozen adjacent sketches. Jervaulx Abbey is south of Middleham in the North Riding.

Carthage, and not Yorkshire, is the scene of six studies at the end of the book.

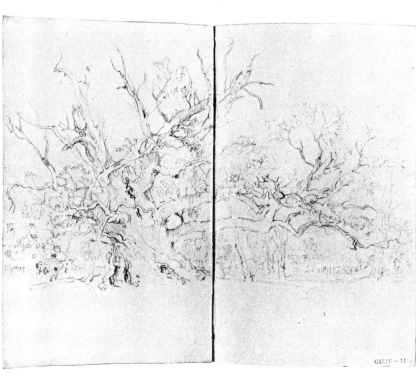

10a, 11 The Cowthorpe Oak

CXLIV continued: studies for historical subjects

CXLVI *32* Knaresborough. (Darkened by exposure in a frame)

CXLVII *11* *Aysgarth Force*

28 Wycliffe

The sketchbooks *Yorkshire 2, 3, 4,* and *5* all relate to the summer and autumn in 1816 when Turner took several weeks in a thorough exploration of Yorkshire and north Lancashire. He had a commission to make drawings for a projected Whitaker *History of Richmondshire.* The views, and even the viewpoints, were selected by a committee of local gentlemen: but Turner did not restrict his pencil sketches to the scheduled scenes.

Fawkes had married his second wife in 1816. The young Mrs Fawkes kept a diary in which she frequently mentioned 'Little Turner'. She had the gift of brevity: 'Tues. 23rd [July] Heavy rain. Drove with Walter. Obliged to take shelter in a farmhouse. Walter bought a print of the Prodigal Son. Wed. 24th. Left Browsholme. Got to Malham Village. Dreadful rain. Thurs. 25th. Went to see Gardale Waterfall. Returned home. Heavy rain. Turner went on sketching tour.'

He himself wrote about the weather in a letter – *bogged most completely Horse and its Rider, and nine hours making 11 miles* (in Upper Teesdale). After working his way to Lancaste (*Yorkshire 5*) he returned to Farnley in mid August and to London on 15 September.

The engravings which were completed form a remarkable series, very consistent even though there were a dozen different engravers. Their faithfulness to Turner is borne out by their rainy northern skies – even, as in the Eggleston Abbey opposite, by a certain whiteness of texture, as if there was still rain in the air. In other subjects we are aware of the sharpness and clarity of a 'bright spell' after a stormy day.

The engravings are finely textured and quite different from the Cookes' in this respect, as in the compositions. Turner is no content here to seize upon broadly picturesque elements, but works hard to place his subjects in their true environment of great banks of damp foliage, heavy skies, and subtle, smoky distances. Compared with the, usually, clean outlines of the Southern Coast series this presents a challenge to the engravers, who do not always succeed in producing well-organised pictures. Somewhat obtrusive foreground figures do not help. This is not so in the engraving reproduced opposite, however, where a number of amusing incidents keeps the eye moving round the picture: ruins may be beautiful, but life goes on!

Aysgarth Force, and Wycliffe, at left, were subjects in the Richmondshire series – to be reinterpreted, of course, in watercolour, before the engraver got to work.

These Yorkshire sketchbooks and the (relatively few) engravings are worthy of closer investigation. The sketchbooks are variable as we might expect in the condition but they contain much delicate pencilwork combined with a mature certainty of draughtsmanship.

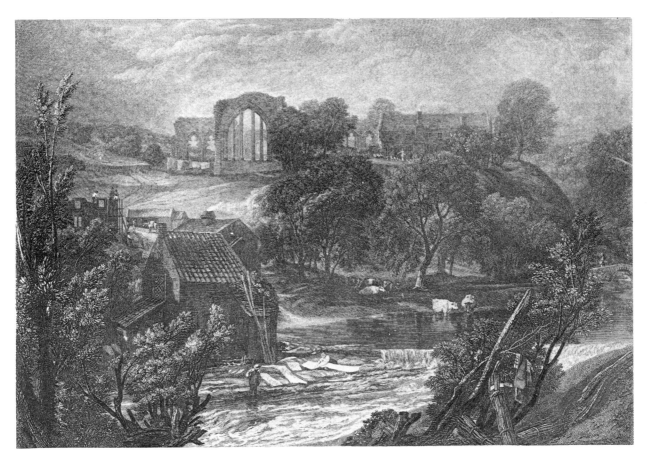

Eggleston Abbey, near Barnard Castle, engraved by T. Higham. Published in 1822 in the *History of Richmondshire*

4

8

A smaller notebook, *Yorkshire 6* relates to a different summer, perhaps of 1818. At last he has a softer pencil – perhaps the ending of the Napoleonic Wars had meant that supplies were available from Paris. There is from now on a welcome increase in the contrast between the grey of the pencil line and the cream of the paper, which eases our task of reproduction.

In these three beautiful pages the pencil of course is being used to represent colour and light and shade, and not, as in the previous Yorkshire books, to provide the maximum of factual information.

18

8 Otley

Blacker pencilwork, and a more emphatic style, are characteristic of perhaps the most attractive of the *Yorkshire* sketchbooks, labelled simply *Farnley*. It contains only twenty pages of drawings, plus a few lists and memoranda. No doubt Turner's purpose in recording the library and lodge-gates of Farnley Hall was purely practical; but the interior, particularly, provides a fascinating document (opposite).

Some rough designs in this book for a shipwreck theme may be quite closely connected with Farnley. Turner's coloured design for *Wreck of an East Indiaman* – a drawing, not the painting *Wreck of a Transport Ship* – was inscribed by the artist *Beginning for Dear Fawkes of Farnley* (see page 18). It is quite likely that Fawkes suggested the subject.

3 1, 4, 5
young trees by a lake

89a

14 lodge Gate at Farnley

15a, 16, 17
Library at Farnley Hall

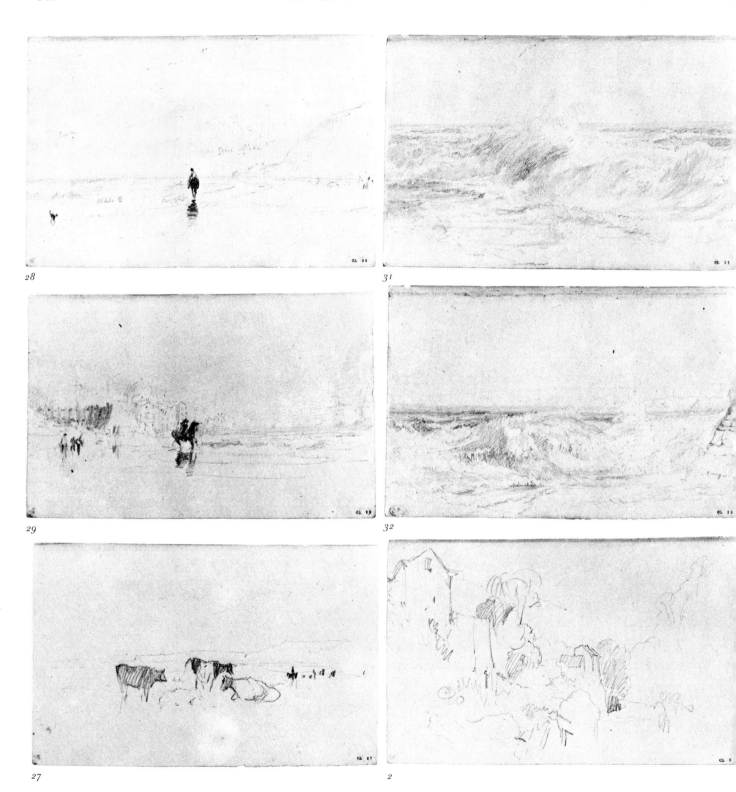

28

31

29

32

27

2

Three thin sketchbooks, which cannot be dated more accurately than 1816–18, contain seaside drawings as well as inland, softly modelled riverside subjects. Comment is superfluous, except to rest the eye of the reader jaded with half-tone reproduction. I will only point out that the studies of isolated figures and their reflections in large expanses of wet sand show Turner in his most original mood, recording with economy not reduced to cliché something which had been revealed to no one before him, though to many after. The waves show him patient and analytical; and, I think, younger. The beautiful landscapes of buildings, trees, and bridges have a gently Post-Impressionist air, or so I think.

Inside the cover of CLI, with various important signatures and some seaweed, is a crudely geometrical headland – a note perhaps of Turner's intention, verified in folio 17a – or perhaps, being so crude, it was by someone else.

The stain on CLI 16 was caused when Turner's river, forgetting itself, flooded the basement of the Tate Gallery in 1924.

The name 'Aqueduct', comes from a *Liber* plate, unpublished, called *The Stork and Aqueduct*.

That is the end of the *Yorkshire* sketchbook.

18 Hawkesworth Moor

16 aqueduct

side cover: '5 taken out. J.R.'

17a

CLII 5 *Millrace*

6a

7a Bodiam Castle

11 drawing for *Battle Abbey*

Views in Sussex

This was the title of a series of engravings by
W. B. Cooke: The Vale of Heathfield was
one of the subjects. Bodiam Castle, here seen
in quietly understated line, was, with other
castles, a subject for the series, as were Battle
Abbey and the site of the Battle of Hastings –
including the spot where Harold was sup-
posed to have fallen, and Turner included
an 'are' (see p. 24). There is a *Hastings*
sketchbook of 1815–16, smaller than these
two, of which I have included only some
Yorkshire pages (see p. 145).

Most of the drawings in the Sussex
sketchbooks are plainly practical, though
beautifully detailed in the manner familiar
from the Yorkshire books of the same period.
The *Vale of Heathfield*, though, is particularly
lively, with the *Eddystone* watercolours
reproduced on page 132, and some virtuoso
passages like the group of trees (opposite,
above) for which the Castle ruins were no
more than an excuse. This is a drawing
which has never ceased to fascinate me.

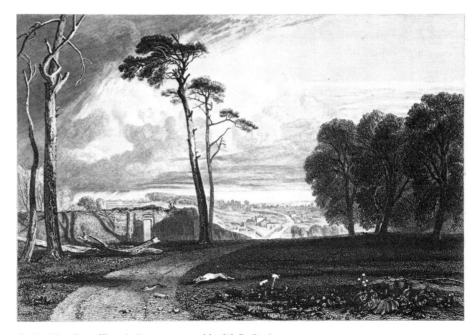

Battle Abbey, from *Views in Sussex*, engraved by W. B. Cooke

79 *Capelle*

The Rhine tour

In August of this year Turner dragged
himself away from his illustration work and
went to what is now Belgium to see the field
of Waterloo. From Brussels he took the
stage-coach to Cologne and from here he
explored the Rhine up to Mainz. He
returned via Aix to Antwerp, Dordrecht,
and Rotterdam.

In a small pocket-book he made copious
but fragmentary notes on the towns he
visited and drew, in a bold, unaffected way,
and, I think, with considerable charm,
all the everyday things that interested him

50 Dordrecht

8 Dutch casks etc.

n the journey. He accounted for his
xpenses in francs, listing every place where
e spent any money, and he even left us, on
ne page, a dated itinerary. This fades out
ound Dordrecht on 11 September – he
ems to have returned to England from
otterdam on the 15th.

At the end of the book is a list of some
st belongings, including ¼ *Doz of Pencils*,
Cravats. He also lost a *Book with Leaves* and
Box of Colors.

Quite untypical of the rest of the pages is
e composition sketch of Dutch boats
ecalmed (folio 50), which may be the
rimal state of his great *Dort* painting.

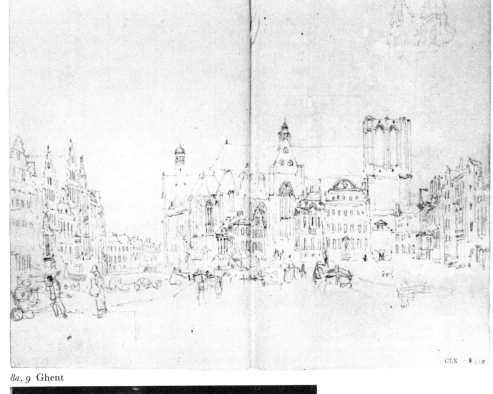

8a, 9 Ghent

urner must have had the idea of a painting
the battlefield in his mind for the two
ars since it happened. His interest in the
bject was not the victory of Wellington or
e defeat of Napoleon but the tragic
echanism by which so many lives had
en lost. The painting, exhibited in 1819,
cked the patriotic excitement associated
ith the name of Waterloo, and, says
inberg, was not admired. It is lugubrious.

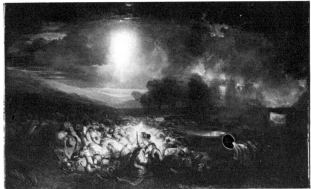

The Battle of Waterloo. Tate Gallery

16a Waterloo

His drawings of the place and of the
obscure farm, La Haye-Sainte, which had
been the pivot of the battle, express by their
flatness and emptiness a sense of mourning –
though I am sure they were quite practical
in intention.

21 La Haye-Sainte

*21a Causeway down which Bonaparte advanced : Picton killed here : Orchard :
4000 killed here : 1000 killed here*

Away from the sorrows of the battlefield the pages are packed tightly with Gothic architecture, castles, and scenes on the Rhine – these often three, four, or six distinct sketches on a spread.

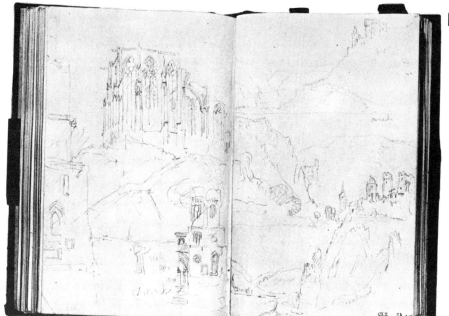

64a Bacharach, 65 Welmich

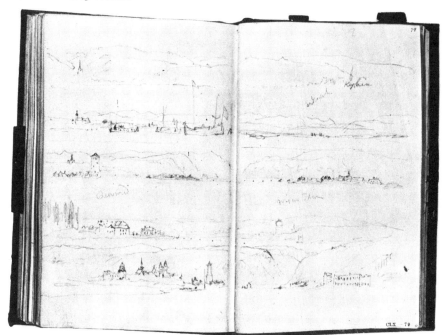

78a, 79 on the Rhine: *Weissenthurm* etc.

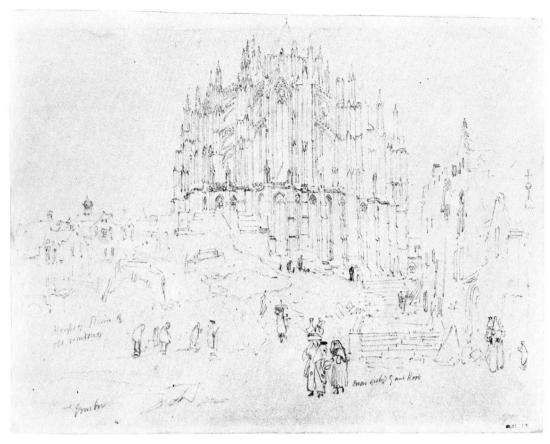

CLXI Cologne

CLXII 4 Antwerp

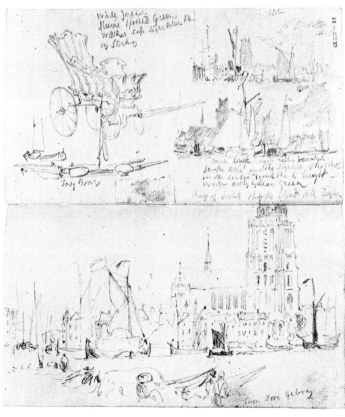

85a, 86 Dort

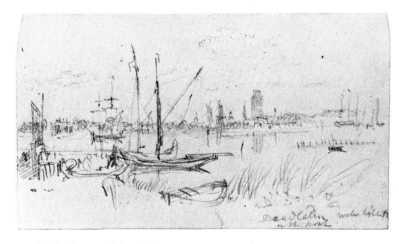

77a Dead calm, water lighter in the port

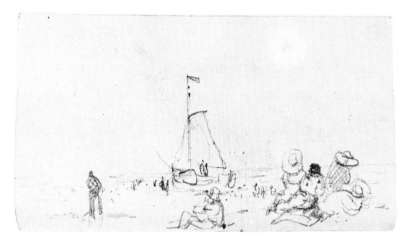

34a

A larger book was used for some very detailed buildings and for formally composed sketches, presumably intended as the framework of watercolours. The two books contain most of his work in pencil on the Rhine and round Cologne and Bonn. Fifty watercolours resulted from his studies, all bought by Fawkes – probably they had been commissioned by him, for Turner was assiduous, even for him, in his collecting of views. Some at least of the colour work, I feel sure, must have been done on the spot.

The final sketchbook, in Holland, has riches of all sorts. As if Turner is now off duty, the mood is relaxed: but not his ever-active right hand.

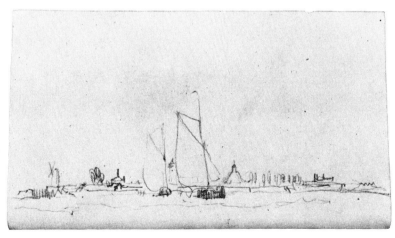

10a

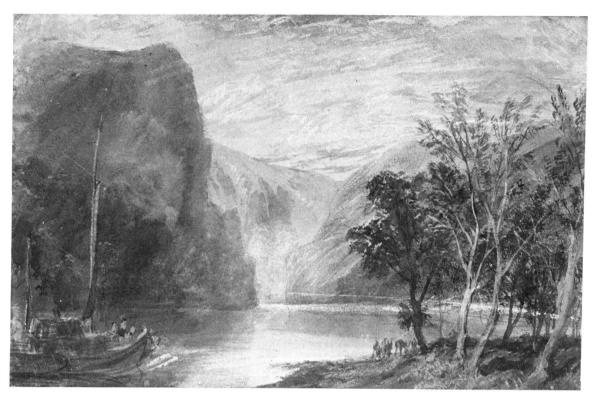

The Loreleiberg on the Rhine: watercolour in the Leeds City Art Gallery. $7\frac{1}{2} \times 11\frac{3}{4}$ inches

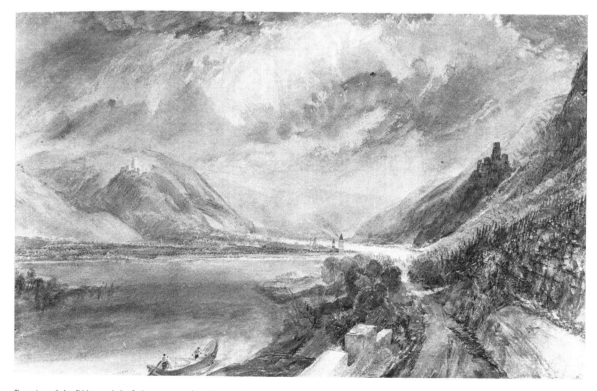

Junction of the Rhine and the Lahn: watercolour in a private collection. $7\frac{3}{4} \times 12\frac{3}{8}$ inches

15a beeches: *To Raby SW*

Rhine watercolours, and castles in Durham

Immediately on his return to England Turner had some important 'houses' to do in Durham. In particular he had been commissioned by Lord Darlington to paint Raby Castle.

A story in Thornbury that he landed at Hull and rushed straight to Farnley, pushing a roll of 50 watercolours into Fawkes's hand, is scornfully discounted by Finberg, who insists that the artist did not reach Farnley until the middle of November, and that the drawings are much too finished to have been done on the tour. But Thornbury's 'fiction' may be half-true; I suggest that Turner arrived with a roll of brilliant 'colour beginnings' – which he did not hesitate to show to his most sympathetic patron – and then proceeded to fill in the details, taking about a month on the job and referring to his pencil notes.

Drawings like the very atmospheric *St Goar* reproduced in Butlin's *Turner Watercolours*, or the *Loreleiberg* reproduced here, bear every sign of having been produced in this way: broad, fluid colour masses laid down in the full blaze of actuality; some scraping; then, later, the rather fidgety, fresh brush drawing added over the top, worked in here and there, and used to pull the picture together. Butlin quotes Ruskin that 'Every one of these sketches is the almost instantaneous record of an *effect* of colour or atmosphere, taken strictly from nature.' Finberg, who also saw the whole collection together, says that with few exceptions the watercolours were painted into a 'semi-opaque' grey wash over white paper. This very strongly suggests one of Turner's larger sketchbooks, such as he had taken to Switzerland (the *St Gothard* book) and such as he later took to Italy. There is no reason to suppose he altered his habit when he visited the Rhine. Such large books contain work left in various degrees of completion, including, in at least one Italian book, 'colour beginnings' (see p. 189). My guess is that Turner took a large sketchbook, about ten by fifteen inches, to the Rhineland, used it for 'colour beginnings', and then took it apart to finish the drawings for Fawkes. He listed a box of colours among those lost possessions (p. 159) and I think he used them on the tour.

The Rhine series, now scattered about the world, must have formed a remarkable and significant group of drawings, for here Turner was working not in his detailed style for the engravers, but rapidly and with concentration on poetic effect – for an appreciative audience. Detail, Ruskin wrote, was subordinate, and colour 'became the leading object'.

The *Dort* or *Dordrecht* painting (well reproduced in Gage) with its brilliant yellow sky and water, was the first of the oil paintings to break through into this new world of colour. It was exhibited in 1818, at the Academy. People were dazzled; but they had ceased to dare to criticise. Fawkes bought the painting.

Meanwhile Turner laboured on with his pencil, not apparently less vigorous after his exertions on the Rhine, and certainly prepared to take pains with the next assignment. Gibside, a great house on the Derwent in Durham, Hilton Castle and Raby Castle (between Barnard Castle and Bishop Auckland) were the subjects, the first two of engravings in Surtee's *Durham* (1819) and the last of a splendid oil painting.

20, 20a

30a, 31 Streatlam Castle, Staindrop (near Raby)

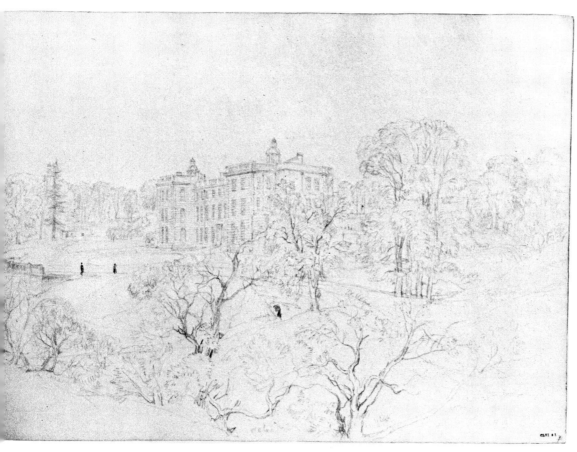

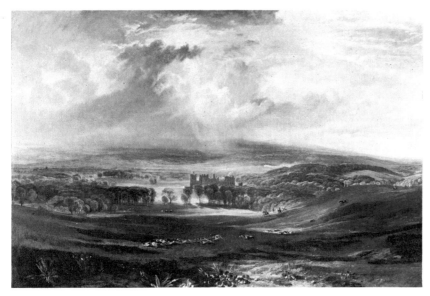

Raby Castle. Walters Gallery, Baltimore

In spite of all the detailed architectural drawing in the *Raby* sketchbook – there are sixteen large pages, some of which have been pasted down and hide other drawings – the picture is an expansive landscape of hills and trees in mist and cloud-patterned light. Hunters and hounds race across the park in the foreground. The castle, though centrally placed in a column of sunlight, occupies a very small area of the canvas. One is bound to respect the thoroughness with which Turner, in his sketchbook, investigates the castle and its surroundings, including the sympathetically drawn beech trees (p. 165). He also drew the huntsmen and dogs *in situ*.

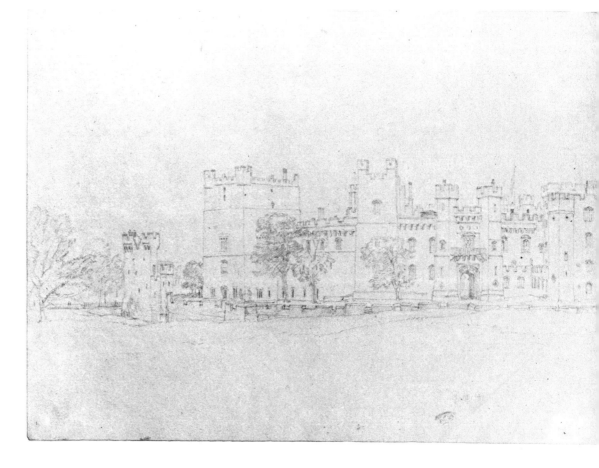

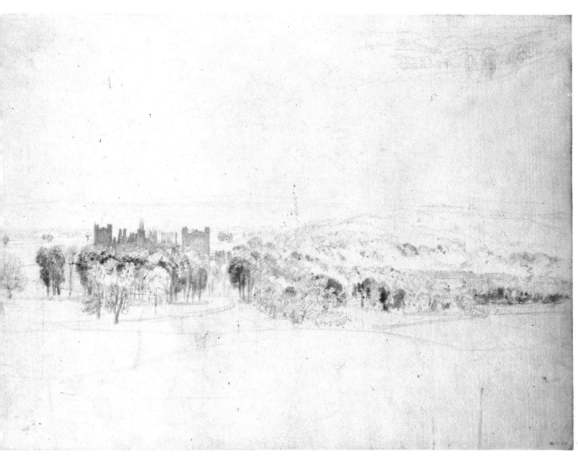

23a, 24

18a, 19 Raby Castle

CLVII *20*

15

17

The smaller *Durham* book accompanied
Turner on an expedition to Newcastle and
also contains studies of Durham Cathedral
seen across the river, hence Turner's label.
He made a 'colour beginning' of this subject
incorporating a rainbow (CCLXIII, 125)
which we shall hope to reproduce in a
later volume. On an early journey to the
North-east he had seen the Cathedral with a
rainbow (*Helmsley* sketchbook, LIII). The
most interesting drawings in this Durham
book are on folios 15, 17, of a ruined castle
seen through trees – it was now late in the
season: they would be almost leafless. The
subject provides a theme of interpenetrating
planes which Turner handles with summary
skill. But the house, right, in its simplicity, is
one of his most appealing drawings – on a
single, parallel plane.

92

3 Newcastle-on-Tyne

Two small sketchbooks remind us of Turner's
other, persisting preoccupations. *Walmer
Ferry* – if that is what he wrote, indistinctly,
on one of the drawings, was on the Thames,
not at Walmer in Kent. The little book, with
pages entirely washed in grey, is concerned
only with Turner's river and its vegetation.

The *Liber Notes* sketchbook has only
eighteen pages drawn on, out of 160: it is
named after a not very important list of
Liber subjects inside one cover. Finberg dates
the book 1815–16 but I think the style of the
drawings is of 1818. The four pages
reproduced here are not perhaps of much
import, but I would have found it difficult
to leave them out. They have a quality
hard to define: perhaps of *light*. They
introduce the final phase of Turner's
dialogue with his River.

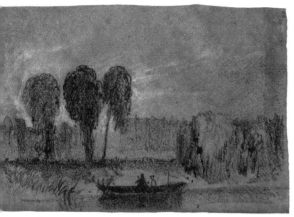

CXLII 97 Zion House?

6

Yellow Lotus June

4

3 Barking?

5

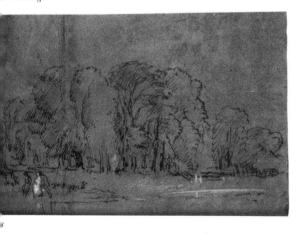

6a

The Thames and Richmond Hill

If Turner really walked the coast from
Hastings to Margate the three prints here
are a poor monument to such a journey. I
include them merely to bear out the title of
the sketchbook. The Inventory states that
they may be dated 1821, along with sketches
of that year in connection with further issues
of Cooke's *Southern Coast* series. Turner's
label says, in fact, *Richmond Hill. Hastings to
Margate.*

 It is a busy, disorganised collection, as
the reproductions here will show. From

Walton Bridges

Windsor Castle and *Ankerwyke Priory*

he mixture of material, however, emerges
he clear theme of the view from Richmond
Hill which was gradually taking shape in the
rtist's mind as a major work. Its importance
s not only proved by his choice of the largest
anvas he ever painted, but also fore-
hadowed by the number of versions and
ketches which led up to it.

CXL

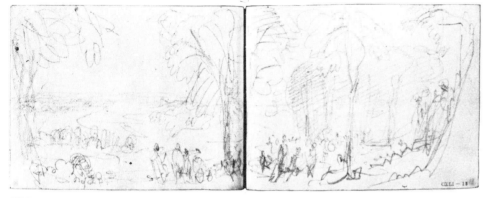

CXLI *12a, 13*

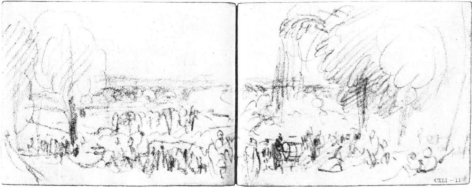

10a, 11

26a, 27

The title of the next sketchbook is accurate enough in Turner's language. Some of his 'hints' came from Watteau, as we see. At the stage of the drawings in this book I think some hints pointed in a different direction from Richmond Hill – towards a bridge with a rainbow. This different theme is indicated to some extent in the sketches overleaf (p. 176). In the event a composition with figures was decided upon, the figures grouped among trees, which, in the sketches at left, frame the river view.

The distant Thames valley landscape, though complex and demanding great skill, was the least of Turner's problems: he was completely the master of such large perspectives. Even so, he did a careful, finished watercolour version before he started on the canvas. This watercolour, for all its finish, bears every sign of being done from nature: it is, quite simply, naturalistic. The composition was much more problematic. The colour sketch gives a very different impression, almost of pagan ritual, from that embodied in the final oil painting opposite where some sort of festival is in progress: supposedly an elegant gathering in celebration of the Prince's birthday. But the trees in the foreground are unfortunately so much Claude-style wallpaper. Turner's originality failed him in this case. All the same, the conception is grand.

The watercolour version of the subject in the Lady Lever Gallery, Port Sunlight (detail below) uses no frame of trees, and the figures are prettified groups: some boys with a kite and some ladies holding their parasols rather obviously to catch the light. Amusingly, the central foreground is occupied not by a figure but by the artist's equipment: and a heavy load it looks. (Note the white palette.) The young lady to the right is, I think, sketching the view, but surely would have a less cumbersome outfit than this. Whatever her artistic status, she is the possessor of the first of those long necks, seen from the back, which occur with unfortunate frequency in Turner's figure painting of the 1820s. No doubt, the long nape was part of Regency fashion but Turner makes it into a phallic symbol.

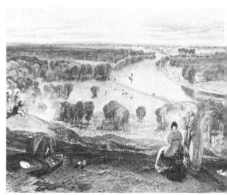

watercolour, detail

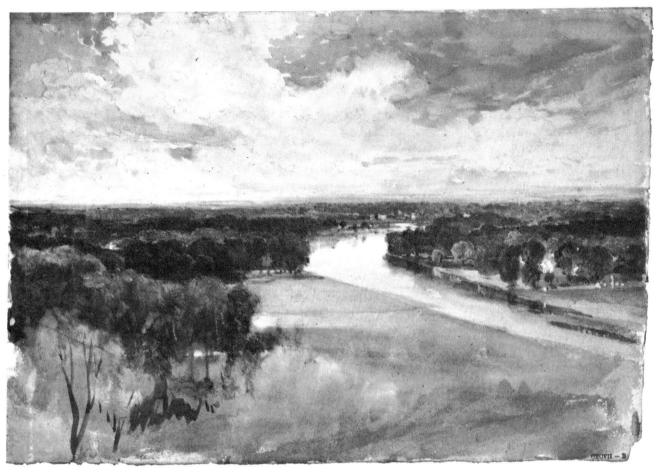

CXCVII–B $7\frac{1}{2} \times 10\frac{1}{2}$ inches

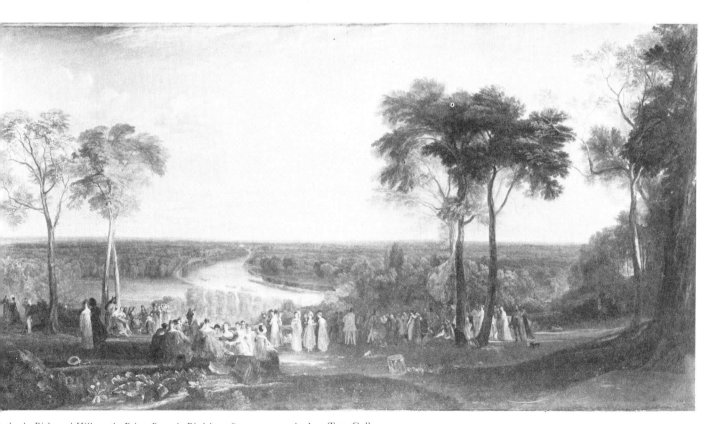

gland: Richmond Hill, on the Prince Regent's Birthday. 1819. 70 × 132 inches. Tate Gallery

21a, 22

18a, 19

17a, 18

Bridges and Skies

The arches of a bridge, the arch of a rainbow, and some richly patterned clouds and trees are the elements of what might have been a different great 'River'. Rainbows, familiar enough to Turner, who was so often out in the weather, appear like chromatic blessings among the warring elements of Turner's skies. With his theories of 'primitive' colour I believe he saw them in that way.

The sky, always a preoccupation as so many urgent scribbles show, assumes greater importance in Turner's work from about 1817 onwards. He frequently includes the sun itself – daring in his time, and a habit shared only with van Gogh.

16a Richmond

CXCVII–G $10\frac{1}{8} \times 16\frac{1}{4}$ ins

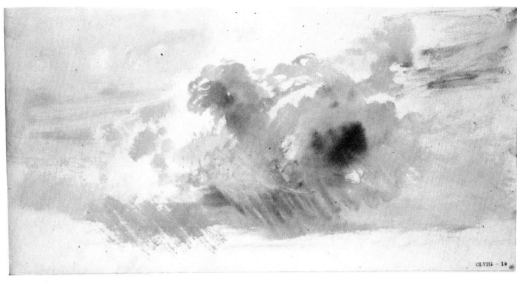

CLVIII *19*

, 20

A sketchbook dated 1816–18 contains no less than 65 watercolour studies of clouds. The illustration here is of a page selected at random. There are less complete studies and many much more intense. I hope to show a fair selection in a future volume concerned with Turner's sketches in colour. The present volume is already overweighted before Turner has even visited Italy.

A small book of 1819, fractionally larger than *Hints River*, gives us, for the time being, a last look at the Thames – always capable of revealing a fresh, enticing curve. And Turner has the last word: *Beautiful*.

15 The Thames above Richmond

CLXIX *25a, 26*

Edinburgh from Calton Hill

CLXVII 39a, 4

Edinburgh from the village of Dean

CLXVII 84a, 8

CLXVI 62

Scott's Antiquities

The *Provincial Antiquities of Scotland* was a work planned to contain fifteen engravings after Turner and text by Walter Scott. Edinburgh Castle always inspired Turner and these two panoramas are both remarkable in different ways, a common factor being the skill with which the large compositions are organised, using little more than a line of varying weight. Turner was in a hurry, typically, and he made some enemies in Edinburgh: '. . . finding him such a *stick*, we did not think the pleasure of showing him to our friends would be worth the trouble and expense' – so wrote an artistic Edinburgh lady. Also he failed to turn up to a dinner laid on by a portrait painter, Nicholson (Finberg, p. 254).

CLXVI 7a

19

he year started with Turner's Perspective
ectures in January and in February an
greement between him and Cooke to
roduce 36 engravings for a series of views
a the Rhine. Plans for the publication
ere given up when a similar work was
nnounced, by Ackermann (*Tour of the Rhine*,
ngravings after Schutz). It was possibly the
ollapse of Cooke's scheme which freed
urner temporarily from engraving work
nd enabled him to go to Italy.
Before he left he was very much in the
ublic eye: his work was prominent in
xhibitions of Sir John Leicester's collection
ight oils) and Walter Fawkes's showing of
ore than 60 of Turner's watercolours got a
ery good press. Fawkes printed a booklet

to commemorate the occasion, dedicated to
the artist. The patron's words are touching:
'I can never look at it without intensely
feeling the delight I have experienced during
the greater part of my life from the exertion
of your talent, and the pleasure of your
society.' I think Fawkes himself deserved
great credit: as a patron he approached the
level of creativity. He had seen Turner
through his most difficult period, eagerly
collecting his work, but more than that,
encouraging the freest expression of his
talents.

Turner was now 44. In the Academy he
had the large *England: Richmond Hill* – his
'River' painting – and the *Entrance of the
Meuse: Orange-Merchant on the Bar*, *going to
pieces*. Both are now in the Tate Gallery.

He set off for Italy early in August. Before
he left he was armed with a manuscript

guide provided, Finberg believed, by
Hakewill: it is written into one of Turner's
small sketchbooks (CLXXI). Hakewill, on an
earlier tour, had provided sketches for some
of Turner's illustrations of Italy, done
before he ever went there. 'Don't go to Brig
but to Guise at the foot of the Simplon – go
leisurely over the Mountain. The descent on
the Italian side the finest.' Of Lake Maggiore:
'Take two boatmen and pay them 3 francs
ea. p. day. The men will point out what is
worth seeing – The Orrido, Fiume Latte,
&c.' In return for such valuable instructions
Turner was to buy some cameos and
trinkets specified by Hakewill.

A further preliminary notebook labelled by
Turner *Foreign Hint* (CLXXII) contains six
pages, like the ones below, copied from a
guide-book, and some pages of manuscript
notes as well.

CLXXII *18* and *19*

The first sketchbook on the journey he labelled *Paris, France, Savoy 2*, repeating the title of 1802. An avenue of tall trees reminds us of a page in the earlier book (see p. 39). He did not arrive in Rome until mid October: on the way he stopped at Turin, Lake Como, Milan, and Venice.

CLXXIII *10*

CLXXI *17a, 18*

CLXXIII *21*

CLXXVII *3a Tour de Bandini*

CLXXIV *62a*

31

19

Of 22 sketchbooks completed while he was abroad 16 are small books of pencil work, usually with about 90 leaves drawn on both sides, sometimes two or three views to a folio. The total approaches 2000 drawings. Four larger books had a grey wash into which he worked in pencil, chalk, or watercolour – sometimes in body colour. The grey was removed by rubbing out for the lights. One book contains sketches in watercolour on white paper; some of the drawings are of the quality of those illustrated on pp. 185 and 6. This *Como and Venice* book may quite possibly belong to the 1830s, but the paper is watermarked 'Whatman 1816', and Turner's watercolour is so extraordinarily variable in the Italian sketchbooks of 1819 that we can reasonably regard these as the peak: the lowest depths are not illustrated here.

Much unfinished work is of great interest, and Turner was clearly in his most experimental frame of mind. But there is no consistent body of coloured sketches such as might be expected from the *Como and Venice* examples and those reproduced on the endpaper and jacket. We are forced to conclude that he was mainly concerned to record as much as he could in pencil – most, but by no means all, in his quickest style – and in monochrome. There is certainly sufficient to show that he was aware of, and responding to, colour at least as positively as he had been in the Rhine drawings of 1817.

I have been unable to find many of the descriptive written notes on colour mention by Reynolds, though I did find that the wo *Claude* appears several times on various pencil sketches.

As for the pencil work itself, my selection superficial. The range of his style is here, b a representative selection of 2000 drawings is impossible in the equivalent of eight page I have ignored half a dozen of the pencil books completely: those which cover expeditions from Rome to Naples, Pompeii and Albano. Regretfully I have left out any example of the monochrome 'chiaroscuro' work, which, though dull, is at least consistent. In the drawings reproduced I ha not been able to follow my rule of half size.

CLXXV *78a*, *79* Rialto Bridge

CLXXV *12* Milan Cathedral

CLXXV *43a* Camerlenghi Palace, Rialto

CLXXV S. Giorgio Maggiore S. Maria della Salute

CLXXXI 7 Campanile S. Marco

The Doge's Palace

CLXXXI *3*

CLXXXII — 9

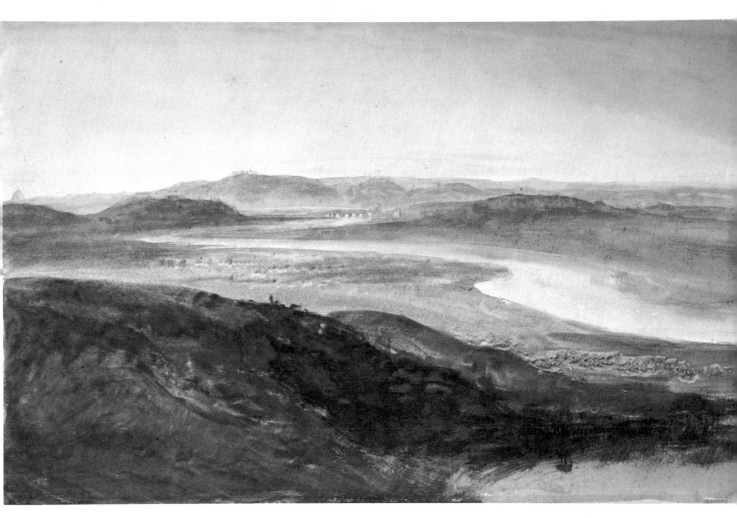

CLXXXVII

CLXXXII *65a*, *66* The Forum

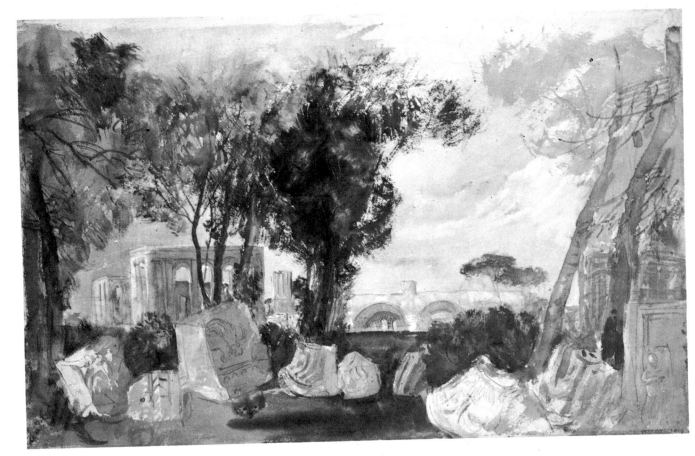

CLXXXIX *30* Rome

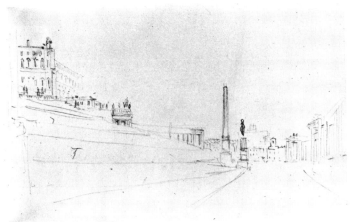
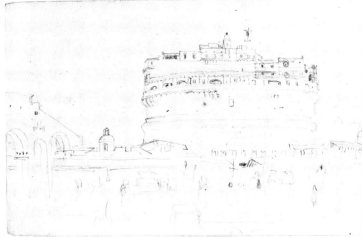

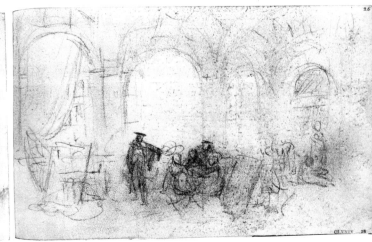

CLXXIX Tivoli and Rome

.XXXIX *55*

One of the small Roman pencil books,
Tivoli and Rome (opposite) contains miniatures
of the gardens of the Villa d'Este; the
distinctive structure of the Castle of S. Angelo;
and one tonal, portentious study for the
large picture *Raphael . . . Rome from the
Vatican* on which Turner was to labour when
he returned to London.

Three small pages from the book called
Return from Italy take us just into 1820,
January. He was in a hurry to get back.

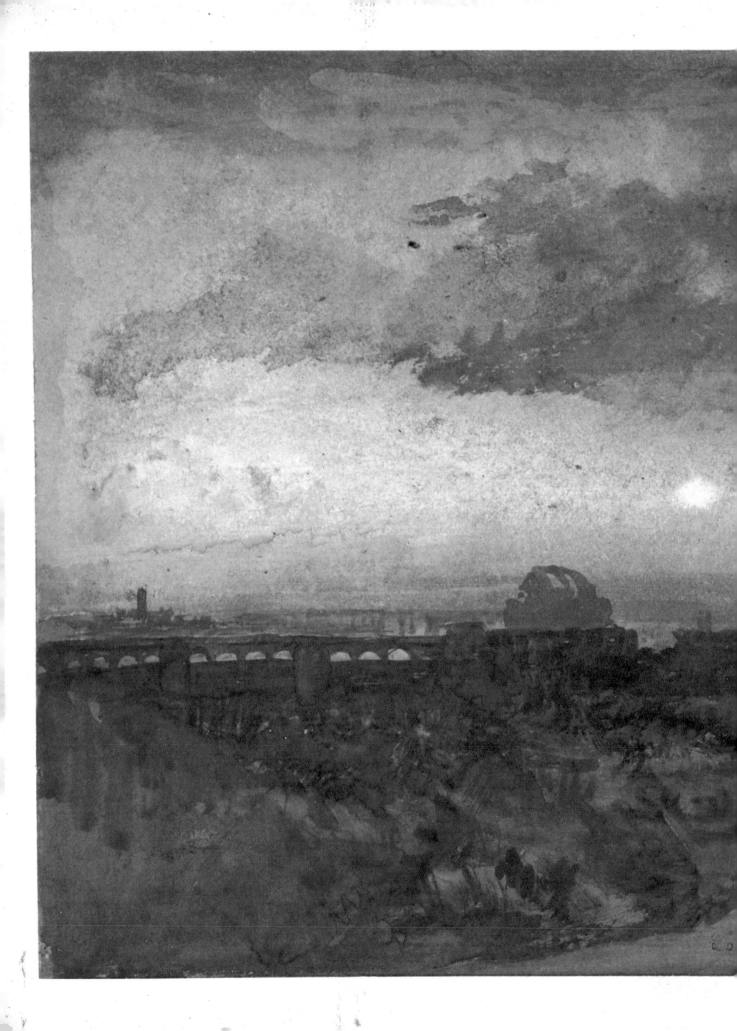